FESTIVAL IN THE NORTH

The Story of the Edinburgh Festival

GEORGE BRUCE

LONDON
ROBERT HALE & COMPANY

© *The Edinburgh International Festival Society Ltd. 1975*
First published in Great Britain 1975

ISBN 0 7091 5061 X

Robert Hale & Company
Clerkenwell House
Clerkenwell Green
London EC1R 0HT

Filmset by Specialised Offset Services Limited, Liverpool
and printed in Great Britain by
Compton Printing Limited
Aylesbury, Bucks

CONTENTS

ILLUSTRATIONS

Sonia Dresdel and Walter Fitzgerald in *The Queen's Comedy*

Heather Stannard, Andrew Faulds and Tony Britton in *The Player King*

Paul Rogers and Isabel Jeans in *The Confidential Clerk*

Ian McKellen as Richard II

PREFACE AND
ACKNOWLEDGEMENTS

The Edinburgh Festival is greatly to be treasured. It has enhanced the lives of many people in Scotland and in many parts of the world. It has brought a new gaiety to Scotland, and by means of its provision of great music, drama, painting, sculpture and film, a deeper understanding of life itself.

Accordingly I felt honoured to be invited to write an account of the Festival, which I have attended from 1947 to the present date. In consequence of my admiration of, and affection for, the Festival, the account could not but be partisan, nor do I consider it should be otherwise. It is also inevitably subjective in so far as I have expounded at greater length on those events which made the greater impact on me. I hope, however, that my tastes and interests are sufficiently catholic as to be representative of many who have attended the Festival. In any case I have supplemented my remarks with the comments of critics, who, despite their strictures, value the Festival highly.

While the chronology of the Festival is generally observed in the book, the approach is thematic, whereby it is possible to pursue an interest in a conductor, orchestra or company though each may not have performed in a sequence of Festivals. Sometimes this has meant a recovering of the same ground, but generally from a different point of view. In the last chapter I have quoted liberally from the opinions of the Directors of the Festival as expressed in the twenty-fifth anniversary Souvenir Programme, for though the matters to which they refer have already been dealt with, the quotations give insight into what the Directors valued especially. I am grateful to them for permission to make these quotations.

I have been much helped in the arduous and complicated task of compiling the book by Mr Iain Crawford, Publicity Manager of the Festival. I am grateful to Mr George Bain, Secretary and Administration Manager, for his unfailing patience in many

consultations and to Mrs Muriel Robertson, a secretary, for work on my behalf in the Festival archives.

My thanks are also due to Messrs J. Roy Rankin, James Dunbar-Nasmith and David Baxandall, members of the Festival Council, for advice.

Permission to quote from sources stated in the text is also gratefully acknowledged.

<div align="right">

GEORGE BRUCE
February 1975

</div>

DEDICATION

*This book is dedicated to
the Edinburgh Festival Society,
the founders and inheritors of
a great civilizing enterprise.*

1

PROLOGUE

Edinburgh, The Festival City

". . . et le château – perche là" said the French girl in Princes
Street gardens, surprised into an exclamation which made
everyone look up yet again to the Castle which makes the
Edinburgh skyline Edinburgh. But not only a young French
visitor may be carried away by the drama of the ridge that
projects the Castle as its climax. On the occasion of the siting of
the two Henry Moore sculptures on the lawn of the Botanic
Gardens in front of Inverleith House, the sculptor was invited by
David Baxandall, the then Director of the National Galleries of
Scotland, to discuss their positions. He was delighted by their
setting in the mingled urban and natural scene. He enjoyed the
reminders of classical Greece on the Calton Hill and he noticed
with pleasure how the outline of his 'Reclining Figure' (1951)
echoed the splendid rhythms of Arthur's Seat. From there his eye
travelled inevitably westwards to the irregular outline of
buildings that climb along the High Street and then from St Giles
to the Castle and beyond to the Pentland Hills.

The historic drama, the outcome of which is Edinburgh,
created by man and nature, shows itself again and again, as one
looks from the Castle itself, north or south, or from the Calton
Hill, or from where the road breaks through the rock by
Arthur's Seat to reveal, as Scott called it, "Mine own romantic
town," or most dramatically when the Salisbury Crags appear
suddenly round a street corner, bathed rosy in an evening
light – a view so breathtaking that one finds oneself asking, is it
real, or is it a theatrical illusion? Such scenes call for one
fulfilment – festival. And Edinburgh has it.

The stones, the buildings, the Old High Street resound with
tales of romantic history and notable names – Knox and Mary
Stuart, the murder of Rizzio; the arrival of Charles Edward
Stuart to claim the capital for his father; Boswell and Johnson
pacing the cobbles of the Old Town; Burns and Clarinda;

Deacon Brodie — respectable burgher by day, thief by night; Sir Walter Scott on his daily journeys from his house in Castle Street to the Law Courts. This is sufficient to justify claims for attention from the nations to the historic city, but Edinburgh's warrant to be adjudged a fit place for an International Festival of the Arts is to be found in classical Edinburgh. There the streets, crescents, places, monuments, institutions and galleries of the New Town — as its inspirer Lord Provost Drummond referred to it in 1767 — pay homage in their style to the Rome and Greece from where sprang the culture of Europe.

But buildings alone give no surety for the right climate for fostering the arts and sciences. That climate is provided by the inhabitants, of whom in Edinburgh a surprising number, drawn from the whole range of society, showed by their curiosity about philosophic ideas and new scientific discoveries during the eighteenth century that new communications were welcome and these included the Arts. The democratic practice of the Arts had been demonstrated sporadically in the Old Town in the earlier part of the century. In the High Street lived Allan Ramsay, the wig-maker who was also a poet. His pastoral musical play, *The Gentle Shepherd*, was to be performed 200 years after its first performance, at the Edinburgh Festival in 1949, in that Classical Building, occupied until 1969 by pupils of the Royal High School. His son Allan Ramsay, the painter, was to have his portraits acquired by the National Gallery of Scotland and so on view through all the festivals. To the High Street came Robert Burns to meet his publisher William Creech, who was later to be Lord Provost of Edinburgh. Down the street a short way in Anchor Close, William Smellie edited and printed the first edition of the *Encyclopaedia Britannica* — a symbolic book for Edinburgh for the city was to show an encyclopedic curiosity in the years to come that ranged through the Arts and Sciences, and throughout society, from the philosophers who met in the precincts of the University, to the journeymen gardeners on the north side who founded the Leith Walk Linnaean Society for mutual horticultural instruction.

If the ideas fermented in the Old Town, they were clarified and set in order in the New. Here came to settle the lawyers and writers and men of science. Frequently two or more professions met in one man. There was Scott in Castle Street, later Stevenson in Heriot Row, who though legally qualified did not practise, and in Charlotte Square for a period, Lord Cockburn, the judge

and memorialist of his time. He recorded:

> The first modern Music Festival was held in Scotland in 1815. It sprang more from charity than from love of harmony. But the music, as I am told (for though I heard some of it I did not comprehend it) was good, and the Outer House [Parliament House] where it was performed, was not ill calculated to give it effect. We have become an infinitely more harmonious nation since then. Indeed none of our advances is more decided than our musical one. But this is not for one with deaf ears to speak of.

This was a too humble predecessor to be regarded as a harbinger of the International Festival of today. Yet in these days Edinburgh was a city of international repute. The French traveller Léon de Buzonnière in 1827 considered "there was no spectacle in the universe more majestic and picturesque than the view from the middle of Princes Street. He found not a single building in bad taste, except for the tower commemorating the English Admiral Nelson." And in such buildings were held entertainments and parties, at which in Saint Cecilia's Hall, Urbani might sing his or Haydn's or Beethoven's arrangements of Scots songs, Chopin on an occasion played *his* own compositions in the Hopetoun Rooms, while Susan Ferrier, the Scottish novelist, would have in attendance at her home such notabilities as De Quincey, Sydney Smith (one of the founders of the *Edinburgh Review*), Macaulay the historian, and the great Sir Walter Scott himself.

Yet beyond the men and women of talent and genius it was the character of the people that visitors found attractive. Captain Topham from England noted that "The air of mirth and vivacity, that quick penetrating look, spirit of gaiety, which distinguished the French, is equally visible in the Scotch." Amyat, King George's chemist, who lived in Edinburgh for some time, commented:

> Here I stand at what is called the cross of Edinburgh and can in a few minutes take fifty men of genius by the hand . . . In Edinburgh, the access of men of parts is not only easy but their conversation and the communication of their knowledge are at once imparted to intelligent strangers with the utmost liberality.

Robert Mudie in his magazine *The Modern Athens* summed up Edinburgh: "the modern Athens" had "gusto, grace and gravity".

This, for sure, is no picture of ourselves today, but I have felt it

necessary to write this prologue because too often and for too long the Festival has been referred to as an imposition on a city which has no connection with the art events performed in it. The truth, I believe, has been clouded by an over-simplified view of the Scot. Thanks largely to the mass media or the stage he, typically, is regarded either as an enthusiastic sentimentalist preoccupied with a folk past or as a religiose moralist. The readers of this essay will more readily relate themselves in idea to that eighteenth-century society in which the "democratic intellect" – to use Dr George Davie's splendid phrase – began to hold sway, through the increasing availability of education.

Regrettably under pressures objectives of that education narrowed to an excessive emphasis on information, but recently – and I refer to 1946 – the Arts, and especially music, have been greatly encouraged. Some such factor as this must account for the fact that the average attendance of people from Scotland, at the Festival, computed over three years, is 57 per cent. This does not take into account the Tattoo, so the percentage must be higher. Since of that percentage 31 per cent come from outside Edinburgh, this is very much in the first instance Scotland's festival. This point is reinforced when one considers performers.

The first great new dramatic success, *The Thrie Estaites*, was under the aegis of the Glasgow Citizen's Theatre, while the Festival Chorus, which has won the greatest acclaim, brings together singers from all the airts in Scotland. At this stage I mention no more than these contributors. The evidence is sufficient to rebut the charge that we are apathetic to experience of music, drama or the visual arts as they are presented in the Festival or that the standards of performances are beyond our native capabilities.

There is, however, another point to be noted. Whereas in the eighteenth century and the early nineteenth people from abroad came to Scotland to learn from our native genius, today that aspect makes a limited contribution to the Festival. I reserve comment on this important matter for the last chapter. Suffice it to be said in the meantime that I do not believe even a superabundance of great art from the world at large is a depressive on local effort. That is not the way this kind of experience works.

When the conductor's baton is raised, when the curtain goes up, that is a moment of expectancy, even of mystery, for each

individual. What follows is memorable or inconsequential to one person. He or she is not there to be educated nor is the word 'entertainment' accurate in this situation. He is there to submit to the peculiar experience that may come by our temporary identification with a larger and deeper and finer quality of imagination than we ourselves possess. This may be achieved by direct confrontation with the vision of a painter – we look at a picture; or it may be mediated to us by an interpreter – a pianist (Schnabel so regarded himself); or through the conductor of an orchestra. We applaud together but we experience singly, and in the presence of the masterpiece applause is about the limit of our articulation of what has happened to us. We cannot even describe the experience to ourselves, for its nature is in apprehension, not comprehension. In 1967 ancient Greek drama was performed in modern Greek, a language which only a small percentage of the audience understood, yet the majority of that audience were in no doubt that at the end of the play they had suffered with and been elated by the players on the stage. For my part what some man had written some 2,500 years ago had been transported down the centuries and across many frontiers, had communicated a profound, tragic and characteristic human experience, and so was effected catharsis – "a proper purgation of feeling", as Aristotle put it.

Moments of great imagination on stage or in the concert hall are not confined to festivals. But these great Edinburgh festivals over the years have provided a treasury of human experience, of gaiety and tragedy, of horror (sometimes), and of the most exquisite tenderness and beauty, in such quantity and of such quality as to make computation of value in any terms impossible. In a time of devaluation of life the Festivals have given new value to life. The pages that follow tell the story of twenty-eight Edinburgh Festivals.

2

The Beginning, 1947

"*Edinburgh has already smoothed out her habitual frown and is taking on an Athenian aspect. When the fiddlers tune up this August they may be playing in a new era.*" (James Bridie, BBC Third Programme, 11 April 1947.)

If the 1940s were not Edinburgh's 'golden age' – a description used appropriately of the city 150 years previously – those years did mark a revival of the Arts, though the practice of music and painting had never been suspended since Urbani sang his settings of Burns in St Cecilia's Hall and Raeburn painted in his studio in York Place. Both buildings continue to be used for their original purposes. The continuity of standards was ensured in those arts by the Reid School of Music and by the Royal Scottish Academy, which had its own painting school. The Reid School's great Professor Tovey generated an enthusiasm for music through his teaching and concerts that spread far beyond the bounds of the University. The visits of Pablo Casals – who could be heard for sixpence – and the more frequent appearance of the Busch brothers in the Reid School were an indication of the quality of music which Edinburgh could hear.

In painting the Royal Scottish Academy and its younger brother the Scottish Society of Artists in the 1940s could show an art that, while aware of what was going on elsewhere – was developing on its own terms of lively, bold colour and free treatment of the subject. Critics from the south were surprised by its distinction and self-confidence. Then the chance of war brought an international company, chiefly military, to the city, mainly from Poland and Czechoslovakia. The British Council, under its representative H. Harvey Wood, responded by arranging readings and discussions by writers drawn from all over Britain, so that the intellectual life of the exiles would be stimulated. Harvey Wood put the Scottish poet Edwin Muir in charge of these. He also began the Lunch-Time Concerts in the

National Gallery of Scotland, which were continued by Tertia Liebentall with the greatest success until her death in 1970.

Despite all this, when the idea of a festival was first mooted in 1944 grave doubts of its success were expressed by some inhabitants on account of the character of the Edinburgh people who were 'dour', 'niggardly', 'suspicious' about the 'morality' of 'artists' – especially actors and actresses – and who at best were indifferent to artistic enterprise. This view was not shared by the promoters of the Festival, though it was taken account of in an article in *The Scotsman* of 7 August 1947 by H. Harvey Wood, the first Chairman of the Programme Committee and the first to discuss the idea of the festival with Rudolf Bing, the first Director.

"This, the world has been told," Mr Wood wrote,

is no brave cultural enterprise, but a sordid catch-penny scheme, devised by a city which has no claim to respect in the cultural sphere, a city which cannot maintain a repertory theatre throughout the year, a city which allowed her one and only symphony orchestra to die for want of a paltry grant. Such criticism is as obviously stupid as it is dishonest.

The promoters of the Festival idea have never been blind to the economic implications of the scheme. If the first Festival fails, it will mean not only the failure of an artistic venture, but the loss of considerable sums invested in it and the prosperity which such an enterprise successfully conducted might have brought to Edinburgh. If, as now seems certain, the Festival succeeds, Edinburgh will not only have scored an artistic triumph but laid the foundations of what may well become a major industry, a new and exciting source of income. At a time when we need as never before to attract visitors and foreign capital to this country it would be as senseless to disguise this aspect of the Festival as it is childish to attack it.

The visitors came in large numbers and the attendances increased over the years, but what Harvey Wood could not have anticipated were the financial problems created by a disproportionate rise in costs. On the other hand, who can estimate with certainty the unseen financial benefits that have accrued to Scotland as a whole because Edinburgh has become again a name known world-wide and a place to be visited? The sagacity and foresight of the original promoters were remarkable. However the emphasis may have shifted the Festival today is very much what they envisaged twenty-eight years ago, much as it was sketched in the article which Harvey Wood wrote for *The*

Scotsman two weeks and three days before the first Festival. In it
he tells how about three years before the Festival he, with other
officials of the British Council, met Rudolf Bing, General
Manager of Glyndebourne Opera, to hear his ideas about
possible cultural developments in Britain. Harvey Wood
described the meeting and its outcome thus.

The Edinburgh International Festival of Music and Drama was first
discussed over a lunch table in a restaurant in Hanover Square,
London, towards the end of 1944. Rudolf Bing, convinced that
musical and operatic festivals on anything like pre-war scale were
unlikely to be held in any of the shattered and improverished centres
for many years to come, was anxious to consider and investigate the
possibility of staging such a Festival somewhere in the United
Kingdom in the summer of 1946. He was convinced and he
convinced my colleagues and myself that such an enterprise,
successfully conducted, might at this moment of European time, be
of more than temporary significance and might establish in Britain a
centre of world resort for lovers of music, drama, opera, ballet and
the graphic arts.
 Certain preconditions were obviously required of such a centre. It
should be a town of reasonable size; capable of absorbing and
entertaining anything between 50,000 and 150,000 visitors over a
period of three weeks to a month. It should, like Salzburg, have
considerable scenic and picturesque appeal and it should be set in a
country likely to be attractive to tourists and foreign visitors. It
should have a sufficient number of theatres, concert halls and open
spaces for the adequate staging of a programme of an ambitious and
varied character. Above all it should be a city likely to embrace the
opportunity and willing to make the festival a major preoccupation
not only in the City Chambers but in the heart and home of every
citizen, however modest. Greatly daring but not without confidence
I recommended Edinburgh as the centre and promised to make
preliminary investigations.

 It is possible that Rudolf Bing had a predispostion towards
Edinburgh for according to Lionel Birch after a performance of
the *Beggar's Opera* in 1939 by the Glynebourne Opera, "Mr. Bing
walked through the city with Mrs. Christie [Audrey Mildmay]
and the magic of the setting made them think of it as a possible
festival town."
 Harvey Wood's suggestion was accepted. It was too late to
finalize arrangements for 1946, but 1947 was agreed as the first
Festival year. So with the support of the Countess of Rosebery,
Sidney Newman of the Reid Chair of Music at Edinburgh

University, and the Editor of *The Scotsman*, Murray Watson, Harvey Wood called on the Lord Provost and submitted the project to him. He recorded in his article: "It says much for the vision and enterprise of the city which was being invited to embark on this ambitious and hazardous enterprise that in November of the same year practical agreement had been reached, a preliminary budget had been prepared and approved."

In the Souvenir Programme of the first Festival Lord Provost Sir John Falconer committed the city to the Festival:

> For the three weeks of the Festival Edinburgh will be wholly given up to Festival affairs – she will surrender herself to the visitors and hopes that they will find in all the performances a sense of peace and inspiration with which to refresh their souls and reaffirm their belief in things other than material.
>
> We wish to provide the world with a centre where, year after year, all that is best in Music, Drama and the Visual Arts can be seen and heard in ideal surroundings.

High-sounding words, but even before the first opening praise had been sung in St Giles's Cathedral, the programme had been acclaimed. "Seldom", commented *The Sphere* "has any British town housed such a galaxy of distinguished artists. The orchestral combinations alone are amazing. Along with the great orchestras, soloists of our time . . ." and so on.

All that was required, apparently, was good weather. The heavens responded and bathed Edinburgh in continuous sunshine. One critic from London complained, "Edinburgh is so sultry."

What surprised the critics at the first Festival, an abundance of great music, splendidly performed, no longer surprises. Nevertheless, it is good to be reminded that the first Festival observed the prime requirement of the highest standards. The first Festival did more. It set a course. It showed it was committed to please the generality of music lovers, but that it had also taken account of the year and the location.

By engaging the Orchestre des Concerts Colonne to open the Festival concerts and by inviting the Louis Jouvet Company as the first performers of drama from abroad, the spirit of the 'auld alliance' was invoked. These were the first fruits of peace – and it was the nourishing of this spirit that Sir John Falconer, the Lord Provost of Edinburgh whose word had set the Festival going, had stressed as an objective. The international aspect was

beautifully realized in the greatest quartet of instrumentalists ever
to play at the Festival in the persons of Schnabel (Austria),
Szigeti (Hungary), Fournier (France) and Primrose (Scotland),
and touchingly realized in the reuniting of Bruno Walter with
the Vienna Philharmonic Orchestra. Those were gestures to
banish the black days of war.

With the inclusion in the Festival of Glyndebourne Opera, the
General Manager of which company, Rudolf Bing, being now
Director of the Festival, the emphasis was very much on music.
There was no official art exhibition and no great choral offering,
but the critics of the day knew that they had witnessed a new and
great artistic event.

Desmond Shawe-Taylor wrote in the *New Statesman*: "The
Edinburgh Festival is a magnificent challenge to our joyless and
cheeseparing times: so much interest packed into three short
weeks that the choice of dates becomes a problem for the
intending visitor."

Richard Capell commented in *The Daily Telegraph*:

> The Edinburgh Festival which ends today has been a roaring success
> and its continuity in 1948 assured . . . Edinburgh has developed a
> manner of festival-making of its own. Nothing for instance has
> every been known like the succession of famous orchestras
> appearing, from the Colonne of the first week to the culmination in
> Bruno Walter's reunion with the Vienna Philharmonic – one of
> time's revenges!

The *Manchester Guardian* began its comment in a leader article:
"The Edinburgh Festival draws today to a splendid close", and
went on to praise the Vienna Philharmonic Orchestra:

> The Vienna Philharmonic might stand for the unconquerable spirit
> of European civilisation. After a career of unexampled splendour in
> Europe's prosperous times, and after the ravages of two great wars,
> the orchestra lives on in almost undiminished strength, vigour and
> prestige. The body of Vienna may be as wasted as the shadow of
> itself; the glorious spirit lives. But it was not only the orchestra for
> which Edinburgh has to thank Vienna. The whole conception of the
> Festival, its organisation on the artistic side and the recruitment of
> the famous players and orchestras and companies, which have
> sustained it are due in large measure to an Austrian, Mr. Rudolf
> Bing, who became a naturalised British subject only last year.

With the first blow of war, humanity, and so civilized values,
seemed to have perished. For the leader writer in the *Manchester*

Guardian the Edinburgh International Festival had reinstated these values. But why should they be renewed in Scotland? The question was raised by Sir Neville Cardus, the music critic of that paper. "On the face of it," He wrote,

> it is remarkable that Edinburgh should have been chosen to house the first truly great international festival in Great Britain; for Scotland not England is really "das Land ohne Musik" most days of the year ... But cultural ties binding Edinburgh and Scotland to Europe were woven long ago. From Edinburgh and Scotland Kant was wakened from his "dogmatic slumber" by David Hume. Carlyle translated Goethe and Goethe nourished himself on Walter Scott; Boswell called on Voltaire. Beethoven for an occasion interested himself in Scottish folk-song ... Through music Edinburgh picks up again the links of culture forged by hard thinking, not by the easier sensuous way of music centuries since, joining Scotland with the intellectual governance of the world.

Under the benign influence of Schnabel, Szigeti, Fournier and Primrose, who played "like four spirits" and the Scottish sun, Sir Neville's generosity perhaps got the better of his reason. The limited native contribution did worry some critics.

The novelist E.M. Forster, like all privileged to be present at the performance of the famous quartet in the Usher Hall, was also carried away. "What a mercy that such music and such interpreters exist!" he wrote in *The Sunday Times*. "They are a light in the world's darkness, raised high above hatred and poverty." But he went on to comment: "It surely is regrettable that no play by J.M. Barrie or James Bridie is being performed." *The Times* also remarked on this theme: "The participation of Scottish orchestras and choirs is all to the good and perhaps the dramatists – the names of Bridie and Barrie at once come to mind – must undertake the task of giving a native root to an international festival."

This reminder of a failure of confidence in the home-made product was salutary. Self-respect in this situation was crucial, and it seems to me that the absence of things born of our being and made by us gave some justification to an outburst of Hugh MacDiarmid against the Festival. On the other hand the organizers could claim that they had employed most of the Scottish resources in music of festival standard. These included the Orpheus Choir, the Scottish Orchestra and the BBC Scottish Orchestra. There was, however, no commission from the Scottish song-writer, Francis George Scott, then at the top of his

form, nor any approach to MacDiarmid or Edwin Muir, poets of international repute, though it is to be admitted that there was little interest in poetry readings in 1947. But the organizers of the Festival were aware of the dilemma. The point was taken in Harvey Wood's article to *The Scotsman*, in which he wrote:

It has been urged that the organisers of such a Festival should regard it as a duty to present Scottish achievement in music, ballet and drama to the world. Admittedly it would be criminal if Scottish music and drama were unjustly omitted from our programme but as its title implies the purpose of the Festival is not to present "My country right or wrong" or Scotland's cultural achievements great or small. The intention is to assemble in Edinburgh, for three weeks, a selection of the best both for our own profit and delight and so that we may measure by the highest standards the stature of our cultural growth.

Every attempt therefore has been made to ensure that Scotland's contribution to the international Festival is adequate in scale and quality. But it should be realised it is on the international aspect of the Festival that the emphasis has been placed in the honest belief that the arts in Scotland cannot but profit by such encounters.

The Chairman of the Programme Committee went on:

The cost of bringing an American symphony orchestra to Edinburgh would be monumental but it is to be hoped that the great orchestras of New York and Philadelphia may be included in future years and that an American theatrical company may play alongside a British company . . . Perhaps too, in future years, we may hope to have a really first class exhibition of international painting and sculpture in one of the principal galleries of the city.

It may also be hoped that we may find a Scots equivalent of "Jedermann" to be a recurrent and characteristic element in future programmes. It does not seem beyond the power of possibility that Bridie might do for Lyndsay's "Satyre of the Thrie Estaites" what he did for Chaucer's "Pardoner's Tale", or that "The Gentle Shepherd" which held the Scottish stage for generations, might be susceptible to the same arts of revival that were so successfully employed on Gay's "Beggar's Opera".

Harvey Wood's prophecy about *The Thrie Estaites* was wrong only in the name of its adaptor. It was not Bridie but Robert Kemp who, at the end of the first Festival, also voiced his concern about the Scottish contribution in a letter to the *Evening Dispatch*. "I feel strongly that for next year's Festival we must collect a first rate Scottish company, making use of actors and actresses who have gone south."

So it was that in 1948 the players came together for *The Thrie Estaites*, a play that drew its strength from the character of the people, a people, apparently, who spoke their minds freely, who warmed to one another readily, who were proud of their country and confident in themselves, and who were dead hundreds of years ago. They seemed to belong to a very different society from ours, yet a leader in *The Times* on 5 September 1947 suggested that some of their characteristics may have come through to Scots today, even in Edinburgh where people have been adjudged 'stand-offish'. The leader ran:

> Visitors have come, some from abroad, many from England, and more from Scotland, in great numbers . . . Edinburgh has made them welcome. Shopkeepers, waiters, tram conductors, and others who minister to our needs, do not take the perverse pleasure in negatives and dusty answers to which we in the south have become wearily accustomed. The spirit of the place is festive and as the festival is designed as a holiday festival this courtesy plays a large part in its success.

E.M. Forster concluded his article on the Festival with the words: "I have no space left to enlarge on the friendliness and hospitality with which the visitor to Edinburgh is greeted. The atmosphere is perfect. One has the sense of a great and ancient city which cares about the arts." One is forced to conclude that since there were several similar testimonials in other English papers, the praise cannot all have been mere politeness. At any rate they met the point made by Rudolf Bing in his pre-Festival article in the *Daily Express*: "The success of this Festival", he wrote, "will depend on the willingness of the Edinburgh citizens, of all of them . . . to feel and act as hosts during the three weeks of the Festival. They must feel it is their Festival, and the visitors are their visitors."

There was, however, another festival in Edinburgh not yet integrated into the main arts festival – the International Film Festival. As a documentary film festival its material was basically the lives and work of ordinary people. It presented seventy-five films from eighteen countries. John Grierson, the Scots film-maker who was then Director of Mass Communications at UNESCO in Paris, came to Edinburgh to open the Festival. He remarked that it was a daring gesture on the part of the Edinburgh Film Guild to launch the first International Film Festival ever to be held in Britain. In his opening address he said:

We wish that all people would desire to see other people's cultures. It was easy to be sceptical about the place of art and culture, but the creation of respect between nations was based on mutual respect for each other's cultures. It was in man's mind – at work in difficulty and suffering but still maintaining his great progress – that we found our inspiration for the future.

Of Scotland's interest in realist film, he said, "It was perhaps not dissociated with Robert Burns and the line, 'A man's a man for a' that.' It had the same insistence on common things, on the drama on the doorstep."

His remarks pointed beyond the 1947 Film Festival to John the Commonweal, champion of the poor man's honest toil in *The Thrie Estaites*.

3

New Developments, 1948

Sir David Lyndsay, as Lyon King of Arms to the Court of James V, was responsible for arranging plays and spectacles. His *Ane Satire of the Thrie Estaites* was first performed before the King and Queen at the Palace of Linlithgow in 1540. Its performance previous to that given at the Edinburgh Festival in 1948, was in 1552.

The Thrie Estaites were the Lords Spiritual, the Lords Temporal and the Merchants, representatives from which bodies formed the Scottish Parliament. The satire is directed against all three, but primarily against the corruption of the Church. Written in the old Scots tongue, and running originally about seven hours, it did not look promising as a popular Festival success. The producer, the late Sir Tyrone Guthrie, believed that cut down, with the language modernized and specially presented, the vigorous, earthy humour, the shafts of satirical wit, allied to the spectacle, might hold attention. It might just come off. Guthrie considered the sixteenth-century document might still illuminate human vanities and follies. It could be comic, spectacular and dramatic, if the right conditions for the play could be found. So Robert Kemp, the adaptor, James Bridie, the dramatist who had seen something in it from the start, William Grahame, Assistant Secretary and Administrative Director of the Festival, and Guthrie, the producer, set out to find the right place for staging the play. In Guthrie's words:

> We visited big halls and wee halls. Halls ancient and modern, halls secular and halls holy, halls upstairs and halls in cellars, dance halls, skating rinks, lecture halls and beer halls ... Darkness was falling ... I was beginning to be acutely conscious that I had led them all a wild-goose chase. Then spake Kemp in the tone of one who hates to admit something unpleasant: "There *is* the Assembly Hall."
> The minute I got inside I knew we were home. It is large and

square in the Gothic style of about 1850. It has deep galleries and a
raked floor sloping down to where in the centre, the moderator's
throne is set within a railed enclosure. The seats have sage green
cushions; there are endless stone corridors. Half way up the steep
black approach – it stands on one of the precipitous spurs of the
Castle Rock – is a minatory statue of John Knox.

 None of the others thought the hall particularly suitable but they
were impressed by my enthusiastic certainty and it was agreed that
the Kirk authorities be approached as to its use for a play. The
Scottish Kirk, with its austere reputation, might have been expected
to take a dim view of mountebanks tumbling and painted women
strutting before men in its Assembly Hall. On the contrary, no
difficulties were raised; no one suggested censoring the bluer
portions of the text or issued fussy interdicts about tobacco, alcohol
or dressing rooms. There was a single stipulation – no nails must be
knocked into the Moderator's throne.

 Tyrone Guthrie's surprise at the unqualified acceptance by the
Church of Scotland of his proposal to put on *The Thrie Estaites* in
a place where the General Assembly of that Kirk meets annually
is understandable. But perhaps it should have been tempered by
the knowledge that the General Assembly has long been regarded
by some as the successor of The Three Estates or Scottish
Parliament after the dissolution of that body in 1707. At any rate,
many of the opinions expressed in Lyndsay's play may be heard
in the mouths of the fathers and brethren for a fortnight every
May, ringing out from the Assembly floor in the same tones and
accents and with the same dramatic gestures as were employed by
Guthrie's actors, and no doubt by Guthrie's forebears and those
of the adaptor of the Morality, Robert Kemp. Robert Kemp's
father was a minister – and in the Scots tradition, a scholar and
preacher. Guthrie has a permanent association with the Assembly
Hall. There hangs in it a portrait of his great-grandfather
preaching in the open to a highland congregation.

 Now whether or not the *Satire* was commissioned by James V
as an entertainment, its *raison d'être* is beyond spectacle. It is an
urgent protest in the last resort by the Common Man – John of
the Common W al – against unprincipled and corrupt authority
and it is presented as a debate before the people. A French critic
M. Barthe was surprised that the play was so outspoken in favour
of the common people in the sixteenth century, but the
outspokenness was heard two hundred years before at
Bannockburn and in the letter to the Pope of 1320, the
Declaration of Arbroath. And the outspokenness continues in the
General Assembly of the Church of Scotland and elsewhere. So

when C.R.M. Brookes as the Herald, after the fanfare of
trumpets composed by Cedric Thorpe Davie, stepped on to the
stage and spoke these words, he embodied the voice of
generations, the voice of a nation:

> Famous people tak tent, and ye sall see
> The three Estates of this nation
> Come to the Court with ane strange gravity.
> Therefore I make you supplication
> Till you have heard our haill narration
> To keep silence and be patient I pray you
> We sall say nothing but the sooth, I say you.

The unqualified "nothing but the truth, I tell you" has the ring
of a man who is accustomed to contradict. The entry of the
Three Estates backwards, attended by their vices, is equally direct
in its visual indication of the times being out of joint. Then John
the Common-Weal pushes his way through the people to make
his plea:

> Sir, I complain upon the idle men.
> For why, sir, it is God's own bidding
> All Christian men to work for their living.

Douglas Campbell then went on in the part of John to castigate
"the strang beggars, fiddlers, pipers and pardoners, the idle
gamblers, Lords and Lairds, the great fat Friars, Augustines,
Carmelites and Cordelairs."

> And all others that in cowls be clad
> Whilk labours nocht and bene well fed.
> I mean not labour and spiritually.

And all this is against the Common Weal, the common wealth.
The idea that justice, before it can be true justice, must apply to
the whole nation without discrimination in favour of any one
person or class runs through Scottish history, so that when a
Scottish actor speaks those words he becomes the voice of his
people. This is *théâtre engagé*, in effect, and because he is standing
good for a tradition, its living voice, giving back to his audience
what is already theirs by birthright, he will speak with
extraordinary confidence. Yet when Diligence, the Herald, first
set foot on the stage it was not confidence in the idea that made
the audience catch its breath, but the large style of utterance and
gesture, which was performed as if designed by the Lord Lyon
King of Arms himself.

When it was suggested to Rudolf Bing that an Edinburgh

orchestra should be formed to increase Scotland's musical contribution to the Festival, he drew attention to the long period of preparation necessary for an orchestra to acquire standards, character and style. The remark with regard to style may apply also to the life of a community, but once acquired the outward signs of the inner character of the community may linger in the voice and gesture long after the organic life of the community has disappeared. I think something residual from our ancient history emerged in the style of the company in *The Thrie Estaites.* It was articulated most completely in the performances of Duncan Macrae as the Pardoner and Flatterie. These performances were, I believe, the first revelation of his genius.

I may have put too much stress on the idea of justice as the motivation of the play, but the idea was the catch which released from Pandora's box the welter of colour and character that poured on to the stage, that spread to the corners of the large apron, that surged to and fro as the actors hustled up and down the narrow passages between the audience.

This was the Producer's triumph, but the individual performances showed a special kind of merit. For instance the trio, Flatterie – Duncan Macrae; Falsehood – James Gibson; and Deceit – James Sutherland, while conjoining in sycophantic movements, each actor showed eccentric, individual distinctions in gesture and speech. Each decorated the original idea with mannerisms which were appropriate to the interpretation of the character. At the one extreme there were the highly stylized gestures of Duncan Macrae, which he was later to employ in other Scots parts with genius, and at the other were the intimate seductive movements of the wee men. The audience were astonished. They had never seen anything like it before.

Racy Scots characters were on view again in the 1959 Festival in Burns's *The Jolly Beggars,* which was set to music by Cedric Thorpe Davie and sung by the Saltire Singers, but the dramatic potential of the Scots, evident in pulpit and in pubs, has never been fully realized. A justification for the Scottish National Theatre was implicit in the distinctive style of acting to which the Three Estates gave witness. The playwright, the late Robert Kemp, and Tom Fleming have made this point many times and yet how near *The Thrie Estaites* came to being missed.

On 29 April 1948 the *Glasgow Bulletin* reported: "Compared with the bookings of other attractions those for the Scottish contribution to the International Festival of Music and Drama,

the *Satire of the Thrie Estaites* are disappointingly poor." The first
night attendance promised so badly that at the last moment the
authorities imported students and an assemblage of nurses to put a
face on the show. Then the papers spoke their minds. "The
Scottish Morality play *The Thrie Estaites*," reported the Glasgow
Herald, "is likely to be the major success of the Edinburgh
International Festival . . . it was acclaimed both as a work of art
and as a valuable contribution to the renaissance of Scottish
Theatre." The critic of the *Manchester Guardian* wrote of the play:

> The understandable diffidence of the audience quickly changed to
> enthusiasm and wild and prolonged applause followed the last
> ornamental exit of the characters. To everyone's relief it was soon
> apparent that the pageantry, beautiful in costume and grouping and
> in its accompanying music was not to be indulged in for its own
> sake; and that happily one was to be unconscious of the allegory.
> Each character is more of a personality than a symbol, and the
> dominant note throughout is the earthy humour of the Lowlands
> (and of Chaucer).

In costume plays and pageants too often the flaw had been
unreality, but here was colour *and* reality. It was the latter
element which caught the attention of Martin Cooper, critic of
the *Daily Herald*:

> Everyone is comparing the Satire with Reinhardt's production of
> Everyman at Salzburg and there is little doubt it will become a
> permanent feature of each year's Festival. But whereas Everyman is
> a foreign importation the Satire is bone-Scottish — forthright,
> violent and (forgive me my kind Scottish hosts) monstrously one-
> sided as good satire must be.

The reviews strove to outdo one another in their praise. The
Satire was revived the following year with similar success,
dropped in 1950 to make way for the staging of Ben Jonson's
Bartholomew Fair, and then brought back again in 1951, 1959 and
1973. Beautiful and skilful as was the staging of Johnson's play
and polished as were the performances, it illustrated the
difference between looking at a play and being involved in a
moral situation in which, in imagination at least, ethical
resolutions seemed to be required. Eight years later in 1959 after
the first performance in the fourth season of the *Satire*, I went
back-stage to see Tom Fleming who had brought a new power
to the part of Divinie Correction, originally played effectively
and with austerity by Ian Stewart. My progress was interrupted

by Samuel Marshak, the Russian poet and translator of Burns, then in his seventieth year.

He was elated with the experience of the Thrie Estaites. "They must come to Moscow," he said. I suggested that the ideology which they presented was not quite right for his country, but Marshak's enthusiasm was not to be dampened by ideologies. "My people will like them. They will understand." The Scots tongue was apparently no barrier. The humanity in the satire, he said, was what mattered.

In 1948 another expansion of interest was the first great choral concert with the Huddersfield Choral Society and the Liverpool Philharmonic Orchestra under their conductor Sir Malcolm Sargent. On Saturday 28 August they realized the barbaric splendour of Walton's *Belshazzar's Feast* and on the next day they sang Bach's *Mass in B Minor*. There was a native element in this success for the singers represented the acknowledged excellence of the choral tradition of the North of England. Ernest Bradbury, Music Critic of *The Yorkshire Post*, reported their success: "At ten minutes past five this afternoon," he wrote,

a capacity audience in the Usher Hall rose to their feet and cheered without restraint. A vigorous and memorable performance of Bach's great *B Minor Mass* had brought to an end the contribution of the Huddersfield Choral Society to Edinburgh's Second International Festival of Music and Drama. Some 250 sons (and daughters) of the West Riding had conquered new territory and their achievement had been heard on the entire BBC European network in twenty countries from Norway to Greece.

It was an affecting moment as, while memories of Bach's mighty Sanctus were still in our minds, Sir Malcolm Sargent took call after call on behalf of the singers, the Liverpool Philharmonic Orchestra, and Miss Isobel Baillie, Miss Kathleen Ferrier, Mr. Eric Greene and Mr. Owen Brannigan. There was no mistaking the solid enthusiasm for Huddersfield's contribution and as I sat there surrounded by my critical brethren from all parts of the world I was conscious of the grandeur of the occasion and proud of a Yorkshire achievement.

In Belshazzar's Feast the singing never flagged for a moment. Walton's pungent dissonances were attacked with supreme confidence and the final overwhelming chorus, aided by an orchestral artillery with added drums, trumpets and cymbals, did such full justice to the psalmist's hearty invitation to "make a joyful noise and blow up the trumpet in the new moon" that one imagined legendary Scots hearing the whole performance for nothing on the opposite bank of the Firth of Forth.

Ernest Bradbury went on to remark of these Yorkshire singers that "most of them would be back at work tomorrow." Over the years it has sometimes been inferred that the Festival is cut off from the mainstream of life, that it caters for the refined to the exclusion of the more warm-blooded. Within the first two years it presented a Scottish play which drew its strength from a realist popular tradition. One outcome of the play was a letter to *The Scotsman* suggesting that parents and teachers should have been warned of the coarseness of the *Satire*. In the same year one of its greatest triumphs in the concert hall had been brought by men and women of Huddersfield who would "be back at work on Monday".

Not that the coverage was complete. In 1948 the Military Tattoo had not taken its appointed place on the esplanade of the Castle, though Festival visitors had witnessed there displays of piping and dancing. In 1950, however, the Tattoo became art and part of the Festival, though it is still organized separately. The Film Festival achieved official recognition in 1949.

4

The Music Makers in the Usher Hall

After the first Festival, Kathleen Ferrier wrote:

> It was unforgettable. The sun shone, the station was decked with flags, the streets were gay. Plays and ballet by the finest artists were being performed, literally morning, noon and night and hospitality was being showered upon guests and visitors by the so called dour Scots! What a misnomer!

For Kathleen Ferrier the Festival had been a personal triumph. She sang in the Usher Hall with the Vienna Philharmonic Orchestra and Bruno Walter, her first concert with the German *maestro*. Her singing of Mahler's *Song of the Earth* remains in the memory as one of the greatest of Festival performances. The setting was equal to the occasion. The Usher Hall has its own special presence. It sets out its performers on its stage between two great pillars, towards which the audience on the tiers are swung round in two semi-circles as if to conjoin with the musicians, giving at once a sense of amplitude and immediacy. Music provides the most instantaneous drama of all the Arts. From the sounding of the first note consideration of what went before in preparation disappears, for either we are captivated or we have failed the experience. Yet how much lies behind every performance. In this particular case a very great deal indeed, not only the careful rehearsals of the singer, conductor and orchestra, but also the experience and encouragement of a community of artists.

"All art", wrote the Irish dramatist, John Synge, "is collaboration." The Edinburgh Festival is an act of collaboration and was so from the beginning.

When Kathleen Ferrier arrived in Holland in 1946 to sing the part of Lucretia in Benjamin Britten's second opera, *The Rape of Lucretia*, she was met by Peter Diamand who after the performances warmly invited her to return. He could not have

imagined that twenty years later he would be the Director of the
Festival to which she was to make an important contribution.
Peter Pears suggested her for the part of Lucretia to Benjamin
Britten. Edinburgh's first Director, Rudolf Bing, was responsible
for recommending this "new promising young singer" to Bruno
Walter after he had expressed his doubt about finding the right
contralto for the *Song of the Earth*, by which time she had already
been coached for Lucretia by Hans Oppenheim, associate
conductor of Glyndebourne Opera. He, too, was to come to
Edinburgh first to conduct the Glyndebourne Opera and then to
make his home there and so make his distinguished contribution
to music-making in Scotland.

Of his first meeting with Kathleen Ferrier, Bruno Walter
wrote:

> I recognised with delight that here was potentially one of the
> greatest singers of our time; a voice of rare beauty, a natural
> production of tone, a genuine warmth of expression, an innate
> understanding of musical phrase – a personality.
>
> From this hour began a musical association which resulted in some
> of the happiest experiences of my life as a musician.

Little wonder that the first performance at the Festival of *Das
Lied von der Erde* was a very special occasion. It was the beginning
of an association between two great artists. Bruno Walter was
also conducting an orchestra from which some of his former
colleagues had been removed by the persecution of the Nazis.
The following year Kathleen Ferrier returned to sing with her
own people from the North of England, the Huddersfield Choral
Society. In 1949 she gave her first recital with Bruno Walter at
the Festival. In 1951 he wrote her: "Believe me it gives me great
joy to think forward to our re-union at the Usher Hall." On this
occasion Kathleen stayed in Edinburgh with the Maitlands, those
great benefactors to the Arts in Scotland. She sang with the Hallé
Orchestra, under its conductor Sir John Barbirolli, a frequent
supporter of the Festival and a former conductor of the Scottish
Orchestra.

In 1952 Sir John conducted the Hallé with Fischer-Dieskau as
soloist in Brahms's *Four Serious Songs* on 4 September. On the
following evening, he conducted the Hallé with the Hallé Choir
and Kathleen Ferrier, Richard Lewis and Marian Nowakowski in
Elgar's *Dream of Gerontius* and yet again the closing concert with
Irmgard Seefried, Kathleen Ferrier, William Herbert and

Frederick Dalberg in Handel's *Messiah*. For the second time the North of England had provided a splendid Festival choral occasion.

Of the choral tradition in the North of England Herbert Bardgett, Chorus Master of the Hallé Choir, commented in the Festival Souvenir Programme of that year:

> Singers in the North of England have always been endowed with naturally good voices and the broad vowels of the local dialects (as in Lancashire and Yorkshire for instance) are certainly a contributory factory to that round, deep and mellow tone that comes so easily to northern choristers . . . Choral singing flourishes in the cities and in the towns, large and small. One could cite the famous choirs of Huddersfield, Bradford, Leeds, Sheffield and Halifax, to name but a few in Yorkshire, whilst Lancashire can boast of similar societies in Manchester, Bolton, Blackburn, Sale and Liverpool. The singers come from all walks of life.

One girl from Blackburn who had worked on the telephone exchange was Kathleen Ferrier. For the second time at the Edinburgh Festival she sang Mahler's *Das Lied von der Erde*, on this occasion with the Dutch Concertgebouw Orchestra under its conductor Edward van Beinum. She would not do so again. A few months previously, having partially recovered from an operation, she flew to Vienna where she recorded the Mahler with Bruno Walter. Another joint recital was promised for the Edinburgh Festival of 1953, but she was too unwell. She wrote to Ian Hunter who was then Director, and he informed Bruno Walter, who wrote her:

> Dearest Kathleen,
> I got from Ian Hunter the sad news that you do not believe in the possibility of having the recital with me in Edinburgh. I am sure you will realise the pain which my heart feels, and I want you to know that I think of you daily with the deepest affection and send you all my wishes. Our last common work the records of Mahler's songs and *Das Lied von der Erde* belong in my mind to the most beautiful musical events of our time, and whoever hears them must respond with an upsurge of admiration and love for you.

It was Mahler's farewell and it was hers, and it was the Edinburgh Festival which brought together the great talents and the goodness which made that farewell possible. Another letter which pleased her is quoted in her sister's book *Kathleen Ferrier*. It was from the Lord Provost of Edinburgh.

City Chambers
Edinburgh 15th July, 1953

Dear Miss Ferrier,
 I cannot tell you how sorry we all are that you will not be with us at the Festival this summer. Edinburgh at Festival time without Kathleen Ferrier is unbelievable.
 I am writing to say how genuinely grieved we all are to learn of your indisposition, and do most sincerely hope that you will make a speedy recovery.
 We look forward to future Festivals when you will delight us once again with your singing.

<div align="right">Yours sincerely
James Miller
Lord Provost</div>

On the morning of 8 October 1953 Kathleen Ferrier capitulated to the illness which she had resisted with great courage and borne with fortitude. A little under a year previously Sir John Barbirolli had written of her in the Souvenir Programme previous to her performances in the 1952 Festival: "Now, I suppose you will say, tell us something about Kathleen Ferrier the woman. Let me say at once that she has those qualities of dignity, grace and humour (a great sense of humour, bless her), simplicity and affection with which I have found the greatly gifted are often endowed."

In the same programme a tribute was paid by one great pianist, Clifford Curzon, to one of the greatest pianists, Artur Schnabel, who had died the previous year. In the article he quotes Schnabel as saying: "Art is not an occasional refuge or holiday but a perpetual and inexhaustible mandate to the spirit. The efforts to fulfil this mandate belong to the most exacting and most satisfying, and therefore to the supreme functions of man."

In 1952 the great quartet was reconstituted — Josef Szigeti (violin), William Primrose (viola), Pierre Fournier (cello) and, to replace Schnabel, Clifford Curzon (piano). They played the Brahms piano quartets in A Major (Op. 26), the C Minor (Op. 60) which Schnabel had played in 1947, and the G Minor (Op. 25) of Brahms to whom Schnabel had listened and to whom he had played. Clifford Curzon, playing in the 1974 Festival, continued the chain.

In the summer of 1970, less than a month before he was due to conduct the opening concert which celebrated the bicentenary of

the birth of Beethoven, Sir John Barbirolli died. This would have been Sir John's twelfth appearance at the Edinburgh Festival. In the same year, in the performance of *Das Lied von der Erde* by Janet Baker, there was another link with the first Festival. Janet Baker might well date the recognition of her fine talent from her winning the Kathleen Ferrier Award in 1956. The Orchestra which played *Das Lied von der Erde* in 1970 was the Concertgebouw. It had first played in the Edinburgh Festival in 1948. The quite extraordinary significance of the Edinburgh Festival for those great artists who have returned to the city to give their talents was memorably expressed by Schnabel after a single festival. In the 1948 programme he wrote:

The first, the 1947 Festival I count among my most precious recollections. It had a deeply moving character and a unique charm . . . Given in a city with no international record for a display of that kind shortly after years of what human beings themselves condemn as inhuman ferocity, and still in the midst of the painful and continuously dangerous consequences of that horrible period of disintegration and sacrifice, it appeared as an incredibly early demonstration of an unbroken faith in uniting human values and virtues, and must have been hailed as a ray of hope by all participating in it, be it directly or only at a distance . . . This is now shining history.

In 1948 another very distinguished musician, Sir Thomas Beecham, while in Glasgow in February to conduct the Scottish Orchestra, had expressed himself differently and forcibly about the Festival. He had said: "The people of Scotland are damned fools to throw away £60,000 on a musical festival . . . The money should have been spent on building up Scotland's own orchestra." But when Sir Thomas returned to Scotland to conduct his own orchestra, the Royal Philharmonic, for the first time at the 1949 Edinburgh Festival he had altered his opinion somewhat. In a broadcast on the Scottish Home Service as a contributor to 'Arts Review' he admitted:

I have very largely modified that first view because I can see that one of the results of this Festival after three years has been to stimulate curiosity in the whole of the country and will rouse a much greater interest in music of all kinds. Furthermore it has given the public an opportunity of hearing a number of first rate orchestral bodies . . .
 It has apart from its musical value a very great social importance . . . It brings people together from every quarter of the

country, and from England as well of course. It brings other people
from France, Italy, Germany, Austria, Belgium and so on, and it is
quite obvious that at this period in the history of Europe, there are
few things more desirable and more necessary than bringing people
together in amity, and allowing them to meet on perhaps the only
common ground of meeting, where there can be no likely chance of
them disagreeing for more than two minutes or coming to blows,
and that is music.

Witty and captivating as was Sir Thomas's verbal expression it
was his music which captured that Festival and others to come.
Not that his first concert which opened the 1949 Festival was
considered by all music critics as an unmitigated success. The
Critic of *The Times* commented:

> The opening concert of the Festival was a brilliant affair, a little too
> brilliant for perfection. "I will show them" was the plain, if
> unspoken motive behind the performance of Berlioz's *King Lear*, a
> piece of incredible banality, but not a bad vehicle for the display of
> orchestral virtuosity. What Sir Thomas intended to show was not,
> of course, his own prowess – he has long outgrown that state of
> artistic juvenility — but the quality of English orchestral playing in
> comparison with that of Berlin, Paris and Geneva, whose orchestras
> are among the seven best to be heard during the next three weeks.

"Here, [in fact] was God's plenty," to apply Dryden's remark
about Chaucer to the art of music. And so it has been at the
Festival, any year and every year, some no doubt richer and more
varied than others.

Perhaps there have been mistakes in the choice of music. There
was another complaint of 'banality' in 1949 when Mme Suggia
played the Cello Concerto by D'Albert as soloist with the BBC
Scottish Orchestra under its conductor, Ian Whyte. The music
was "tuneful" and nothing more than that. But no one could
seriously complain that the music was unenterprising. The same
programme contained a new symphony with Ian Whyte as both
composer and conductor. Later in the Festival the
same orchestra gave a concert which contained the first
performance of Ernest Bloch's 'Concerto Symphonique'
conducted by the composer, together with three items by living
British composers Cedric Thorpe Davie, Hans Gal and Arnold
Bax. Barbirolli conducted the Berlin Philharmonic, Ansermet
the Orchestre de la Suisse Romande, Rafael Kubelik came to
Edinburgh with the Philharmonia, and there was Sir Thomas, a
host in himself. The Music Critic of *The Scotsman* rhapsodized on

his revelation of the beauties of Schubert's Sixth Symphony in C Major: "What could be more simple than woodwind in thirds bouncing up and down the scale, and yet what could be more beautiful in actual performance!"

Sir Thomas returned in 1950 with Lady Beecham as soloist in the 'Concerto for Piano and Orchestra' by Handel-Beecham. Anthony Pini was his soloist in the first European performance of Virgil Thomson's 'Concerto for Cello and Orchestra'. Though he did not set the Festival going on this occasion, the honour being given to the Orchestre National de la Radiodiffusion Française, under its conductor Roger Désormière, he closed it down with a bang, by conducting Handel's 'Music for the Royal Fireworks' on the Castle Esplanade with massed military bands and cannon. He stopped short of conducting the fireworks which followed the performance. In this year also two brilliant young conductors, Guido Cantelli, who was tragically killed in an air crash in Paris a few years later, and Leonard Bernstein, made their Festival débuts. Bernstein conducted the Orchestra National de la Radiodiffusion Française and Cantelli the Orchestra of La Scala Milan. This orchestra also gave the first Festival performance of the Verdi *Requiem*.

Of all the years of the Festival, 1950 seemed to have more arresting musical events than any other. It was the year of the bicentenary of J.S. Bach's death. To commemorate it, the Edinburgh University Singers, making their first appearance at the Festival, joined with the London Harpsichord Ensemble, under Hans Oppenheim, in three of ten recitals given by the Ensemble. There was another Beecham triumph, *Ariadne auf Naxos*. This received the greatest critical attention of all the Festival events, but the event which demands special consideration, in the context of this book, was the first European performance of Bartók's 'Concerto for Viola and Orchestra' with William Primrose as soloist and Sir John Barbirolli conducting the Hallé Orchestra.

The use of the word 'official' of the Festival to distinguish it from the Fringe, has tended to give the impression of inevitability to its programme, as if the Director were working to a blueprint which he will implement by laying on performers. In fact the Festival lives by being a mixture of the planned and the fortuitous. In the first instance personal creative energies and intelligences have made the Festival possible and by these resources it is kept in being. When the Glasgow-born viola

player William Primrose brought the Bartók concerto from the United States to Edinburgh, he told a tale which revealed how purpose and chance had combined to bring the work to the concert platform. Works for viola players were in short supply in the 1940s. Primrose approached the Hungarian composer Bartók. In the 1950 Souvenir Programme, Primrose wrote:

Bela Bartók was unknown to me personally but I knew his work and was convinced that, if willing, he was the man to supply the viola literature with a new composition. Bartók's publisher Ralph Hawkes, an old friend of mind, arranged a meeting with him and one wintry day in late February 1945, my wife and I visited the composer in his New York apartment, where I asked him if he would write a concerto. He consented, but did not express too much enthusiasm. Rather he appeared worried as to the success of such an undertaking. We discussed the problems of the viola as a solo instrument, and he suggested that I should play for him as he was anxious to have an idea of the technical capacity of the instrument. The day after a performance I gave of the Walton Concerto, to which Bartók listened by radio, I left for an extended tour of the States, finishing up in Central and South America. It was not until the middle of September that we returned to our home in Philadelphia, where I found a letter from Bartók awaiting me, dated September 8th, 1945. In it, he said: "Your Concerto is ready in draft. Only the score is unfinished and if nothing happens I can be through with this in five or six weeks."

My wife and I, fatigued by our extensive air and train travel, decided to take a motor vacation in Maine. Our route should have taken us through New York, but a few miles outside the city we encountered a heavy rainstorm so we bypassed the town, abandoning a plan we had made to call on Bartók. Our vacation over, we set out on our return journey and we stopped for lunch at a small village some 150 miles north of New York. I bought a copy of the *New York Times*, wherein I was shocked to read an announcement of Bartók's death. A few days later I learned that Tibor Serly, Bartók's great friend and closest musical associate, had undertaken to decipher the manuscript and to score the work from the indications therein (which I may add were none too elaborate). I need not say how faithfully and with what loving care he accomplished this self-imposed task. Six months passed and I was told that the score was finished, but that endless and apparently insurmountable difficulties had arisen with the executors of the Bartók Estate. Then I confess I lost heart and let the whole matter drop.

In January 1949 my train schedule demanded that I spend several

hours in Boston, where I noticed that my friend Ernest Ansermet, whom I had not seen for many years, was conducting· that afternoon. I attended the concert and at its conclusion visited Monsieur Ansermet in the artist's room. In the course of conversation he told me that the viola concerto of Bartók was being rewritten for the cello. I insisted that he must be mistaken as I had commissioned the work but he assured me it was a fact and advised me to make immediate enquiries into the matter. Ralph Hawkes confirmed Monsieur Ansermet's statement, but he said (and I quote him), "Morally, the work belongs to you, and I will do everything in my power to see that you obtain it." After numerous and tedious formalities, and on producing Bartók's letter of 1945, I got possession of the work. I spent most of the summer of 1949 studying and memorising the concerto, which I believe to be an inspired and sensitive work.

Two days after Sir John Barbirolli had conducted the Bartók viola concerto, Victor de Sabata led the Chorus and Orchestra of La Scala Milan in the first Festival performance of Verdi's *Requiem*. Perhaps I am guilty of a rationalization when at the end of the second performance given on the last evening of the Festival, dazed by the dramatic splendours of the work, interpreted with astonishing power, resilience and sensitiveness by that great chorus, this listener concluded that the native Italian only could give the full measure of the greatness of Verdi. It was born in the Italian sun and dark, the free gestures in the Italian speech finding their place in their special way in the formality of the Latin Liturgy, so that the whole glowed with an intensity which came out of Italian lives which had found their consummation in the Catholic Church. The professional critic may well set this sentimental approach to rights by his wider experience of music to the effect that complete success can be achieved by professional means no matter where the forces are located. That may be so, but I have no doubt that the composer's location, at any rate in past centuries, was of moment to the character of the work.

There was an interesting case of a reverse situation in the same year, 1950, when the Orchestre National de la Radiodiffusion Française paid us the compliment of including Debussy's Scottish piece, 'Marche Ecossaise', in one of their concerts. This is not simply any *Ecossaise*, for the march is based on a pipe tune composed for the Chief of Clan Ross and which was played to him and his successors on ceremonial occasions. Debussy's original title of the march, 'Marche des Anciens Comtes de Ross',

acknowledges the debt of his music to the 'Earl of Ross's March'. No matter, however, how pleasing, even how appropriate, Debussy's borrowing may be, it cannot give the authentic, ageless thrill of the original bagpipes. Primitive as they are in instrumental terms, the music, though not in this case, has its own sophistication, which could arise only out of a traditional Gaelic culture.

Characteristically, Sir Thomas Beecham seemed to set all theories at nought when he conducted the Glyndebourne Opera with the Royal Philharmonic Orchestra in performances of Richard Strauss's *Ariadne auf Naxos*. Ernest Newman wrote in the *Sunday Times*: "The Royal Philharmonic Orchestra under Sir Thomas Beecham made a thing of constant beauty and expressiveness of the orchestral score, which shows Strauss at his best as a master of fine line-drawing." Dyneley Hussey in *The Listener* went further in his comment: "There was given as perfect a performance as I have ever seen and heard of any opera in all my experience."

Considering the many and varied international elements that went into the melting pot to make one perfect thing of *Ariadne auf Naxos*, theories about indigenous cultures had, perhaps, best be laid aside. Certainly they do not apply to the chameleon conductor, Sir Thomas. "The crowning glory of this delectable entertainment," said Stephen Williams on the air in 'Arts Review', "is the art and enthusiasm of Sir Thomas Beecham who conducts this music as though he had just discovered it for the first time and fallen head over heels in love with it."

Two years later at the opening concert of the 1952 Festival he was discovering for us, as for the first time, that composer of the far north, Sibelius. One critic explained that his success was because his natural instinct for Mediterranean composers made him more acutely aware of the distinctive colours of the north. The critic of the *Manchester Guardian*, Sir Neville Cardus, was more to the point: "The fundamental originality of Sibelius's thought, at least in the Seventh, was not only penetratingly revealed but compellingly communicated."

The other music in that opening concert devoted to Sibelius was the 'Incidental Music to The Tempest' and the Symphony No. 1 in E minor. If I may add a personal note, I should admit that however immediately compelling and splendid and even revealing the works of the great composers of central Europe may be, in the grasp and penetration, and in the persistent exploration of darker passages, in the solidity and occasional

glitter and most especially in the revealing of a persevering mind,
I find something curiously personal to me and my condition as a
Scot in the music of Sibelius.

But to conclude the tale of Beecham and the Festival. He
returned for the last time in 1956, to conduct the Beethoven No.
9 for the opening concert with the Royal Philharmonic
Orchestra and the Edinburgh Royal Choral Union, whose
Chorus Master was Herrick Bunney.

It was the tenth Festival, and it had a display of orchestras,
composers and soloists that bid fair to outdo all previous. The
closing concert was given by the Vienna Hofmusikapelle under
its conductor Josef Krips. Earlier in the Festival Dohnanyi had
appeared in a delightful concert for young people with the BBC
Scottish Orchestra under its conductor Ian Whyte, in which the
composer played his 'Variations on a Nursery Song for Piano
and Orchestra'. He was in his eightieth year, but he played with
the fire and enthusiasm of youth. There was the first performance
of 'Landscapes and Figures' by Arnell, and there was Sir Thomas
Beecham and Sir Arthur Bliss in the same concert.

Sir Arthur had come to Edinburgh to conduct his new
overture, 'Edinburgh', written as a tribute to the city and for the
Festival's tenth birthday. It paid tribute to the native music of
Scotland as well. Beginning from the rhythm of the word,
Edinburgh, as he explained in a programme note, he moved into
the old tune of the 124th psalm – the psalm which the Orpheus
Choir, under its conductor Sir Hugh Roberton, had sung as the
last item in the concluding concert of the 1949 Festival. Then
after an episode with a reference to Mary, Queen of Scots in a
'Pavanne for a Dear Queen', Sir Arthur finished up with his own
intepretation of reels and strathspeys, in the conducting of which
he found himself dancing a few steps on the rostrum. It was a
festive occasion. The conductor–composer continued with his
violin concerto written for Campoli who was the soloist. And
then Sir Thomas Beecham took over the rest of the concert.

Herbert Wiseman, then Head of BBC Music Department in
Scotland, said in a broadcast talk:

> After the interval Sir Thomas Beecham took charge. Bliss is a good
> conductor – better than most composers – but Sir Thomas Beecham
> is a super one when he is on the top of his form – I doubt if we shall
> ever hear a better Brahms No. 2! The phrasing was superb, every
> melodic point was pointed with loving care – I heard tunes I had
> never heard before.

At the outset, I wondered why there were extra instruments – for instance four trumpets in the orchestra when Brahms asks for only two. They were kept in reserve for the closing bars which have, in consequence, never sounded so brilliant. This was a real festival offering. The old magician knew exactly when to produce the rabbits from the hat.

There was another memorable concert by Beecham which included the Strauss 'Don Quixote' and 'Harold in Italy' by Berlioz. So on his last Edinburgh occasion he had included in his programmes one composer for whom he had a special admiration, Berlioz – with one of whose works he had opened the 1949 Festival – and the work of a composer whose friendship he had enjoyed over many years. Richard Strauss in fact died while Beecham was at the Festival in Edinburgh in 1949. Sir Thomas on that occasion was quick to go to Broadcasting House in Edinburgh from where he broadcast spontaneously an affecting farewell.

Beecham's gift to Edinburgh was style. His baton conveyed his special character and quality from the moment it was raised to its final rest. Yet Sir Ronald Storrs gave the music-making of Sir Thomas Beecham more than an aesthetic value when he wrote: "It is through missions such as his, and that of this great Festival, that the contrasting themes of the nations can be blended into one greater counterpoint tending gradually, though with stern struggles and heart-breaking setbacks, to the distant hope of a universal harmony."

"A great orchestra", wrote Neville Cardus in the 1953 Souvenir Programme,

has a character which comes from a certain tradition, a character not to be accounted for in terms of skill. The woodwind of a first class French orchestra might not blend with the general texture and tone of the Concertgebouw Orchestra. It is not easy to imagine the excellent strings of the BBC Orchestra superbly 'led' by Mr. Paul Beard, finding proportion and perspective in the Berlin Philharmonic. Many influences of method, of custom, of inherited pride, of local *habitat*, go to the shaping of orchestral style. I have persuaded myself for years that the Vienna players, under any conductor, evoke some suggestion and flavour of Vienna itself, and that the contrast between the styles of the Vienna Philharmonic and the Berlin Philharmonic is pretty much the same as the contrast between these two cities.

The Philharmonia of London is as brilliant as a new automobile – and as throbbingly vital, even in repose. At its best this

combination will survive comparison with orchestras anywhere in
point of polished instrumentation, taste and authority. I have never
heard the Philharmonia make crude, uncivilised or tentative
sounds ... As I say, the conductor can obviously influence style
granted a reliable range of orchestral skill at his disposal. During the
Edinburgh Festival of 1951 a remarkable transformation happened
to the Philharmonic-Symphony Orchestra of New York when on
consecutive evenings, the conductors were Dimitri Mitropoulos and
Bruno Walter. Subscribers virtually heard night after night two
orchestras for the same money, so to say – a consummation devoutly
to be encouraged in Scotland. Under Mitropoulos the tone of the
New York Philharmonic-Symphony was of streamlined brilliance.
And the temper and character of the playing under him were of the
'New World'. Walter achieved metamorphosis and nothing less.
Conducted by him this same wonderful band softened its colours
and a contemporary efficiency mellowed to warm heartfelt music of
the 'Old World'. In each case we were given an unforgettable
instance of a conductor's personal power.

The first surprise to anyone surveying the Edinburgh Festival
must surely be the display of orchestras and conductors: not only
in isolated years but year after year and year by year the scope
widened. In 1947 the visiting orchestras were from France and
Austria; in 1948 Holland contributed the Concertgebouw, an
orchestra managed by Peter Diamand, which opened the second
Festival with Mendelssohn's 'Italian' Symphony. That year too,
the Festival went further south for the Italian Augusteo
Orchestra. In 1949 Germany, Switzerland and France sent
orchestras; and then in 1950 the Statsradiofonien Orchestra came
from Denmark with its conductor Fritz Busch – a matter of
particular interest to Edinburgh on account of Busch's long
association with the city. In the same year Italy again sent an
orchestra, the Orchestra of La Scala Milan, and France, almost as
usual, was represented.

The Atlantic was first crossed, as far as the Usher Hall audience
was concerned, in 1951 when the New York Philharmonic-
Symphony Orchestra came to Edinburgh and this was the signal
for further long-distance journeys. Other American orchestras
followed – the Boston Symphony Orchestra in 1956, the
Pittsburgh Symphony Orchestra in 1964 and then the Cleveland
Symphony Orchestra 1967, with its conductor George Szell,
paying his second visit to the Festival, his first being with the
return visit of the New York Philharmonic in 1955. For Szell it
was also a return. Some years before he had conducted the

Scottish Orchestra for a short period. In the 1970 Festival he was also invited to conduct but had to withdraw on account of illness. His death in the summer of that year was the second severe blow to that Festival, the first being the death of Sir John Barbirolli.

Meanwhile Edinburgh was getting to know the calibre of mid-European and more eastern orchestras. In 1959 the Czech Philharmonic Orchestra gave the native view of the music of Dvořák and Smetana. In 1960 came the first Russian Orchestra, the considerable Leningrad Symphony Orchestra. Six years later there was a second Soviet appearance, the Moscow Radio Orchestra, and in 1968 came the State Orchestra of the U.S.S.R.

Yet how little the names tell. All is in the realization of the composer's intention by the conductor and orchestra. At a given moment we find ourselves caught by the music as never before, enriched by a new experience, at times of a new work, at times of something more familiar. In 1949 when l'Orchestre du Conservatoire from Paris played Debussy's 'Prélude à l'Après midi d'un Faune' this was indeed true. According to the Music Critic of the *Daily Express*, this elusive music was "exhibited in all its beauty". He went on to comment: "And piquant interest was added to the whole concert by the orchestra's characteristic sound — the thin toned clarinets, finely teamed trombones and horns with almost the femininity and vibrato of that much abused instrument, the saxophone." Once the comment has been made, we can recognize that composer, orchestra and conductor were representing a sensibility that was the outcome of the French enjoyment of life and uniquely French civilization.

The same orchestra played Mahler's 'Kindertotenlieder', and these songs of the death of children were sung very impressively. According to the same critic, "With that note of deep but restrained passion which she presents so well, Miss Ferrier made this grief-laden but finely wrought work her own." The conductor was Bruno Walter, who had two years previously as the last item in their final concert in the Usher Hall conducted the Vienna Philharmonic in the 'Emperor Waltz' by Johann Strauss in such a Viennese manner, according to the critics and everyone present, that only the native Philharmonic could have produced these sweeping and lingering rhythms.

Two years later in 1951 Walter conducted the New York Philharmonic-Symphony Orchestra in the Usher Hall. "On this occasion the Mahler Fourth, affording with its giant rhythms, the

graciousness and gorgeous texture opportunities of brilliant display for every group, revealed the quality of the New York players", wrote Percy Cater in the *Daily Mail*. The variables in the relation between the work, the orchestra and the conductor are numerous. For more that a quarter of a century the Edinburgh Festival has allowed those privileged to attend, to hear the great conductors take advantage of the character and quality of different orchestras and to bring their own experience in life and in music to bear on the work and on the players.

Mahler himself had once conducted the United States's oldest symphony orchestra, now nearly 130 years of age. (The hyphenated title indicates its alliance with its former rival, the New York Symphony.) But more significantly, Bruno Walter had known Mahler well. It was, however, its own Director, Dmitri Mitropoulos, who drew from this great instrument the power and drama expected of the New World, as he conducted without baton or score and with the greatest intensity. Some critics, at his first appearance, considered that the total movement of his body, arms raised above the head without beat, did not make for clarity. But that we experienced something new and powerful there was no doubt. He had the ability to astonish and compel attention utterly.

When the critics came to consider work of our own day, in effect that of the Russian composers Prokofiev and Shostakovitch, their terms of reference were similar. Desmond Shawe-Taylor wrote about the Shostakovitch Fifth in the *Sunday Times*: "This work which Mravinsky himself first introduced in 1937 received a glorious performance which must have convinced even the doubters of its great merits. The sustained arguments of the first and third movements were set forth with magnificent breadth and colour."

Neville Cardus commented in the *Guardian*: "Never before has the symphony – one of the most original of all composed during the present century – excited me and so completely bowled me over by its character and genius as in this performance. It transcended music. Kruschev himself might have been conducting."

But how can music transcend music? Sir Neville is surely pointing to the absorption of personal and national experience into the work and to the expression of that experience as it has been transmuted into music by musicians who are also Russians and therefore subject to the physical and mental environment of

their country. There is a correspondence between the scale of the Russian landscape, the great and often tragic human dramas enacted on it through the long, violent history of the nation and the works of the creative artists of that country. Christopher Grier in *The Scotsman* singled out one work from the final concert for special attention, about which he wrote:

> But the surprise packet was Prokofiev's Sixth Symphony, a disturbing, uncharacteristic and painfully-felt three movement work ... Written under the stress of war, its horrors and its memories, its temper can be gauged by the composer's own comment: "Now we are rejoicing over our great victory, but each of us has unhealed wounds; one person's relations have perished, another has had a physical breakdown – these are things that should not be forgotten."

These factors did not make for ready comprehension, but apprehension of this high-strung music was another matter. Its inclusion in the repertoire indicated an increasing measure of trust in Russia, a willingness to expose in their art what they had come through and also a readiness to put us in touch with their modern masters as they did again when the young cellist Rostropovitch gave the first performance in Britain of Shostakovitch's Cello Concerto.

Peter Heyworth called it a "sustained and deeply moving piece of music." But the Russians did one thing more than give us their best in their own and other continental music. They included the 'Variations and Fugue on a Theme by Purcell' by Benjamin Britten. It was a harbinger of the co-operation between Russian musicians and the English composer in Festivals to come. Music can break all boundaries. Six years later to see Benjamin Britten and Shostakovitch in the Usher Hall and to listen to their markedly different musics and to know that each rejoiced in his musical differences was to be in the presence of a human harmony which men might seek but rarely achieve.

In 1966 in the first European performance of Prokofiev's cantata *They are Seven*, the Scottish people became more actively involved in Russian music with the participation of what was then called the Scottish Festival Chorus and has now been renamed the Edinburgh Festival Chorus. This was the first occasion that the Chorus had performed with an orchestra other than the Scottish National Orchestra. That they did so with a success which was acknowledged by critics, and the conductor of the Moscow Radio Orchestra and other distinguished musicians,

is to their great credit, and especially to the credit of their chorus master, Arthur Oldham. They learned the Russian words phonetically, then recorded a tape which was sent to the conductor of the Russian orchestra who warmly approved of the results.

The Philharmonic-Symphony Orchestra of New York returned in 1955, with Mitropoulos again in charge. In his first concert he repeated Symphony No. 4 in F minor by Vaughan Williams, one of the successes of the 1951 visit. In the same concert Dame Myra Hess played the Beethoven Piano Concerto No. 3. Two other conductors gave concerts with the New York Orchestra — Guido Cantelli, who had conducted at previous Festivals, and George Szell. The visit to the tenth Festival by the Boston Symphony Orchestra brought home what American orchestras could do. Peter Heyworth made this comment in the *Observer*:

"Don't look at the brass, they need no encouragement" was Richard Strauss's advice to young conductors. Heaven knows what he would have thought about the Boston Symphony Orchestra's trumpeters. They raised their bells aloft with the uninhibited fervour of a Louis Armstrong with a strident rasping shriek, more reminiscent of a fire alarm than a musical instrument, mercilessly hacking their way through the most opulent score.

A damaging comment, apparently, but Peter Heyworth continued:

But in every other way it has been a most exhilarating experience to hear this great orchestra in a series of concerts in Edinburgh . . . Its heavy brass is superbly sonorous and in cool brilliance of its strings there is none of the harsh metal that disfigures some of the American orchestras. Above all its French style woodwind is quite superbly lucid, fluent and elegant and the fluttering flutes have a haunting, lyrical charm unsurpassed in my experience by any French players.

Each American orchestra seemed to be a preparation for the next, so when the Pittsburg Symphony Orchestra performed Elgar in 1964, the splendid result might have been anticipated. The Music Critic of *The Times* wrote:

When it came to Elgar's Second Symphony the flood gates were opened and a great stream of warm sonority poured into the hall . . . But it was never harsh or crude a sound, the orchestra has a liquid mellowness of tone as a corporate body very different from much that comes to us from the New World and also plays with a

marvellous flexible unanimity – not for nothing has it worked consistently with Mr. Steinberg for the past twelve years.

William Steinberg had directed the Pittsburg since 1952. Edinburgh audiences in 1964 heard the sensitive deployment of great orchestral resources over a wide range of music.

There was Mahler's 'Kindertotenlieder' again with its unforgettable memories for many people in Edinburgh. In the same programme Dietrich Fischer-Dieskau gave the first performance in Britain of *Canto* by Peter Menin. The first item in the Orchestra's first programme was an imaginative surprise – Gunther Schuller's 'Seven Studies on a Theme of Paul Klee'. The delicate, precarious visual balances of Klee's pictures were beautifully translated into aural rhythms. The placing of this item could have been an admonition to those of us who had prepared ourselves for what Sir Walter Scott once referred to as "the big bow-wow".

The maturing conception of musicality in orchestras from the United States was demonstrated with the arrival of the Cleveland Symphony Orchestra for the twenty-first Festival. The power was still there – the ability to take the audience by storm, but the perspectives and intentions had become defined and refined by the absorption into musical America of European talent. The loss to Europe, frequently by Nazi persecution, of great musicians, including conductors and composers, was to the gain of civilized living in America.

George Szell was America's gain. When he gave the opening concert at the twenty-first Festival with his orchestra, and for the three following days, he was very much Edinburgh's gain. He began with Bach's Suite No. 3 and ended with Stravinsky's 'Firebird Suite' – presenting the two composers who were to be given special attention at that year's Festival. These items let us know of the excellences, the purity and brilliance of this orchestra, its fitness as a vehicle under the sensitive disciplines of Szell to convey the letter and the spirit of Bach and Stravinsky.

Alas he is no more. In his obituary notice in *The Scotsman* Music Critic Conrad Wilson recalled this Edinburgh visit in these words: "The orchestra was at the end of a lengthy European tour but it responded to him with the rhythmic vitality, the balance, the unforced beauty of tone, that have made it, under Szell's guidance, perhaps the best of all the American orchestras."

One other American orchestra, the Chicago Symphony

Orchestra, made its contribution to the Festival within the first twenty-five years when it visited Edinburgh in 1971. On that date the Orchestra celebrated its eightieth birthday. It too brought programmes which showed the range of its power and sensitiveness. Sir Georg Solti was its conductor, and with him came Giulini, who held the post of principal guest conductor.

The achievement of orchestras from the United States has lain largely in the interpretation of music which was the product of European cultures; largely but not entirely, for the Americans also brought the works of their own composers which sometimes carried echoes of folk traditions of the New World, and sometimes belonged to the category of being good cosmopolitans. The main interest, however, was in performance, whereas we waited with curiosity to hear what the Russians would make of compositions which were the fruits of their distinctive culture. However much history was interrupted by the Russian Revolution of 1917, the past remains present in their musical culture. In all four performances by the Leningrad Symphony Orchestra at the 1960 Festival was included a work by Tchaikovsky. To Peter Heyworth in the *Observer* they were "concerts that will not readily be forgotten by anyone who had the good fortune to hear them." He went on to comment:

The blend of virtuosity, massive power and zest that it brought to its concerts last week show that it is beyond question one of the world's greatest orchestras . . . its special quality of sound is, of course, well suited to Russian music . . . Occasionally it sacrifices compactness of tone to sheer weight of sound, but its eruptions at climaxes of Tchaikovsky symphonies are prodigiously exciting.

It has been a particularly fascinating and instructive experience to hear this great orchestra play Tchaikovsky's Fifth and Sixth Symphonies under its permanent conductor, Eugene Mravinsky, for his interpretations stand in marked contrast to the usual Western conceptions of the music. Mravinsky's approach is intensely dramatic. His readings have prodigious force and excitement and at the *allegro vivo* in the first movement of the 'Pathétique' it seemed as though the Usher Hall had been stricken by some cataclysm, so huge was the weight of sound and so violent the rhythmic force behind it.

But the qualities of Mravinsky's performances extend much further than mere dramatic excitement. His ability to wield a phrase and its dynamic markings into an organic whole so that it seems to surge forward of its own accord, is masterly. His grasp of successive changes of tempo and ability to hold them firmly in relation to one

another, which seemed uncertain in Beethoven's Seventh Symphony, is unfaltering in Tchaikovsky, so that the big movements acquire an epic grandeur missing in Western interpretations.

"The Scottish Festival Chorus was quite magnificent," commented Philip Hope-Wallace in a broadcast. Conrad Wilson described the effect of the music in *The Scotsman* in a manner which may revive memories of the performance.

. . . certainly the sound of the words had a sting which is lacking when the music is sung in French. The armour plated *ostinati* and the swooshing vocal *glissandi* were put over with terrific attack and in listening to the music with its strong, brilliant orchestral colours as well as by its choral effects and its high voltage tenor solo (marvellously projected by Vilem Pribyl) one realised why in composing it Prokofiev became so excited that he had to go for a walk to calm himself down.

Two years later the State Orchestra of the U.S.S.R. visited the Festival in very unhappy circumstances, during the week when Russian forces occupied Czechoslovakia. The music made its own comment on the divisive politics of men.

1968 was the year when Peter Diamand, who was now Director of the Festival, featured Schubert and Britten. The cover design of the Souvenir Programme was a flight of doves. The first work in the opening concert was Britten's *Voices for Today*. It was performed by the London Symphony Orchestra, conducted by Ivan Kertesz, with the Edinburgh Festival Chorus and the Boys of St Mary's Roman Catholic Cathedral, Edinburgh. Composed at the invitation of U Thant, Secretary General of the United Nations, to celebrate the twentieth anniversary of the United Nations Organization, it was first performed on 24 October 1965 simultaneously in London, Paris and New York. Britten included in the text for the music words by Sophocles, Blake, Lao Tzu, Shelley and Yevtushenko. There was also the sentence: "How blessed are the peace makers; God shall call them his sons." Britten's Concerto for Violin and Orchestra, with Menuhin as soloist, and his 'Spring' Symphony completed the programme.

"The fruits of the spirit are slower to ripen than intercontinental missiles", Camus wrote. Britten used this sentence also as part of his text for *Voices for Today*. A fortnight later the New Philharmonia Orchestra, conducted by Giulini and Britten with Galina Vishnevskaya (soprano), Peter Pears (tenor),

Dietrich Fischer-Dieskau (baritone), the Edinburgh Festival Chorus and the Melos Ensemble, performed Britten's *War Requiem*. So Italian, Russian, German, English and Scottish talents combined in the moving lament for war.

Donald Mitchell wrote of these works in the Souvenir Programme that they

> spring out of sympathies, out of passionately held convictions and profound beliefs, which were already manifest in what one might describe as Britten's socially committed works, composed during the politically turbulent and momentous 1930s – e.g., *Advance Democracy* (1938) and *Ballad of Heroes* (1939), or the *Pacifist March* of 1937. In the works from the 'sixties, naturally enough the whole basis of the composer's attitude has broadened immeasurably: a political platform, as it were, has developed into a universal stage. *Voices for Today* speaks for international amity; *War Requiem* (and the *Cantata Misericordium*, 1963) for peace, compassion, and common humanity.

When Donald Mitchell wrote the words "peace, compassion and humanity" he did not know how peculiarly pertinent they were to be in the circumstances of the performances of Britten's works in the 1968 Festival. In the light of his comment and the works themselves, the dismissal of the Arts as irrelevant to social needs, or the categorizing of the artist as one who lives in an ivory tower, is evidently untrue.

Conrad Wilson, in his article in *The Scotsman* on the concert given by the State Orchestra of the U.S.S.R. on 24 August, having reminded his readers of the demonstration against the Soviet Union outside the Usher Hall, commented:

> Nevertheless one had only to listen to the sombre intensity Rostropovich brought to Britten's Cello Symphony and the Bach Sarabande he played as an encore, the heartrending beauty with which the Orchestra played Rachmaninov's Second Symphony and the evening's second encore (an elegiac little piece for strings which in the emotion of the occasion I found myself unable to place) to know that the performers and their large, tense enthusiastic audience, were on the same wave-length. Even the orchestra's introductory visiting card – a grimly measured perpetuum mobile, by the young Soviet composer, Arvio Piart – seemed peculiarly apt, serving as a disturbing prelude to the bleakness of the Britten.

Demonstrations, protests, pickets outside the Usher Hall, letters to the papers urging people not to attend the Russian concerts, a letter to *The Scotsman* complaining about the warmth of the applause at the Russian concerts – this was the background

to the music. But what was the audience applauding? If it was the music which Conrad Wilson described, then they were praising an interpretation of the political situation which put all in that hall for the moment on the side of humanity. It may be that the anguish of our day will best be understood in the future through the works of art of our day. One musician, however, gave special point to the music he played. Immediately before Yehudi Menuhin played Beethoven's Violin Concerto in the Usher Hall with the Scottish National Orchestra under its conductor Alexander Gibson, he concluded a speech to the audience with these words: "I dedicate this performance as Beethoven did his life, to the indomitable and defiant spirit of man."

Menuhin had a right to speak thus, for his approach to music has always been to bring out its inner meaning, but perhaps no musician closely associated with the Edinburgh Festival had shown the "indomitable spirit of man" more persistently than Sir John Barbirolli. Yet it is not for this reason that special consideration must be given to this sensitive warrior. The tribute has been delayed because the Hallé and Sir John have been on our Scottish doorstep for many years and the stress in this book has been on the international character of the Festival. Sir John, in fact, was conductor of the Scottish Orchestra from 1933 to 1936, from which post he was released to succeed Toscanini as conductor of the New York Philharmonic Orchestra, and from there back to Britain to take charge of the Hallé and to make it the instrument of rare quality that Festival audiences came to know between 1947 and 1969.

Keats, in a letter to his brother, makes a reference to the "chameleon poet". No doubt all conductors must be chameleons, responding to the changes of light and colour in the music, but the phrase seems to apply to Barbirolli especially, in a physical sense as well as a mental one, for his whole body would respond to the character of the work and with the result that one tended at the time to say this or that was Barbirolli's special composer. The fact was that his flexibility, his apparently unqualified commitment to the storm or calm of the music, was allied to an equally strong mental grasp of the style of the work. On the one hand, his Elgar in the first Festival was commented on in *The Scotsman*: "Our visitors will hear nothing more English of its kind that this work" (the Introduction and Allegro for Strings); and on the other hand at the 1948 Festival, Ernest Newman wrote of Barbirolli and the Hallé in the *Sunday Times*:

Of Sibelius [the fifth] I do not hope ever to hear a more splendidly convincing performance. It was an inexpressible pleasure to see a great work gradually taking shape in performance as it must have done in the mind of its creator, developing steadily logically from acorn to mighty oak, and treated respectfully as something existing in its own right.

He burned with a transparent flame so that the music that passed through him and became alive at the tip of his baton took to itself the colour of the composer's mind, and yet despite the catholicity of Barbirolli's taste, he was frequently motivated by personal reasons. Something more than programme balance must have caused Barbirolli to select Elgar's Second Symphony for the first concert of the Hallé at the 1947 Festival. It was the work to which he once referred as having set him going. Festival programmes testify to his interest in Elgar over the years and the comments of the music critics are witness both to Sir John's consistency of interpretation and their own professionalism.

The opening concert of the 1957 Festival commemorated the centenary of the birth of Elgar. Naturally the Hallé with Sir John were the performers. It included the Concerto for Cello and Orchestra. "Did he ever write anything more personal and intimate than its third movement?" asked Christopher Grier in *The Scotsman*, and then continued: "Eavesdropping on it yesterday — and it was played with an extraordinary quality of hushed sustained intensity and at a very slow pace — one felt like a spectator at the revered uncovering of some shrine." The cello was Sir John's instrument. He was in a position to applaud the performance of Janos Starker, the soloist on this occasion.

Of Barbirolli's intensity of interpretation we hear from time to time. Conducting the New Philharmonia Orchestra in 1965 he gives to the Fifth Symphony by Carl Neilson what one critic called a "superbly tight reading". It was at this performance that his own vocal contribution of sympathetic sounds, "groans" to the ears of the critics, were heard to some slight disadvantage of the music. When the cello was the solo instrument his *simpatico* was noticeably louder and one can understand this conductor's desire to employ every possible personal resource to draw from the orchestra the complete musical experience. There was for 'glorious John', as Vaughan Williams dubbed him, no such thing as a routine performance though there were exceptional occasions as on Saturday 4 September 1954, when the Hallé with the Sheffield Philharmonic Chorus gave a performance of Verdi's

Requiem, dedicated to the memory of Kathleen Ferrier. After the last, whispered "Libera me" Sir John motioned to the audience to rise. The silence was one of those moments of ennoblement which should be treasured.

Sir John Barbirolli was to live nearly seventeen years after his friend's death and this despite his rejection of the admonitions of doctors to lay off work for a spell. As early as 1949 he was compelled to cancel all his engagements except those at the Edinburgh Festival and these he fulfilled against his doctor's advice who reported that he was suffering from severe strain. Two years later he again risked his health by conducting at the Edinburgh Festival. That year, 1951, Kathleen Ferrier sang for him in Chausson's 'Poème de l'Amour et de la Mer' and again at her last appearance at the Usher Hall at the final concert of the 1952 Festival in Handel's *Messiah* with the Hallé Choir. The conjunction of the north of England choral tradition with Barbirolli and Kathleen Ferrier in the most beloved choral work of all makes the event, in retrospect, seem something more than a happening.

Sir John's last appearance in the Usher Hall also provided a coming together memorable to the people of Scotland when he renewed his association with the Scottish National Orchestra (the successor to the Scottish Orchestra) in 1969 in a concert which included Symphony No. 5 by Sibelius, a work with strong appeal to the Scottish temperament. Conrad Wilson referred to the "breadth of phrasing" of the interpretation, commented on the "rich weight of the bass tone" which Sir John drew from the orchestra, and concluded by remarking on "the manifest love he lavished on the music, all very special and very personal. They do not make conductors in Sir John's mould any more."

Had Conrad Wilson known that that concert was to be Sir John's last Edinburgh Festival he could not have thought up a more apt line than his last sentence. At last the flame which had burned with such intensity in the music had consumed the body John Barbirolli had driven so hard in loyalty to music and to people, first to the people of the north of England whom he had made his own and then to those who came to share the music he made. And so at the Festival of 1970 another silence was observed, this time before the opening concert on 23 August, which Barbirolli was to have conducted. The silence was preceded by these words spoken by the Right Honourable James W. McKay, the Lord Provost of Edinburgh:

The twenty-fourth Edinburgh International Festival of Music and Drama opens today, but missing from their customary places are Sir John Barbirolli and George Szell – two outstanding musicians who were, as few others were, admired and respected throughout the whole world of music – for their knowledge and authority and, perhaps still more, for their love and respect for music. Both Barbirolli and Szell had close associations with our Scottish Orchestra in the years before the war when they mounted this rostrum to guide and inspire their musicians through the vast repertoire. Many will remember these occasions, many will recall their memorable contributions made to the Edinburgh Festival since its inception in 1947. We had felt privileged at the thought that both would be again with us this year. Barbirolli and Szell have set standards and established values for which they will be remembered for years to come.

It may be that the abiding memory of Sir John Barbirolli for some members of the Festival audiences is of the occurrence near midnight on 10 September 1966 in the Usher Hall when he conducted by candlelight Haydn's 'Farewell' Symphony. The new Festival Director, Peter Diamand, had the idea that a programme in which a number of Festival artists would take part under the heading 'Farewell' Symphony might make an agreeable ending to the Festival. Precisely who these artists were to be, even Sir John did not know, and when amongst them he discovered a verse speaker in the person of Tom Fleming, who was to introduce the last item which Sir John was to conduct, he was a little put out – not on account of last-minute adjustments (these are built-in festival risks) but because the mixture would not do. With misgivings he sank into the chair on the Usher Hall platform provided for him, though none who witnessed that pale contemplative face could have suspected anything was amiss. And then Tom Fleming began to speak the lines:

Our revels now are ended. These our actors,
As I foretold you, were all spirits, and
Are melted into air, into thin air:

By the time he had reached the words –

We are such stuff
As dreams are made on; and our little life
Is rounded with a sleep.

– Sir John's misgivings, like Prospero's world had vanished into thin air. The figure on the rostrum itself that took up the baton to

make yet again another "expense of spirit" in the flicker of candlelight did not appear made to last, but then how many years had it not disappeared into the tempest of the music, to reappear again to conduct another two hundred or so concerts per annum.

With the deaths of Szell and Barbirolli in 1970 the new decade began with a sense of loss but also of renewal. The baton Barbirolli put down was picked up by Colin Davis in the opening concert – a Beethoven concert given by the New Philharmonia Orchestra which included the Ninth Symphony with the Edinburgh Festival Chorus. Many years previously I had been astonished by the performance of the La Scala Milan Chorus in the Verdi *Requiem*. The Edinburgh singers were no less astonishing in their intensity, the clarity, the apparently easy confidence in the singing of the top notes and their absorption into the Beethoven. Their dynamism was equalled by delicacy in their performance in the closing concert with Alexander Gibson conducting the Scottish National Orchestra in Beethoven's Fantasy for Piano, Orchestra and Chorus. The pianist was Clifford Curzon. Of the power of the Edinburgh Chorus we knew, but the playful delicacy of their response was just as secure. The audience was captivated and so, it turned out, was the conductor and soloist, for after repeated recalls the conductor announced that they – presumably Clifford Curzon and himself – had so enjoyed playing the work that they would like to do a part of it again. Clifford Curzon beamed approval, the conductor went to the rostrum and there ensued what appeared to the audience to be an amicable dispute as to how much we were to hear with the pianist pointing to a very early page of the score, and so with the exception of the longish piano introduction we heard the whole work again.

Alexander Gibson is noted for his ability to handle large and varied forces. The more diverse the elements, the more they seem to blend and become one under his sympathetic direction, and never more so than at this closing concert, and especially at the repeat. Up to that point this Festival had not been the happiest in performance for one of the most admired pianists, Clifford Curzon, but that evening everything came together, was warmed into life, and all the tenderness, exquisiteness, and drama flowed from the piano to the conductor and to and fro between choir and orchestra till all seemed to radiate Beethoven's robust happiness. It was a grand finale to the celebration of the bicentenary of Beethoven's birth. National pride is nearly always

out of place, but one might be permitted a little rejoicing in the character and quality of the rendering of the choral part of Beethoven's Ninth and of his Fantasy.

When I am asked, as I am all too frequently, was it a good Festival, I am always embarrassed, for the simple truth is that they are all good Festivals, not one without some greatness. But you cannot always tell where the most memorable occasions will occur. Who could have guessed, for instance, that we would have left the Usher Hall at this same Festival feeling we had heard Beethoven's 'Egmont' overture for the first time, so fresh, so superbly was it realized by the London Philharmonic Orchestra under Giulini. We had the same kind of astonishment later in the programme with the playing of Beethoven's Seventh Symphony – sensitiveness, power and that suddenness that makes you catch your breath when bounding vitality is interrupted by threat – Giulini had it all there.

There was another great occasion when the Concertgebouw under Bernard Haitink with Janet Baker and Vilem Prybl as soloists performed Mahler's *Song of the Earth*. On the previous occasion when the Concertgebouw performed this work in the Usher Hall, Kathleen Ferrier was the soloist. It was her farewell to the Usher Hall. The exquisite tenderness of Janet Baker's singing, especially of the 'Farewell' at the end of the Mahler, gave a new memory to be treasured. In 1956 Janet Baker won the *Daily Mail* Kathleen Ferrier Award. Since 1960 she has been a frequent performer at the Festival. The loyalty of fine musicians to the Festival is the highest professional testimony to its value because they are the means of ensuring a tradition of the highest musicianship which continues through variations in musical policy of Festival Directors.

Janet Baker began her association with the Festival fifteen years ago. Twenty-five years ago Clifford Curzon made his first appearance with the Hallé under Barbirolli. In the Souvenir Programme of 1952, as mentioned earlier, Clifford Curzon paid tribute in writing to that great interpreter of Beethoven, Schnabel. In another sense he paid tribute again with his performances in the 1970 Festival. There can be little doubt that the Festival for probably the majority of those who attend is an opportunity to hear accepted masterpieces played by masters. It is therefore mandatory, it seems to me, that the distinguished visitors include in their repertoire such acknowledged works, as indeed they do. Not can one grudge the return of a great

conductor to let audiences hear again what he has already made memorable.

In eleven of the past thirteen Festivals Carlo Maria Giulini has conducted in the Usher Hall. His first appearance, however, in Edinburgh, in 1955 was at the King's Theatre as a substitute for Vittorio Gui, who was ill. He took the Royal Philharmonic Orchestra through the intricacies of the score of Verdi's *Falstaff* with that responsive brilliance which Festival audiences came to know and admire in the years that followed. One recollects moments of wonderful exhilaration that seem to arise from his magical baton, but most memorable have been the performances of works that sound depths of experience, that reassert the blessing, the tragedy, and the dignity of life. These words are hardly on the page before the memory has gone to at least one of the six great occasions when Giulini conducted Verdi's *Requiem* at the Festival.

He opened the 1960 Festival with the Philharmonia Orchestra and the Philharmonia Chorus in a performance of the work. He conducted the new Philharmonia Orchestra and Chorus – the same force under a new name, with the same Chorus Master, Wilhelm Pitz – in the *Requiem* twice at the 1969 Festival. Yet again, twice in the same Festival, he conducted it on the occasion of its centenary in 1974. On these last occasions the Orchestra was the London Philharmonic and the chorus the Edinburgh Festival Chorus. One dare not begin to recapitulate the great moments of the drama of "Verdi's greatest opera" as it has been called, as these were presented, but I draw attention to one peculiar effect that comes, I believe, from the devotion of this conductor's great art to the proper end of interpreting the work of the composer absolutely. It is the quality of the silence that occurs in rhythmical pauses and at the end, even though the audiences may be applauding. For the registration of music is finally on an inner ear. After the great work in the hands of the great interpreter, with forces of the highest quality, the silence itself is different. In Giulini's performance of the *Mass in B Minor* by Bach, in 1967, when the New Philharmonia Chorus joined with the Nederland's Chamber Orchestra, and again in 1968 in the performance of Britten's *War Requiem*, this time the Edinburgh Festival Chorus joining with the New Philharmonia Orchestra, there was the same rare profundity.

I must admit that to use words about any great musical event is to do some injustice to it, no matter what is written or spoken.

They are too selective and impure. Nevertheless one must make do with the given medium and perforce make the most obvious remark about Klemperer's conducting of Beethoven. It is authoritative. He conducted the Philharmonia at the Festival in 1967, and returned for three other Festivals. Karajan made the 1967 Festival memorable, especially the Bach *Magnificat* with the Berlin Philharmonic Orchestra and the Edinburgh Festival Chorus, to which he referred as "one of the three great choirs of Europe." There were many visits by Rafael Kubelik and affectionately remembered occasions of Sir Adrian Boult with the BBC Symphony Orchestra. Memories of these visitors tend to be of the outstanding rendering of masterpieces.

Of the resident orchestras, the Scottish National Orchestra and the BBC Scottish Symphony Orchestra, one has thought of them in the first instance in their almost annual appearance as playing sustaining roles. The BBC Scottish Orchestra had initially the advantage of not being committed to a repertoire confined to those 'classics' which would draw an audience. It broadcast on the Third Programme as well as on the Scottish Home Service. This enabled Ian Whyte, its conductor, to work with his characteristic assiduity on modern compositions which he admired. As a result the Orchestra claimed attention in the early Festivals on account of items of special interest in its programme.

In 1949, for instance, the first long journey to make music by a composer was made by Ernest Bloch from his home on the Pacific coast of the United States to Edinburgh to conduct this orchestra in his 'Concerto Symphonique', completed the previous year. In his radio programmes on the Scottish Home Service Ian Whyte had put as much emphasis on work by Scottish composers as far as was possible – there was a marked shortage of material. The lack had the beneficial effect of requiring new works. In the 1952 Festival the BBC Scottish Orchestra gave the first performance of Erik Chisholm's Concerto for Viola and Orchestra. Not that prejudice in favour of the home-grown was permitted to influence judgement. Two years later Ian Whyte, in a delightful concert for young people, conducted 'Practical Cats' by Alan Rawsthorne. The work had been commissioned by the Edinburgh Festival Society. The performance by the Orchestra in 1956 of Dohnanyi's 'Variations on a Nursery Song' for piano and orchestra, with the composer at the piano, has already been remarked upon. I draw attention to it again because it allows me to note the responsiveness, on the musical side particularly, of the

Festival administration to special interests. Ian Whyte was devoted to the cause of youth. Dohnanyi was young in heart to the end.

When, under Lord Harewood, the Festival policy moved from an emphasis on orchestras to composers, the contributions of the resident orchestras became more central. On account of its broadcasting commitments the BBC Scottish Symphony Orchestra, as it has been renamed, has made a limited contribution, but an individual one. James Loughran when he was its conductor responded to the emergence of the Scottish composers Thea Musgrave and Thomas Wilson with the first performance of Wilson's Concerto for Orchestra in 1967 and a performance of Thea Musgrave's Concerto for Orchestra the following year. In 1970 under its present conductor, Christopher Seaman, it gave the first performance of Iain Hamilton's Violin Concerto, and in 1974, under the composer's baton, this orchestra gave a performance of a new work by the seventy-year-old Italian composer, Goffredo Petrassi.

The story of the flowering of the Scottish National Orchestra and its association with the remarkable achievements of Scottish Opera under their director and conductor Alexander Gibson, over the past eleven years, requires a book to itself – and in Conrad Wilson's *Scottish Opera* a part of the achievement has got one. Here our interest is limited to the application of these developments to the Edinburgh Festival, and developments that have been encouraged by that international platform.

It will be remembered that Sir Thomas Beecham in 1948, in a characteristic outburst, called the people of Scotland "damned fools" for spending money on an international festival. We have heard too often the view that the Festival is an imposition on a local scene, and presumably, therefore, acts as a depressive on local culture. This simplistic approach has little to do with the case, but there is an aspect to the observation which may be worth noting.

For the first half of this century the creative imagination in Scotland found successful expression in literature and painting. One notable exception was the music of the Scottish song-writer, Francis George Scott. He was well aware of the difficulty of inventing an art song idiom which would relate to the character of Scottish poetry, and take account of "modern techniques and ideation". Nevertheless he achieved this, but when he tried his hand at composing for an orchestra, he found himself, he

remarked, at the disadvantage of being unable to get practical experience. Now the situation is different. All the means of musical communication are available here – orchestra, choir and opera. How far they would have developed had there not been an Edinburgh Festival is a matter of doubt, even allowing for the existence of Alexander Gibson. But in telling the tale of Gibson and the Festival, the tale of the orchestra, opera and choir, one bears in mind wider implications of the achievement.

The Scottish Orchestra, to give it its original name, first appeared in the Festival under its conductor Walter Susskind in 1947, twelve years before Alexander Gibson's first Festival appearance with it. Then it provided the last Sunday concert, which included music by Britten, Dvorák, and Ravel's piano concerto with Michelangeli as soloist. This last piece was warmly received, though the orchestra's other contribution to the first Festival, to Glyndebourne Opera's productions of Verdi's *Macbeth* and *Le Nozze di Figaro*, caused the expression of doubts, by some music critics, of its quality. At any rate it did not appear again until 1951. This was certainly not due to lack of interest by those concerned with the planning of the Festival. The suggestion that an Edinburgh Festival Orchestra should be created was made after the first Festival. Critics in London pointed out that this must be a long-term programme. In the nineteenth century Rossini had said that, Italy excepted, the most musical nation in Europe was Scotland, but that Scotland had never developed its potential on account of the poverty of the nation. So it was in the first year of the Festival. Even the sweet singing of the Glasgow Orpheus Choir in that Festival told of a restricted musical objective.

In 1951 Walter Susskind conducted the Scottish National Orchestra in Jirak's Fifth Symphony. In 1954 Karl Rankl conducted the Scottish National Orchestra in Schoenberg's *Gurrelieder* supported by the Edinburgh Choral Union (Chorus Master, Herrick Bunney) and the West Calder and District Male Voice Choir (Chorus Master, Archibald Russell). Then in 1959, on the occasion of the bicentenary of the birth of Robert Burns, the Burns Federation combined with the Festival Society to commission a new work by the Scottish composer Iain Hamilton, to mark the occasion. His Sinfonia for Two Orchestras was a severe exercise in a modern, cosmopolitan idiom that owed nothing to the native inheritance of the composer. The conductor was Alexander Gibson. The work was in his first Festival

programme with the Scottish National Orchestra. Also in that programme was Beethoven's 'Emperor' Concerto with Wilhelm Kempf as soloist. The balance of interest was an indication of the balance of many of the programmes which Alexander Gibson was to present throughout his years with the Orchestra, but the Hamilton was an indication of the adventurous spirit of the conductor, which, combined with a great practical ability, has led to developments, by means of Scottish Opera and the Edinburgh Festival Chorus, that could not have been foreseen.

The musical achievements that followed in the 'sixties under the direction of Alexander Gibson were of such importance to the Festival and to music in Britain as to warrant the term 'historic'. In 1963 he created Scottish Opera. Its objective was not, apparently, in the first instance, performance in the Festival, but its first effect on the Festival was felt in the following year, 1964, when the Scottish Opera Chorus, with the Scottish Junior Singers, the Boys of St Mary's Catholic Cathedral, Edinburgh, Charles Craig, tenor, and the Scottish National Orchestra under Alexander Gibson, performed the *Te Deum* by Berlioz. In the same programme the Orchestra performed Webern's 'Six Pieces', and gave the first performance in Britain of Shostakovich's edited version of Schumann's Cello Concerto. Rostropovich was the soloist. Five days later Alexander Gibson brought together works by Berlioz, Elgar, Janácek, and Beethoven's 'Emperor' Concerto with Rudolf Serkin as soloist.

The new policy of Lord Harewood, the Director of the Festival, of featuring the work of selected composers, in 1964 Berlioz and Janácek, made considerable demands on the Scottish National Orchestra and the Chorus, but the requirement was adequately met. In 1965 the Scottish National Orchestra with the Festival Chorus and soloists performed Mahler's Symphony No. 8 as the opening concert. So great was the pressure of public feeling that the work was repeated in 1966 with the same forces, though with the exchange of one soloist. The impact of the Scottish Festival Chorus, later renamed the Edinburgh Festival Chorus, was decisive.

It was, of course, the same musician, Arthur Oldham, who had been responsible for assembling and training the choral forces for the Berlioz *Te Deum* in 1963, which included the Scottish Opera Chorus, who forged the Edinburgh Festival Chorus. Created to fill the need of a single work, with no prospect beyond Mahler's Eighth, it became one of the Festival's finest acquisitions, perhaps

the finest. Once in being it was much too good to lose.

Arthur Oldham has told how he went about the task of recruiting the 240 adult voices and the 120 boys for the Mahler The lengths to which he went to attain excellence for the single occasion is an indication of the determination of the host musicians to give the highest possible standard. To achieve this end Arthur Oldham searched Scotland, concentrating on the amateur choral societies, but excluding no possible recruit so that a number of reliable, good voices were first heard with the Festival Chorus.

The scattered recruitment meant that rehearsals had to be conducted in groups in Edinburgh, Glasgow and Aberdeen, the Aberdeen group being rehearsed initially by a deputy though it was visited from time to time by Arthur Oldham. He took weekly rehearsals in Edinburgh and Glasgow. "I like them to learn things loudly and with confidence", Arthur Oldham has said, and this approach must account to some extent for the extraordinarily confident, free response of the choir – a giving of their full powers without reservation. Now this ease of spirit, relaxation, is the condition which we have assumed belongs especially to the Latin countries. From northerners we expect discipline, firmness, clarity, and good, honest tone as suits the choral numbers that are heard from male voice choirs, but this achievement in character and excellence went against the assumptions about the Scots character itself, assumptions that did not take account of the *perfevidum ingenium Scotorum*, a habit that had been noticed as early as the fifteenth century.

Arthur Oldham got back to the tap-root and made out of the energies and talents at his disposal the greatest indigenous musical force ever to come out of Scotland, and one that has already applied itself to a wide range of music demanding great variety of response and linguistic ability.

In 1967 the Edinburgh Festival Chorus sang Kodály's *Psalmus Hungaricus* with the London Symphony Orchestra, under their conductor Ivan Kertesz, to such effect that they were invited to London to record all the *Háry János* music, which was done under the same conductor. It was in this year that they performed Bach's *Magnificat* with the Berlin Philharmonic Orchestra under von Karajan. They also performed Stravinsky's *Oedipus Rex* and his *Symphony of Psalms* with the London Symphony Orchestra under Claudio Abbado. Yet again with the London Symphony Orchestra under Kertesz in the opening concert in 1968 the choir

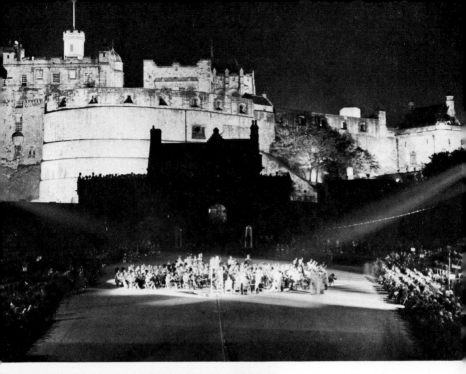

Sir Thomas Beecham
conducts massed bands in
Handel's 'Music for the
Royal Fireworks' on the
Castle Esplanade as the
finale of the 1950 Festival

Wilhelm Furtwangler at
the Usher Hall in 1953

Sir Arthur Bliss conducting his overture 'Edinburgh', a present from the composer on the occasion of the tenth Edinburgh Festival in 1956

Herbert von Karajan, conductor of the Berlin Philharmonic Orchestra, who has appeared many times at the Edinburgh Festival

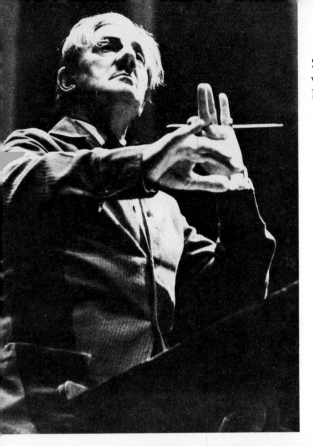

Sir John Barbirolli,
who conducted at eight
Festivals

Carlo Maria Giulini
with the London
Philharmonic Orchestra
at the end of the 1974
performance of Verdi's
Requiem

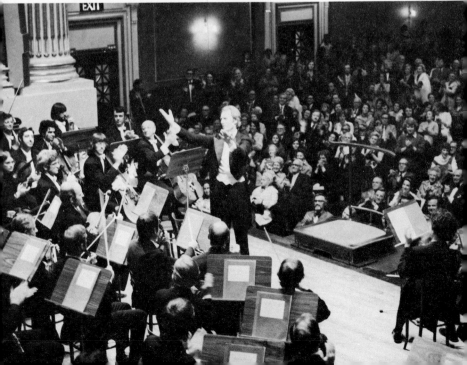

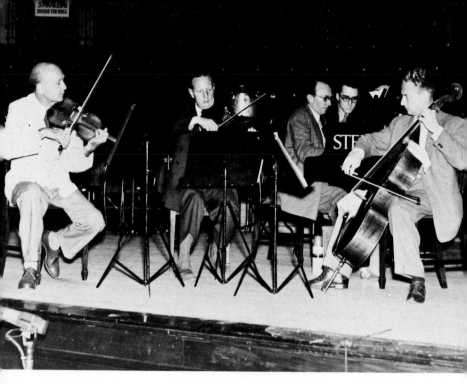

Above Szigeti, Primrose, Curzon and Fournier rehearsing in
the Usher Hall in 1952;
Below left Kathleen Ferrier with Irmgard Seefried in 1952;
right Jean-Louis Barrault on the occasion of his third appearance
at the Edinburgh Festival, with the New York Chamber Soloists

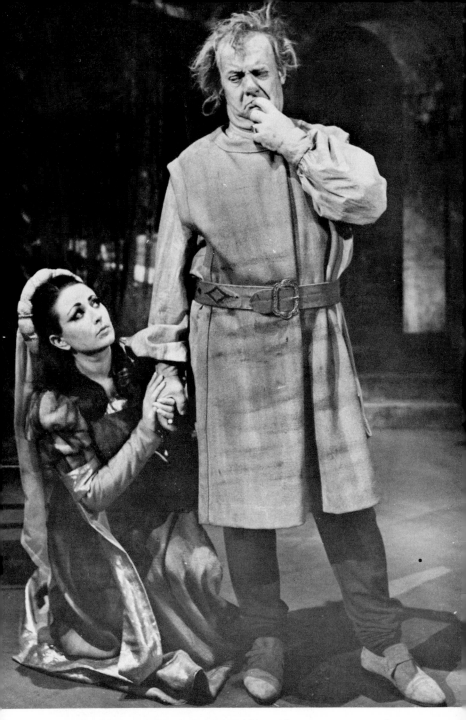

Maddalena Bonifaccio and Tito Gobbi in The Teatro Comunale
Florence's production of *Gianni Schicchi* in 1969

A scene from Aribert Reimann's *Melusine*, presented by
Deutsche Oper Berlin at the 1971 Festival

A scene from the opera *Die Soldaten* by Zimmermann, performed
by the Deutsche Oper am Rhein at the 1972 Festival

Geraint Evans as Leporello in *Don Giovanni*, 1973 and 1974

Elisabeth Söderström in *Jenufa* at the 1974 Festival

Peter Lagger, Daniel Barenboim and Heather Harper relax after
a performance of *Don Giovanni* in the 1974 Festival

performed Britten's *Voices for Today* and later in the Festival with
the new Philharmonia Orchestra under Giulini, Britten's *War
Requiem*. They also performed with the same orchestra and
conductor Schubert's *Mass in E Flat*. They followed these
exacting demands by performing in 1969, as previously
mentioned, the Berlioz *Te Deum* with the Scottish National
Orchestra under its conductor, and with the New Philharmonia
Orchestra under Giulini, Rossini's *Stabat Mater* and the *Magnificat*
by Petrassi.

The contribution of the Edinburgh Festival Chorus to the 1970
Festival was considerable and very memorable. They sang in the
Beethoven Ninth with the New Philharmonia Orchestra in the
opening concert under Colin Davis, as already noted. They
closed the Festival in Beethoven's Fantasy for Piano and Chorus
with the Scottish National Orchestra and Clifford Curzon as
pianist under the baton of Alexander Gibson, and, most
astounding of all, was their singing of Beethoven's *Missa Solemnis*
with the New Philharmonia Orchestra, conducted by Giulini. At
the end of this performance their exacting and self-critical Chorus
Master, Arthur Oldham, was heard to remark that he considered
his life's work had been achieved. Such a rare experience was the
outcome of great labour, deep musical experience, superb skills,
and devotion.

The Chorus continues to make its magnificent contribution. In
1971 they again opened the Festival. On this occasion with the
Scottish National Orchestra conducted by Alexander Gibson,
they sang an *Ave Maria* and a *Pater Noster* by Stravinsky, in
homage to that composer who died on 6 April 1971. In the same
concert they sang Walton's *Belshazzar's Feast* and a new work,
Te Deum for Orchestra and Chorus, by the Scottish composer
Thomas Wilson. This was commissioned by the Edinburgh
Festival Society. So the notion – it was no more than
that – suggested after the first Festival in 1947 that an Edinburgh
Festival Ochestra was much to be desired, was far transcended in
that first concert of the twenty-fifth Festival. Who in 1947 could
have dreamed that not only would there be in Scotland an
orchestra of calibre, but a great chorus and Scottish opera,
whose own chorus in this same Festival sang in Rossini's *La
Cenerentola* with the London Symphony Orchestra which was
conducted by Claudio Abbado with soloists from Maggio
Musicale Fiorentino.

In 1972 The Edinburgh Festival commemorated the hundredth

anniversary of the birth of Vaughan Williams by devoting the opening programme to works by him. The orchestra was the Royal Philharmonic and the conductor was Sir Adrian Boult. This was a touching occasion. Sir Adrian was paying tribute to an old friend who had dedicated *Job*, the other work in the programme, to him. The *Dona Nobis Pacem* was composed for the centenary of the Huddersfield Choral Society in 1936. When that choir was heard at the 1948 Festival singing the Bach *Mass in B Minor* and Walton's *Belshazzar's Feast*, we remembered the north of England choral tradition and admired the confident solidity of the tone of the Huddersfield Chorus. One could not have believed that a Scottish chorus would have as much confidence and tone and a great deal more, as the audience heard in its singing of the Vaughan Williams' works. That year the Festival Chorus also sang Stravinsky's *Symphony of Psalms* with the Scottish National Orchestra as well as Brahms's *A German Requiem* with the London Philharmonic Orchestra conducted by Daniel Barenboim.

The list of triumphs is too long even to enumerate. In the 1974 Festival the Chorus appeared three times with two orchestras: with the London Philharmonic singing Verdi's *Requiem* conducted by Giulini; in the Bruckner *Te Deum* conducted by Barenboim; and with the Sydney Symphony Orchestra when they sang Ravel's *Daphnis and Chloe* under Willem van Otterloo. Name any year after 1965 and the name 'Edinburgh Festival Chorus' will bring to mind great music remarkably performed – in 1967 Kodály's *Psalmus Hungaricus*, in 1968 Britten's *Voices for Today*, and in the same year Britten's *War Requiem*. Give praise here, for praise is due.

There is one other feature to be remarked in the contribution by Alexander Gibson and his musicians to the Festival, which might be entitled 'giving the composer the baton'. The Scottish National Orchestra has presented in its Festival programmes, especially from 1960 to the present, a large number of contemporary or near contemporary works. Sometimes these were conducted by Alexander Gibson, running from Schoenberg to Henze, sometimes by visiting conductors – Barbirolli made his last appearance at the Festival in 1969 with the Orchestra, when he conducted 'Sinfonia delle Campane' by Malipiero – but increasingly by the composers of the works themselves. In 1970 Henze conducted the first performance in Britain of his Symphony No. 6 and also his 'Essay on Pigs', a work for

baritone and orchestra. In 1971 Luciano Berio, sharing the platform with Alexander Gibson in the closing concert, conducted the Swingle Singers with the Orchestra in his works 'Bewegung' and 'Sinfonia'. The 1972 Festival featured Polish music. The Scottish National Orchestra gave the first performance of Penderecki's Cello Concerto under Alexander Gibson. (It also included the first performance of Symphony in Two Movements by the young Scottish composer Sebastian Forbes, which was an Edinburgh Festival commission.) Then in the closing concert Alexander Gibson shared the conducting again, on this occasion with Witold Lutoslawski, who conducted his 'Three Poems for Chorus and Orchestra'. As far as the Scottish National Orchestra was concerned, 1974 was the year of the composer.

In 1965 the Festival celebrated the sixtieth birthday of Sir Michael Tippett by featuring his work. There were also featured works by Boulez and Messiaen. One of these works Tippett referred to as "very motionless modern music". Gerald Larner records, in the Festival Souvenir Programme of 1974, how Tippett said, "I could never use this kind of thing for expressive purposes unless it were part of a piece based upon sharp contrasts. And this suddenly clicked and I knew that a symphonic work had begun." The work, Symphony No. 3, was performed by the Scottish National Orchestra in the opening concert. As conducted by the composer the explosion of energy and the stillness to which he referred were both there.

This year, too, the Edinburgh-born composer Thea Musgrave took the baton from Alexander Gibson to conduct her Horn Concerto. In the work horns appeared on the floor and tiers of the Usher Hall, to answer or echo the soloist horn, Barry Tuckwell. This was for Miss Musgrave no new, bright and eccentric device. She has explored similar resources in other works. Her music has always been distinguished by clarity, to the point of luminosity, and structure. In early works there is a rare delicacy. Now she has added a dramatic interest.

Once by far the major interest in the music from the Usher Hall was in performance. Now this is matched by new music. The creative element is increasingly present.

5

Chamber Music

"What a mercy that such music and such interpreters exist! They are a light in the world's darkness, raised high above hatred and poverty. Despite their greatness and our smallness, they have the power of making us feel great." The comment was made in the *Sunday Times* of 21 August 1947 by E.M. Forster on the performance in the Usher Hall of the Brahms Trio Op. 101, the Schubert Trio Op. 100, and the Brahms Piano Quartet in A Major by the Schnabel–Szigeti–Fournier–Primrose Quartet. Neville Cardus had already remarked in The *Guardian* as previously quoted, that they "played like four spirits". He continued, "Schnabel more than ever is able to transform to wisdom the simplest chords and isolated notes and compel us to hold breath during a pause."

The Usher Hall was not the best environment for the kind of achievement which Sir Neville Cardus described. More sympathetic to that intention of chamber music which seeks to draw the listener into a small circle of sound, compelling him at moments of climax "to hold the breath during a pause", is the Freemasons' Hall, which has become the accepted place for the performance of chamber music over all the Festivals. In recent years after restoration, Leith Town Hall has also come into regular use, while for special occasions Saint Cecilia's Hall has played its part. Looking back to the first Festival it is difficult to recapture the doubts whether mid-morning recitals of music, requiring a greater concentration than the display of an orchestra, would be successful. We know how frequently the notice 'House Full' has appeared. The Directors knew that certain distinguished names would attract a large audience to the Festival, so Schnabel was in the Usher Hall as a member of a quartet. It also housed distinguished soloists.

The late Frank Howes, the Music Critic of *The Times*, in an article entitled 'Morning Music' in the Festival Souvenir

Programme of 1949, suggests how early in the Festival the
Freemasons' Hall ceased to be regarded as off the beaten track.
"But the visitor", he wrote,

> whose interest was not limited to the larger forms of symphonic and
> operatic music discovered that a visit to the Freemasons' Hall in the
> morning gave him a different range of pleasure . . . Dr Jacques and
> his String Orchestra, with a repertory that rarely touches the main
> highway of symphonic music, unobtrusively provided what the
> more enterprising sort of music-lover was looking for. By the
> second Festival there was nothing unobtrusive about it at all – Mr
> Boyd Neel with his String Orchestra found the hall crowded with
> those who liked a Brandenburg concerto as a prelude to a work by
> Bartók . . . And so the morning concerts assumed an importance in
> the general scheme much more than that of make-weights, side-
> shows, wet-weather insurance.

That importance for some has come to be the most memorable
event in the Festival, or at least amongst the most memorable
events. The pyrotechnics of Beecham was sheer exhilaration and
one can recollect the moment years after, but the climaxes of the
string quartet tradition at the Freemasons' and the Leith Town
Hall belong to another order of experience. In 1947, amongst
others, we had the Calvet String Quarter and the Menges String
Quartet – both from Paris, as if to stress, along with the
Orchestre de Concerts Colonne, and La Compagnie Jouvet de
Théâtre de l'Athenée, the renewal of the Auld Alliance. In 1948
the Hungarian String Quartet came to Edinburgh, in 1949 the
Griller and the Busch amongst others. The Griller returned in
1950 when the Budapest String Quartet and the Loewenguth also
played in the Festival, and for a third time in 1951, in which year
the Amadeus String Quartet made its first of many distinguished
contributions to the Festival.

The common factor of all these quartets is that their members
have played together over considerable periods, though almost
inevitably changes occur. This has not been the case of the
Amadeus, for Norbert Brainin (violin), Sigmund Niessel
(violin), Peter Schidlof (viola), and Martin Lovett (cello) played
in the 1973 Festival as they did in 1951. The violins and the viola
are Austrian; the cellist is British. The Quartet was formed in
1948 after studying under Max Rostal in London. By 1973 the
Quartet had made twelve appearances at the Edinburgh Festival.
Their name, for audiences at the Festival, has become identified
with Beethoven, though in their first Festival their programmes

consisted of works by Haydn, Schubert, Brahms and Tippett.

The demand in quartet playing is for the most sensitive and intimate co-operation. The discovery of Beethoven by the Amadeus has been an unending revelation. In the concentration on four musicians becoming one, the listener is engrossed in the limits of their dynamics and tonal values, so that any additional musical aid would appear adventitious. In these conditions, when the music is a statement about the quality and character of the spirit, as are Beethoven's last quartets – no other word will do – the music may become "a light in the world's darkness".

The climax of the contributions by the Amadeus Quartet to the Festival was in 1970 on the occasion of the celebration of the bicentenary of the birth of Beethoven when they played all Beethoven's quartets. Previously the Amadeus had made major contributions to the 1968 Festival when Schubert was one of the two featured composers (the other being Britten), and to the 1963 Festival when Bartók was the featured composer.

The Amadeus Quartet had played the seventeen Beethoven quartets at the Stockholm Festival in 1962. Their meticulous appreciation of the character of Beethoven's early quartets and the quartets of his maturity was applauded in the Press and in the concert hall, but the superb experience was, to the present writer's ear, in the performance of those last quartets, which whenever heard as in the 1970 Festival go beyond expectation. The word 'discovery' is appropriate, but not only for the audience, for it was used by Norbert Brainin in a conversation when he was talking about the effect of playing these quartets on the players. As he talked he also remarked how little analysis or decription could tell about this extraordinary music, which was always fresh and endlessly revealing, even to players who had gone over it for about a quarter of a century. Perhaps all that the listener can stammer is that he left the hall in a state of serenity or bliss, certainly in a different condition of being from that in which he had entered.

Little wonder universities and cities honour such musicians. The Amadeus Quartet have been for some years 'quartet in residence' at York University, but Edinburgh University must surely have outdone all others when in December 1934 it conferred the degree of Doctor of Music on the three brothers – Fritz, Adolf and Hermann Busch. They were presented for the degree by Professor Sir Donald Tovey, largely through whose friendship they became frequent visitors to

Edinburgh before the Festival. At the 1949 Festival Adolf and Hermann Busch played as members of the Busch String Quartet, while Fritz Busch conducted the Danish Statsradiofonien Orchestra in the 1950 Festival. Fritz Busch died in 1951. Audrey Christie wrote of him in the Souvenir Festival Programme of 1952,

> It seemed most just and right that Glyndebourne and Edinburgh together should provide the frame for Fritz Busch's last performances, for these places probably held the happiest of his memories of Great Britain. How happily these two – Edinburgh and Glyndebourne – combined to give scope for his great musical gifts to shine forth for the last time! Fritz Busch died suddenly within a few days of departing from Edinburgh at the end of last year's Festival.
>
> Out of the supreme simplicity of Busch's nature shone his unwavering honesty of musical purpose. Never did he try to exalt himself through the medium of music, but always to exalt music through the medium of his own great and sensitive musical capacity.

The words of Mrs Christie (as Audrey Mildmay an opera singer of exquisite talent and the wife of the founder of Glyndebourne), though referring to Fritz Busch's interpretations of symphonic and operatic music, are peculiarly apt to the relationship of the musician to his music in chamber music, to the Busch Quartet itself, but inevitably to the achievement of all performers in this field. In fact the tribute generalizes itself through all the Arts. No artist, I believe, seeks for self-expression. That kind of self-concern is not consistent with either true creative endeavour or with interpretation. So the influence of great musicians spreads through their submission to the mind of the composer, himself in some respects an interpreter, as well as a creator of events. But also in a more literal way they put themselves at the service of the community of artists. Audrey Christie continued:

> During the years spent among us in this country he was keenly anxious to pass on to our young British musicians his own simple, sincere and masterly approach to music. Many there are amongst our young conductors, singers and instrumentalists ready to pay him warm and eager tribute. From Edinburgh itself came several young aspirants to work in the young days of Glyndebourne under his benign, though exacting, eye, including Ian Hunter, the present [1951–56] Artistic Director of the Festival.

The effect of that musical community of Edinburgh, which drew much of its life from the inspired enthusiasm of Sir Donald Tovey, was evident in the early Festivals and especially in performances in the Freemasons' Hall, though the first Scottish choir to be heard was the Glasgow Orpheus under its conductor Sir Hugh Roberton, and the first Scottish compositions of marked individuality were songs by the little-known composer Francis George Scott.

Scott developed an idiom in his song-writing that corresponded to the dramatic and frequently ironic character of the Scottish poems which he set, an idiom which took account of certain of the contemporary music techniques without losing touch with the Scottish character of the poems. There was, it might have seemed at the time, in Scott's work the basis of further developments of a music with a national reference, but no one followed his lead. The composers of the next generation – Scott died in 1958 – took off from more developed musical traditions as was evident in Robin Orr's Sonatina for 'Cello and Piano which got its first performance in the 1948 Festival, and in Erik Chisholm's Concerto for Violin and Orchestra which was first performed at the 1952 Festival.

On the other hand when a Scottish composer was called on to support a Scottish play, with music, as was Cedric Thorpe Davie for *The Thrie Estaites*, the liveliness and authenticity of his musical imagination was undeniable. Indeed when this composer made a setting for Burns's cantata *The Jolly Beggars*, he developed some of the folk tunes so that they showed the sophistication of art music, and wrote new music where he considered the original tunes inferior, yet in both cases they seemed married to Burns's verses so convincingly that it was difficult to believe that nearly two hundred years had intervened between the composition of the poetry and the music. There are references to Scottish themes in other work by Cedric Thorpe Davie – and for that matter the late Erik Chisholm took a special interest in Pibroch – but this is a different matter from developing a tradition. One Scottish composer, Ronald Stevenson, believes that it is possible to acknowledge Scottish vernacular idioms, but his work has not been represented in the Festivals.

I mention this matter because the chamber concerts included performances of Scottish Gaelic songs and of Lowland Scots songs. Revealing as these were of the richness of traditional music in Scotland, as they were presented in the first Festival – the

Lowland Scots songs being sung by professional art song singers
Marie Thomson and John Tainsh – they occupied the debatable
territory of folk songs given the status of art song. In the Festivals
that followed, with the revival and rediscovery of folk song in
Scotland, the Festival extended its reach to incorporate Gaelic
Ceilidh and Lowland folk song as such. The chamber concerts
have also come to include folk music from many lands. The
inclusion of the traditional Scots songs in the first Festival
indicates that from the outset the policy was a broad one which
encouraged, as far as was possible, work done in the home
country. Francis George Scott's songs were sung in several
Festivals, his chief interpreters being John Tainsh and Joan
Alexander. In more recent years there has been a notable increase
in contributions of new work by Scottish composers. It should be
said that however distinguished their music, by far the greater
part of it does not apparently relate significantly to the country of
their origin.

The main contribution to the Festival from Scotland in this
area of music was performance. In 1948 John Tainsh sang with
the Boyd Neel Orchestra, in 1949 Joan Alexander with the
Jacques Orchestra. In 1950 Edinburgh University Singers made
their first appearance in the Freemasons' Hall in programmes
commemorating the bicentenary of the death of J.S. Bach. They
were conducted by Hans Oppenheim and also appeared under
their director Ian Pitt-Watson. In this Festival the Dickson sisters,
Joan (cello) and Hester (piano), made their first contribution.
They shared their programme, in which they included Tovey's
'Elegiac Variations', with the contralto Mona Benson. All three
had been encouraged and enlightened by Tovey.

Sensitiveness to what was appropriate to the occasion, as for
instance the inclusion of Tovey's 'Air with Variations' (Op. 11)
in one of the Busch Quartet programmes in 1949 and the pursuit
of an interest from one Festival to another, characterized
programme planning from the early Festivals. Thus the Griller
String Quartet included a Bartók Quartet (No. 2 in A Minor,
Op. 17) in one of their programmes in 1949 and in 1950 Quartet
Op. 10 by Kodály, thereby sustaining the interest in Hungarian
chamber music set going by the Hungarian String Quartet in
1948. This was continued with the appearance of the Budapest
String Quartet in 1950, the Vegh String Quarter in 1952, and in
1955 the return of the Hungarian Quartet, who played in each of
their three programmes Bartók and Beethoven. The following

year in the tenth Festival the Vegh String Quartet included in
their programme Quartet No. 3, by Matyas Seiber. They also
played one of the later works of Bartók – the Fifth String
Quartet (1934). Earlier music by Bartók could also be heard at
this Festival in the ballet 'The Miraculous Mandarin'.

In the same Festival, Dohnanyi, besides playing his 'Variations
on a Nursery Song for Piano and Orchestra', was also the pianist
with the New Edinburgh Quartet in his Quintet for Piano and
Strings No. 2 in E Flat Minor, Op. 26. He was heard again in the
Freemasons' Hall in three of his own compositions, the last of
which, 'Ruralia Hungarica, Op. 32', gave an indication of his
ready acceptance of folk sources. But then Dohnanyi has been
called "the last of the great Romantic composer-pianists."
Younger composers considered there could be no harking back.
These resources could not be used, at least at their face value, by a
generation that belonged to a different society.

The generalization demands questions of it. In Hungary folk
music continued to be enjoyed and disseminated throughout
society. True, it had been subjected to romantic treatment by
Dohnanyi, but there might be other approaches to it. It might be
possible in this social situation to make a new music which has
the vitality of the communal music, but which would have
intellectual stimulus. By 1963 the policy of featuring composers,
initiated by Lord Harewood, was bearing fruit, and never more
richly than in the Bartók programmes of that year. Festival
audiences had had opportunities to become acquainted with
Bartók in previous years. Now the full range of Bartók's
achievement was offered from his writing for solo instruments to
symphonies and operas.

It was generally agreed that the performance of Bartók's
chamber works was one of the outstanding events of the 1963
Festival. In one programme, which included works for piano by
Bartók, Olga Szonyi and Andras Carago sang Bartók's
'Hungarian Folk Songs'. In industrialized Europe, folk songs are
thought of as a special genre. But these folk songs and Bartók's
piano music – and for that matter his other chamber
music – were all fruits of the same tree. The character of the
singing showed the kind of confidence found in a flourishing
tradition, one so strong that it allowed for that reduction to the
essential which gives much of Bartok's work its powerful
vitality.

David Wilde was the pianist in the prgramme. The coverage

of Bartók's music was wide. Yehudi Menuhin played Bartók's Violin Sonata No. 1 in the Usher Hall. In the same recital he was joined by Gervase de Payer (clarinet) and Hephzibah Menuhin in Bartók's Contrasts for Violin, Clarinet and Piano. The Tatrai String Quartet and the Amadeus String Quartet played between them the six Bartók Quartets. and its was here in experiencing the increasing intensity of the musical drama, as Bartók's individual idiom developed, one recognized the privilege the Festival conferred on its audiences.

To have grown a music from deep roots in one's national past without any apparent looking back but finding new strength and communicating a new imagination, this is an aspect of the greatness of the music which must be particularly appealing to people of other small nations who have a rich but limited heritage – a heritage which has not been developed, and which perhaps cannot be developed because it is too late.

One thinks inevitably of the host nation, Scotland, and of the case of the commission of Iain Hamilton (*see* page 62) to celebrate the bicentenary of the birth of Burns. Interesting and novel as was his 'Sinfonia for two Orchestras', it proclaimed his total immersion in a cosmopolitan idiom. The remark implies no rebuke. That would be impertinence. A composer, or poet, must do as he needs must.

Four years previously, in 1955, without in any way deferring to a 'Scottish' style to suit the occasion, Thea Musgrave had set poetry by Alexander Hume and Maurice Lindsay for vocal quartet, flute, clarinet, double bass and reciter. The work 'Cantata for a Summer's Day', was written for the BBC, Scotland, its first performance being broadcast on the Scottish Home Service. At the Festival it was performed in the Freemason's Hall by the Saltire Group under the direction of Hans Oppenheim. The poetry, the major part of which was in Scots, called for a lyrical, delicate music and this was exquisitely provided. The idiom seemed so appropriate that it was difficult to imagine any other could have been as successful. But then Thea Musgrave's respect for the poetry allowed it to register its, inevitably, more national effect without hindrance.

Thea Musgrave contributed her Quartet No. 1 to one of the Juillard Quartet's programmes in 1960. In 1974 the New Music Group of Scotland marked their first appearance at the Festival by opening their concert in the Freemasons' Hall with Thea Musgrave's Chamber Concerto No. 2. The other works were

Sonata for Cello and Piano by Thomas Wilson, 'Rebirth' by Edward McGuire, and 'Whisper Music' by Martin Dalby. The details are noted because this wholly Scottish concert by contemporary composers was according to Conrad Wilson in *The Scotsman*, ". . . in the context of the Festival . . . an unprecedented event. Here was official recognition that modern Scottish music could sustain a whole concert, that there is a (very good) new ensemble to perform it, and that there is a (sizeable) audience to listen to it."

The witty intelligence, the musical discrimination and the charm of Thea Musgrave's invention is known – Conrad Wilson refers to her "exuberant concerto" – whereas the words that come to mind in connection with Thomas Wilson's works for orchestra or chorus at least refer to the 'logic', 'structure', 'tension' and 'seriousness' of his compositions. In this piece Conrad Wilson records that the "ear was captivated and satisfied throughout" and that the work had "a genuine and refreshing vitality". The younger composers Dalby and McGuire's music was "attractively coloured".

The fact is that the Freemasons' Hall, Leith Town Hall, and on occasion St Cecilia's Hall, provide a Festival in themselves, so wide is the range of chamber music offered. As in the orchestral and choral concerts, the acknowledged masterpieces are to be found in good measure in every Festival, but room is also made for works that only occasionally get a hearing.

In 1961, for instance, the Drolc String Quartet played Schoenberg's four string quartets, and in 1962 the Borodin String Quartet and the Allegri String Quartet played the eight quartets of Shostakovich, the composer featured that year. The flexibility of the quartet form was once again evident. Gerald Abraham wrote in the Souvenir Programme of that year:

Different sides of Shostakovich are revealed in his string quartets. . . . He came to the string quartet relatively late in life. No. 1 dates from 1938 and very attractive though it is, it was soon eclipsed by the Piano Quintet of 1940. This is not the place to discuss the quartets, which must be done in some detail or not at all. But two things must be said. Collectively they represent the most important contribution yet made to Soviet chamber music, if not to Russian chamber music generally. And the Western listener must always bear in mind that they owe little to the Western chamber music tradition. Russian chamber music has almost always gone its own way; for one thing it has always shown a tendency to be suite-like,

so we need not be surprised to find that Shostakovich's Second Quartet (1944) consists of 'Overture', 'Recitative and Romance', 'Valse' and 'Theme and Variations' or that the writing lacks the exquisite technical finish, the 'goldsmith's work', of more familiar chamber music. But the true quartet style has grown upon Shostakovich, and often in the late quartets – e.g., in the first movement of the Fourth Quartet (1949) or the third movement of No. 5 (1951) one is reminded of Borodin's style. The quartet never becomes quasi-symphonic in his hands.

First thoughts about composers from Eastern Europe may produce the words 'impact' or 'brilliance', the former in the first instance in connection with Shostakovich. Yet of the twenty-two works by Shostakovich performed at the 1962 Festival, sixteen were chamber works. The connotation of 'chamber music' to the frequent attender at the Freemasons' Hall and Leith Town Hall by 1964, that is to say after Bartók, Shostakovich and Janácek, must have been given a different centre, a more turbulent one with less elegance evident.

The range of interests of the chamber concerts has been wide, from the first Festival in which the Jacques Orchestra and the Glasgow Orpheus Choir took part and in which there was a concert of Gaelic songs. Yet it widened and was enriched and not in an arbitrary way. Thus in 1963 the featuring of Bartók's music called for an emphasis on the Hungarian theme. As mentioned, Hungarian singers and the Tatrai String Quartet took part. There was also the Julian Bream Dowland Consort with Peter Pears. The Amadeus was there, Ella Lee (soprano) with Gerald Moore, Larry Adler who shared a concert with the Edinburgh String Quartet, and amongst others Yehudi Menuhin.

Yehudi Menuhin and Larry Adler shared concerts with Indian artists, who were another feature of the 1963 Festival. Peter Crossley-Holland's article in the Souvenir Programme was aptly headed, 'New Perspectives in Music'. In it he drew attention to the two differing traditions of Indian music, one from the north and one from the south, presented. He wrote:

... the two traditions are very different. The music of South India, stemming direct from ancient time, is represented by M.S. Subbulakshmi, a charmingly gifted singer from Madras; T. Viswanathan, distinguished player of the Indian flute; and Balasaravasti, leading exponent of Bharata Natyam, India's classical temple dance ... The style of South Indian (Carnatic) music is sturdy, architectural and restrained, whereas that of North Indian

(Hindustani) music, enriched by Persian influences through the Moghul courts, is vital and ornately elegant. Among North Indian artists visiting Edinburgh this year are Bismillah Khan of Benares, supreme exponent of the Indian shawm; Ali Akhbar Khan, master of the sarode; and perhaps best known of all Indian musicians, sitar player Ravi Shankar.

Another culture was meaningfully and beautifully displayed.

The instrumental ensemble, and especially the string quartet, has been inevitably the central interest of the chamber music recitals in the Festival. Small choirs have delighted – the most recent of which have been the King's Singers – but one only, Edinburgh University Singers, has appeared frequently over a number of years. Reference has already been made to the University Singers and to their founder director, Ian Pitt-Watson. When he was no longer available – Ian Pitt-Watson holds the Chair of Divinity at Aberdeen University – the standard of the choir and its continuity was ensured by two outstanding musicians, Hans Oppenheim and Herrick Bunney.

How, one might ask without hope of an answer, does the right man always appear at the Edinburgh Festival when he is most required? At the moment when a great chorus is needed for the Mahler 'Eight' a great chorus-master, Arthur Oldham, is waiting in the wings to be called. When the highest quality of singing is desired for the chamber music concerts Hans Oppenheim has become a resident in Edinburgh. He expressed his understanding of ensemble singing in an article on Bach's chamber music in the Souvenir Programme of the 1950 Festival, which commemorated the bicentenary of Bach's death, in which he wrote:

Many of our performances of eighteenth century music have to pay the price for the glamour with which they [large numbers of performers] are trying to clothe it . . . It is never its physical superiority, but its vitality and spiritual force which makes Bach's music what it is. Power superimposed from without will only obscure its message . . . In chamber music every player is prepared to be technically, mentally and emotionally responsible for his part and the whole. It may need the authority of one of them to co-ordinate wills and ideas, tastes and approaches, but the music must originate within the body of players or singers.

These opinions explain the character of the contribution on which Hans Oppenheim made to music – one understands from the passage why Kathleen Ferrier expressed her admiration and affection for him – and particularly to music in Scotland, the

country of his adoption. When in Edinburgh with the Glyndebourne Opera he was so taken with the place and the people that he expressed the wish to stay, and almost immediately he was called to the new post of Director of Music to the Saltire Society, the existence of which had a much to do with the composer Isobel Dunlop. He created and trained the Saltire Singers, who were to sing in several Festivals. Unfortunately ill-health compelled him to spend part of the year abroad after 1959. He died in Edinburgh in 1965 and is buried in the churchyard of the Episcopal Church in Haddington, to which he had also given his music.

The passage quoted from Hans Oppenheim also may refer accurately to the character of Edinburgh University Singers, founded in 1944, and specializing in "a capella" music. In their first Festival concert under their Director in 1950, their performance of madrigals by Morley, Bateson, Wilbye and Byrd was especially acclaimed. At the 1951 Festival the choir extended its musical interest to include Britten's Festival cantata *Rejoice in the Lamb* for which the organ part was played by Herrick Bunney.

The Scotsman's Music Critic referred to the choir as "admirably controlled" and "capable of really robust, exciting singing". This then was the instrument which Ian Pitt-Watson handed over, after seven years as Director, to Herrick Bunney who has been its Director since that date.

One of the features of his direction has been to draw from his student singers qualities that belong particularly to them. As conductor of the Edinburgh Choral Union, the large choir that was itself a feature of the early Festivals, and as Master of Music of St Giles with the St Giles Singers under his direction, he knew how to compel the large effect from the former and mature tone from the latter.

The University Singers were of course completely disciplined, but when their conductor called for the gaiety required by certain of the *chansons* of the French Renaissance, the sense of abandon was highly engaging. Little wonder that the word 'enjoyment' became the staple of critics' appreciation.

Thus Rutland Boughton in the *Musical Times* in 1958 commented: "The singing was at once sensitive and finely disciplined, and this concert was, for me (and I believe for many others) among the special pleasures of the Festival." Christopher Grier in *The Scotsman* remarked of the same programme: "I have

never before heard from them such a minute and disciplined attention to detail of every kind, and yet without any loss of spontaneity."

Herrick Bunney was, in fact, exploiting the native resources of his singers – the alert intelligences, the rapport between his intelligence and theirs, the flexibility of young minds and the responsiveness of feelings not yet guarded, the enthusiasm of young people for an enterprise in which they had unqualified belief. Their conductor's musicianship was undisputed but it also required sympathetic imagination to an unusual degree to realize the potential of the choir which had already proved itself under Ian Pitt-Watson, but which by the nature of the turnover of its members – they kept on graduating – demanded replacements almost annually. Christopher Grier's account of the concert continued:

These are young men and women with voices to match, but of their kind, the performances by the Edinburgh University Singers were as distinguished as one could wish to hear anywhere.

It was a mixed programme. On the one hand was the nimble gaiety of pieces like Passereau's 'Il est Bel et Bon' or the Ronde from Ravel's 'Trois Chansons' or the whimsical Matyas Seiber settings of Lear. On the other was the grave beauty of Palestrina's 'Stabat Mater Dolorosa' and the piercing, almost unbearable pathos of 'Trois Beaux Oiseaux' of Ravel. (The sweetness of tone of the present generation of Singers is among their most attractive features, especially when it does not cover up any lack of confidence in attack.) But the centrepiece was Vaughan Williams's *Mass in G Minor* which was sung 'In Memoriam'. Discreetly tailored as regards pace and dynamics to suit these voices, the performance had an expressive dignity peculiarly apt for the occasion. It was the worthiest of tributes to a great composer.

The 1958 programme indicates the scope of the music performed by the University Singers, and it must stand good for their other performances, with the exception of one of their contributions to the 1966 Festival when the Singers performed Kenneth Leighton's *Mass* written specially for them, doing, according to the *Daily Telegraph*, "full justice to its sumptuousness of sound." Kenneth Leighton at the time was a Lecturer in Music at Edinburgh University. After a short spell south of the Border he has now returned to occupy the Chair of Music. The sound of this composer's music is no isolated Festival phenomenon in Edinburgh. The St Giles Singers, Choir of St

Giles Cathedral, frequently sing modern works as the anthem at morning service. The composers most often heard in this category are Kenneth Leighton and Benjamin Britten.

So the Festival is integrated into music-making in Edinburgh, and music-making in Edinburgh penetrates the Festival. An excellent example of this was the playing of the complete organ works of J.S. Bach by Herrick Bunney in St Giles Cathedral for the twenty-first Festival, in sixteen recitals. In 1971 for the twenty-fifth Festival, and the year of Herrick Bunney's twenty-fifth anniversary in St Giles, he repeated the performance.

The mere feat is apt to obscure the idea of the deepening reward to the listener as the preludes and fugues unfolded the mind of Bach. There are no doubt other good reasons for having a three-week festival, but to allow the organ works of Bach to be displayed or the quartets of Beethoven, as interpreted by the Amadeus String Quartet in 1970, adds true splendour to the idea.

I return to the words of Hans Oppenheim – "the music must originate within the body of the players or singers." This sense of origination was evident in the work of the University Singers. In the Saltire Singers and latterly the Saltire Quartet, discipline and freedom, intimacy of understanding, the registration of nuances and boldness in attack – these qualities were theirs under the guidance and through the sensitive musicianship of Hans Oppenheim. They made their first appearance in the Festival in 1953, with Joan Dickson, Paul Collins and Angela Richey in a programme of seventeenth-century music for voices and instruments.

They returned in 1955 when they performed, amongst other music, Thea Musgrave's 'Cantata for a Summer's Day', already referred to in this chapter. Hume's poem 'Of the Day Estivall', written in a thin Scots, on which the tone of the cantata was based, was a pointer to the shift of attention from the local, rural aspects of the Scottish tradition in literature and music and where the expression of sentiment was the main desideratum to Scottish music and poetry with a European orientation.

For the third contribution of the Saltire Singers which they made to the 1957 Festival, their programme was billed under *Musica Scotica*. It was directed by Thurston Dart (harpsichord). The programme of early Scottish chamber music for voices and instruments, including works by Johnson, Kinloch and Burnet, revealed a Scottish music of urbane character. The instrument of the Saltire Singers which Thurston Dart found under his hands

had been trained completely by Hans Oppenheim to express this art. It did not prevent their giving full vent to the exhilarating wildness of Burns's cantata *The Jolly Beggars*, recreated by Cedric Thorpe Davie, when they performed the cantata in the Lyceum Theatre in the 1959 Festival. Before Hans Oppenheim presented the Saltire Singers at the Festival he had already conducted the Festival Chamber Chorus in music by Purcell and in Handel's *Acis and Galatea* at the 1952 Festival.

Members of that choir came from north of the Forth, so week by week Hans Oppenheim made his way to Kirkcaldy where he had found some enthusiasm and good singers who were responsive to this gentle, frail-looking musician. They took him to their hearts and he came to enjoy regularly in Kirkcaldy a new dish to him – fish and chips. It's a nice thought to ponder – that fish and chips went into making *Acis and Galatea* a success at the 1952 Edinburgh International Festival.

There was one area in the arts, however, close to the life of at least a minority of Scots, which the Festival has touched on sporadically and only marginally – the art of poetry.

In 1963 four concerts featured Scottish artists. The interests ran from a Gaelic concert to Hugh MacDiarmid who read his poems in Leith Town Hall. In this concert of Scottish poetry and music there was a brave attempt to take some notice of MacDiarmid's poetry. It was much overdue. I say 'attempt' because the presentation did not do justice to the platform potential of MacDiarmid's verse.

The presentation of Scottish poetry has until recent years been perhaps the least satisfactory of the Festival's offerings. The Festival has been interested in the presentation of poetry, though not as a regular feature, since 1948. In that year, under the auspices of the Apollo Society, two poets, Dylan Thomas and Cecil Day Lewis, appeared in public. The other readers were Dame Peggy Ashcroft, Dame Edith Evans, John Laurie and Michael St Denis. However distinguished the contributors, even though some Scottish poetry was included, this was not the right setting-out place in Scotland for this art.

The point may be made with confidence, for poetry of character and quality, which was specially suitable for the stage, was available. The tradition of Scottish poetry was more dramatic, more direct and much closer to the whole community than English poetry. MacDiarmid knew this and protested. At this point the Director, and I fear the programme committee, was

not sufficiently in touch with the makers of poetry in Scotland. In other spheres of the arts encouragement was necessary to bring into being an adequate home-made product; not so with poetry. Further, the art of presenting it had been applied successfully in radio production. The greatest success of the second Festival, *Ane Satire of the Thrie Estaites*, was poetry. Regrettably there was no development from this base. In fact the dramatic potential of the whole tradition of Scottish poetry from Lyndsay to the present has not been realized. It would appear there has been no one in a position of authority sufficiently knowledgeable of the field to cultivate it. The MacDiarmid appearance in 1963 was deferential rather than significant. In 1962 his seventieth birthday was not recognized by the Festival, though he took part in the International Writers' Conference in the McEwan Hall. This stimulating curiosity was produced by Malcolm Muggeridge. (In 1963 John Calder organized an International Drama Conference. Chaired by Kenneth Tynan, attended by an impressive gathering of dramatists, directors and actors, it is remembered for its 'happening' when a female nude was briefly seen in a wheel chair in one of the galleries of the McEwan Hall.)

Just how far removed were the 'planners' from the obligation to celebrate anniversaries is evident from the 1967 and 1972 programmes, in which years MacDiarmid celebrated his seventy-fifth and eightieth birthdays. These obligations were also missed opportunities. The successful recital, under the auspices of the Saltire Society, of MacDiarmid's poems, read by Iain Cuthbertson and Ian Gilmour, and settings of MacDiarmid peoms by Francis George Scott, sung by Joan Alexander (soprano) bore witness to this. Later in the year the Traverse put on Tom Fleming performing MacDiarmid's *A Drunk Man looks at the Thistle,* which in some respects might be regarded as a twentieth century equivalent of Lyndsay's sixteenth-century *Satire of the Thrie Estaites*.

The poetry at the Festival in 1972 consisted of readings by Peggy Ashcroft and the Barrow Poets. There could have been an urgency and excitement, as well as a high standard, had the native product been featured. The desire to promote it is there. In 1971, marking the twenty-fifth Festival, two poetry recitals which included Scottish poets were given in the Freemasons' Hall. The recitals had some success, but the success which attended the programme commemorating the bicentenary of the

death of Robert Fergusson was of a different order. Then, in St
Cecilia's Hall, James Cairncross and Tom Fleming read the poet
of Edinburgh's verses with pathos and humour, while Clifford
Hughes (tenor) sang unaccompanied and very effectively songs
associated with Fergusson. Many will cherish the recollection of
this occasion.

St Cecilia's Hall has been the scene of other very distinguished
successes. In 1968 Dame Edith Evans captivated the audience in
her recital, while in 1969 Dame Sybil Thorndyke, in three
programmes which included Scottish ballads, gave us her
endearing art. Of such like, if there is any like, one can only wish
for more, but alongside these accomplished importations, I
believe it is possible to set a native art of accomplishment and
interest.

In this chapter the spoken word, the vocal chamber recital and
the instrumental ensemble have been separated, but the Festival
presents a texture of musical events whatsoever area is
considered. Rich as the experience was in those items in the early
festivals, the prodigality to be heard in the Freemasons' Hall,
Leith Town Hall, St Cecilia's Hall and, on occasion, the Usher
Hall has grown over the years. 1971 was a year of great richness
and diversity in the chamber music and recital programmes.

Pinchas Zukerman and Daniel Barenboim packed the Usher
Hall with their exquisite playing of sonatas by Mozart,
Beethoven, Schumann and Schoenberg; St Cuthbert's Church
was full to overflowing when Menuhin played works for solo
violin by Bach and Bartók. Pierre Fournier with his son Jean at
the piano gave a distinguished account of sonatas by Debussy,
Mendelssohn, Martinu and Brahms. There was a brilliant Liszt
performance by Peter Katin in a programme called 'Walter Scott
in Music and Song'.

Among the *Lieder* recitals were two given by leading Spanish
singers Victoria de los Angeles with Miguel Zanetti, singing
Monteverdi, Pergolesi, Schumann and Debussy in the Usher
Hall, and Teresa Berganza in an exceptionally beautiful recital
with her pianist-husband Felix Lavilla which included the rarely
heard Haydn cantata 'Arianna a Naxos' in a programme of
Mussorgsky and Spanish songs.

There was Indian music from Ravi Shankar, a charming
recital–cabaret of Italian songs from baritone Renato Capecchi,
piano recitals from Claude Frank, Michael Block, Michael Roll
and Radu Lupu, a flute recital from outstanding Swiss flautist

Peter Lukas Graf, the Fine Arts Quartet, The Matrix and the Early Music Consort, the English Consort of Viols, the Trio Italiano, and a marvellously authoritative performance of piano and violin sonatas by Wolfgang Schneiderhan and Walter Klein.

The following year, 1972, Julian Bream fell ill and had to cancel his engagement. At a few hours' notice Pinchas Zukerman and Daniel Barenboim stepped in and, assisted by several members of the English Chamber Orchestra, delighted a capacity audience at Leith Town Hall with a brilliantly performed programme of chamber music. Julian Bream recovered from his illness to appear with Dame Peggy Ashcroft in a poetry and music recital, and to take part in a concert with the Melos Ensemble conducted by David Atherton. At the Freemasons' Hall, the young American soprano Jessye Norman and Irwin Gage at the piano sang songs by Schubert, Brahms, Ravel and Strauss and was applauded to the echo. This year the King's Singers made their first appearance in the Festival by opening the morning concerts. Among the works they performed was the premier of 'Ecolga VIII', which was written for them by the Polish composer Krzystof Penderecki, who attended the performance. The son, Karl Ulrich Schnabel, and daughter-in-law of Artur Schnabel gave a particularly appealing concert of rarely heard works for four hands by Mozart, Schubert, Weber and Mendelssohn. Helen Schnabel played Artur Schnabel's 'Seven Piano Pieces'. The 'Seven Pieces' were composed in 1947, the year of the first Festival, to which her father-in-law had made his unique contribution. "Art", her father-in-law had commented, "is not an occasional refuge or holiday, but a perpetual and inexhaustible mandate of the spirit. The efforts to fulfil this mandate belong to the most exacting and most satisfying, and therefore to the supreme functions of man."

In a world of time servers these words can have no meaning. They will gain no headlines today. Yet when one measures against them the musicians of the Festival, and especially the musicians of the chamber concert, they described aptly and exactly the discipline which sustains the art of each. Artur Schnabel had walked with, and learned from, Brahms. He died in 1951, but his understanding of music and his valuation of it has been passed on, so that when an audience is thrilled by the performance, say, of Clifford Curzon, that thrill, it might be said, began even before the birth of this great pianist, who has

played at many Festivals, most recently in 1974. The comment by Schnabel was taken from the article which Clifford Curzon wrote as a memorial tribute to Schnabel in the Festival Souvenir Programme of 1952.

The great tradition continues. In the same year of the two Schnabels, Alfred Brendel played sonatas by Schubert and Beethoven in Leith Town Hall. He too pays a studious respect to the composer's intentions. In Leith Town Hall the soprano Catherine Gayer, with Aribert Reimann at the piano, was also heard, singing *Lieder* by Schubert, Debussy and Strauss. Dietrich Fischer-Dieskau and Daniel Barenboim gave their exceptional talents to the 1972 Festival in a great performance of Wolf's 'Morike Lieder'. There were all these and more. Surprisingly chamber music was heard at the Haymarket Ice Rink, where Peter Maxwell Davies directed a programme entitled *The Fires of London*, in which were performed works by Ockeghem-Birtwistle, Bruce Cole and Maxwell Davies himself. The new venue, associated with more popular arts, attracted a predominantly young audience, who gave an enthusiastic reception to Maxwell Davies's 'Eight Songs for a Mad King', brilliantly sung by William Pearson.

In 1973 in the large audiences at the chamber music recitals was a considerable number of young people. In *The Scotsman* Conrad Wilson wrote:

> Though Europe's big international festivals tend to stand or fall on the quality of their opera productions, it is in fact the morning concerts at the Freemasons' Hall which have long given Edinburgh its special character. There above all are what makes Edinburgh different from other Festivals; their standards are high, their programmes interesting; and even if some performers find it hard to attune themselves to appearing in the morning, it remains a marvellous time to listen to music.

In *The Financial Times* Gillian Widdicombe had this to say of the chamber music at the 1973 Festival:

> This year Edinburgh has made a deliberate assault on the musical avant-garde. A high-powered, hand-picked assault of international calibre, far removed from the kind of play-school prattling that seems to get sheltered by impressive initials. From Stuttgart, the unrivalled Schola Cantorum came: sixteen singers as skilled in the arts and inventions of contemporary vocalising as the inimitable sorceress Cathy Berberian. And the original Miss Berberian came too, for two performances of her nostalgic *A la Recherche de la*

Musique perdue . . . There were two concerts by Les Percussions de
Strasbourg and several featuring the Swiss Heinz Holliger. So Peter
Diamand has added, at last, a contemporary link to the Lord
Provost's musical chain.

She went on to say that Holliger's contributions "ranged from
the fascinating to the silly", and certainly the late-night concert
of improvisations and long-winded and percussive musical jokes
in the Assembly Hall went on long after most of the audience had
departed "bored blue", as Miss Widdicombe reported crisply.
But Holliger's concert with Boulez was an outstanding success
and the performance in Leith Town Hall of various works by
contemporary composers by Les Percussions de Strasbourg could
only be described as thunderous.

However all was not *avant-garde* in the smaller halls – as Ernest
Bradbury pointed out in *The Yorkshire Post.*

Mozart has been represented at all the morning concerts this week,
apart from Monday's King's Singers programme . . . On Tuesday
Martha Argerich included one of the piano sonatas in her recital at
Leith Town Hall, where the Amadeus Quartet, assisted by Cecil
Aronowitz are now in residence with morning programmes that
include three of the great quintets.

Chamber music in 1974 was another mixture of contemporary
and classical. The Festival opened with a recital by Catherine
Gayer, with Richard Rodney Bennett at the piano, of cabaret
songs and Strauss arrangements by Schoenberg and songs by
Gershwin, a composer Schoenberg greatly admired. The Trio di
Milano offered Beethoven, Mozart and the American composer
Charles Ives, whose centenary it was that year, as well as a
composition by one of its members Bruno Canino, 'Labirinto
No. 5'. The pianists John Ogdon and Richard Goode stuck for
the most part to the classical repertoire but Australian Roger
Woodward, although he played Beethoven's C Minor Sonata
("I consider Beethoven a modern composer", he said), included
works by Takemitsu, Anne Boyd and Iannis Xenakis in his
recital.

There was an outstanding performance of eight Mozart piano
and violin sonatas by Szymon Goldberg and Radu Lupu, and The
King's Singers and Jessye Norman once again delighted their
audiences. The centenaries of Schoenberg and Ives were
celebrated in the smaller halls by Cleo Laine singing 'Pierrot
Lunaire' and a group of Ives songs with the Nash Ensemble, and

several chamber works of Schoenberg were performed by the Tel Aviv String Quartet and the Tuckwell Wind Quintet. The composer Ernst Krenek gave a performance of his own 'Spätlese' with Dietrich Fischer-Dieskau, and John Williams in his guitar recitals included works by two composers present at the Festival, Goffredo Petrassi and Richard Rodney Bennett.

Such has been the development and proliferation of chamber music in the Festival that this art has become a festival in itself.

6

The Soloists on the Concert Platform

Of the soloists there have been so many of great distinction that even in a larger volume than this no adequate mention could be made of the renown they have brought to the Festival. Some of their names are legend. Cortot came to the Festival in 1948 to play a special programme to commemorate the centenary of Chopin's concert in the Hopetown Rooms in Edinburgh. Chopin found the weather bad but the welcome warm, especially in the home of his host, the Polish Dr Lyszcynski, at 10 Warriston Crescent. Despite ill-health Chopin played a long programme of his works, leaving, unfortunately, an incomplete record of the programme. Cortot's research, however, enabled him to reproduce the programme in the Usher Hall on 4 September. "His playing", wrote the Music Critic of *The Scotsman*, "had moments of the old magical beauty." One recollects the singing tone, the gentle flowing and ebbing of the Cortot sound, as if the piano did not have a physical existence, but perhaps memory has overstressed this side.

In 1947 there were conjunctions of names which cannot again be heard together. There were Elisabeth Schumann and Bruno Walter, Joseph Szigeti and Artur Schnabel; in 1948 Kathleen Ferrier and Gerald Moore, Gregor Piatigorsky and Ivor Newton – a formidable roll call. But fortunately still in play from the early festivals are Peter Pears, Leonard Bernstein, Claudio Arrau and several other highly distinguished artists. In 1949 Suggia came, majestic in appearance and in sound.

All that is required of a musician is presumably his music, yet the kind of contribution to the Festival which has struck the deepest has implied more than the cultivation of technical and aesthetic excellence. Inevitably perhaps one thinks of Yehudi Menuhin, particularly of the occasion of the invasion of Czechoslovakia by Russian forces (*see* page 53) when he

prefaced his playing of Beethoven's Violin Concerto with an address to the audience in the cause of human liberty. Menuhin does not readily advertise his loyalties. They become evident in the character of his playing the works of great composers and in his service to music generally. His playing is always a reading of the mind of the composer through the composition.

His first appearance in the Festival was in 1948 when he played Beethoven violin sonatas with his friend the pianist, Louis Kentner. At this Festival he also was soloist with the BBC Scottish Orchestra. He returned in 1953, the year when the Festival celebrated four centuries of the violin. In this Festival he was joined by Gioconda de Vito and Isaac Stern, the latter making his first of many appearances in the Festival, in Vivaldi's Concerto for Three Violins. It was in the isolation and concentration of the Unaccompanied Sonatas and Partitas of Bach that Menuhin gave one of the most memorable performances of that Festival. In 1958 his partnership with Louis Kentner was renewed. The Festival also heard the Menuhin–Cassado–Kentner Trio, which had been formed in 1956. *The Scotsman* remarked that the Trio has a "sort of inner listening" – a comment which catches the quality of chamber music playing and which might suggest that this kind of music might be less acceptable to the uninitiated than a more extrovert music.

The Trio, however, tried an experiment that proved the contrary. They booked the Embassy Cinema, which is situated in a council housing district in Edinburgh, far removed from the halls in which Festival performances were usually held. The entrance fee was a shilling, enough, it was hoped, to pay for the hire of the cinema. Yehudi Menuhin gave his reason for the venture in which they played the Beethoven Trio in B Flat and the Mendelssohn Trio in D Minor as: "We are so happy in Edinburgh. We thought it would be nice to get acquainted with the people who really belonged to Edinburgh and have no opportunity to get to the concerts." On the morning of the performances Mrs Kentner had remarked to her husband that she doubted if anyone would go. On account of Louis Kentner's being delayed later than the other members of the Trio, Wilfred Taylor of *The Scotsman* called for him in his car. Later he wrote up the episode in *The Scotsman's Log*, from which I quote:

When we reached the outskirts of Pilton the streets were lined with

cars, and crowds of children were being escorted along the pavements. In the distance we could see a number of policemen and a big crowd of people.

"There must be something on here", said Mr Kentner, looking out of the window. "You're on", we said. He seemed genuinely surprised.

The Embassy Cinema was packed. Later the Lord Provost of Edinburgh, Ian A. Johnson-Gilbert, wrote to the Trio. The letter ran:

> ... it was the Festival's ambition not only to embrace the world, but to bring home to the people of Edinburgh the real meaning and true significance of the Arts. The people of Edinburgh now know that great artists are not the detached and unapproachable people which has been for so long the popular belief. By taking your gifts of music into a great housing area you have demonstrated in the most possible practical manner that a musical experience is available for everyone ... The feelings of the people of Edinburgh are surely summed up in the words of the old lady of Pilton who called to you as you left the concert, "You'll aye be welcome here".
>
> The 1958 Festival will live in our memories because of the great contribution which you have made, and I would ask you to accept my warmest and most sincere thanks.

I have dwelt on this episode at some length because it is one of many evidences that the Festival is not wholly dissociated from the Edinburgh community, albeit it is not usually brought to the notice of non-attenders in quite such a dramatic way. Other musicians took the opportunity of letting Edinburgh boys and girls hear them outwith the Festival.

In the early years of the Festival Sena Jurinac, Paolo Silveri, and Ian Wallace from the Glyndebourne Opera, sang in hospital wards. In 1959 Kerstin Meyer, accompanied by Gerald Moore, sang to school children at the Roxy Cinema at Tynecastle. In 1962 David Oistrakh, the Russian violinist, and Frida Bauer gave a school concert at the Embassy Cinema – where Menuhin, Cassado and Kentner had performed in 1958. In 1963 Isaac Stern, Leonard Rose and Eugene Istomin went to Portobello Town Hall; the following year members of the Czech Opera Company sang in Leith Town Hall for young people; in 1965 members of the Bavarian Opera Company did likewise, while in 1966 five members of the Stuttgart State Opera sang in Leith Town Hall. Thus many boys and girls from Edinburgh schools have heard

performances of great distinction, thanks to the generosity of Festival artists.

Nowhere is the absurdity of the comment, regrettably repeated from time to time, that the Festival imposes a 'foreign' culture on Scotland more evidently demonstrated than in the character of Yehudi Menuhin's contribution to music-making in Scotland. Of first importance was the frequency of his visits to Scotland to play great music. Then there was his association with the two professional symphony orchestras, the BBC Scottish Orchestra and the Scottish National Orchestra. There have, of course, been many memorable occasions, such as the opening concert in 1968 when Menuhin was soloist in the Britten Violin Concerto with the London Symphony Orchestra. At this Festival with his sister Hephizibah, he played Beethoven's Sonata in A Major (the 'Kreutzer'). Then he played unaccompanied Bach in St Cuthbert's Church. From there he took Bach to Haddington, to St Mary's Parish Church. This last performance was a free offering to a local community. The music and the identification of the performer with the interests of people and places are notable.

Menuhin's attention had been drawn to the 'case' of Haddington, the small country town which some years ago decided corporately to conserve its environment and subsequently set about encouraging communal activities at the heart of which was concern to put the Arts at the service of the whole community. The Lamp of Lothian Collegiate Centre came into being to foster this aspect of the service, and each year, particularly among young people, creative activities in the Arts has increased. Before Menuhin came to Haddington he had already helped with advice which led to the production of a ballad opera with words by W.H. Auden in St Mary's Church. He played to a packed church, while outside by the ruins of the old abbey many listened to a relay of the recital. Then in 1970 members of the Yehudi Menuhin String Orchestra played in the church and supported young singers and dancers from Haddington and East Lothian. In 1971 Menuhin was the violin soloist with the National Youth Orchestra of Great Britain which was conducted by Pierre Boulez. At a stroke were brought together young and old, the composer–conductor with new ideas, and the great interpreter of traditional music.

I have used Yehudi Menuhin's association with the Festival to illustrate that kind of impact which begins with a man playing a

fiddle and goes far beyond the moment. Others have done likewise for the Festival. Peter Pears, who sang in the first Festival, has made many contributions over the twenty-eight festivals. In 1968 he was tenor soloist in Britten's 'Spring' Symphony (Op. 44) at the opening concert of the Festival, in which the boys of St Mary's Roman Catholic Cathedral, Edinburgh, also took part as well as the Edinburgh Festival Chorus. Two days later Benjamin Britten was accompanist to his friend Peter Pears in a performance of Schubert's *Winterreise* in the Freemasons' Hall. Britten appeared again in Leith Town Hall as accompanist, this time to Dietrich Fischer-Dieskau, in a performance of Britten's 'Black Songs', with the Amadeus Quartet also taking part in this concert. Then once again he joined Peter Pears in the same hall in a performance of his 'Michelangelo Sonnets'. In this concert the composer also accompanied the great Russian cellist, Mstislav Rostropovich, in Britten's Cello Sonata.

The community of great musicians share at least one characteristic, the pursuit of excellence. The devotion to this end, however, is allied to enjoyment of the work to be performed. Isaac Stern the violinist has played in many Edinburgh Festivals. I recollect meeting him in the entrance hall of Broadcasting House, Edinburgh, while he was looking around as if at a loss. His problem was that he had nowhere to rehearse and he had thought that there might be an empty studio, or as he put it, 'somewhere' to go in the building. It happened that the music studio was unoccupied for a short period, to which I took him, and since he had no objection to my presence, I stayed to hear him practise. The rehearsal quickly turned into an exposition of the merits of the work, Sonata in A Major by César Franck. Phrases were played and comment made on the phrases, and then a performance given to this one listener. But of course there was another listener, the violinist himself, listening with the ear of perfection, recognizing that in the Arts nothing is predictable yet everything is possible. What remains with me now from this happening is not the sense of polished perfection but of being in the presence of the fire of life. All self-importance – and an artist of high standing might be forgiven for showing something of this – is entirely absent. Instead there was an unstinted expense of spirit.

Name any of those performers who had been on platforms of the Edinburgh Festival throughout or over many of its twenty-

eight years, and it is this characteristic that conquers, though not without great art. Consider the singers – Janet Baker, who, having won the *Daily Mail* Kathleen Ferrier Award, made her name internationally through the Edinburgh Festival; Victoria de Los Angeles, less frequent in appearance, but spanning the years from 1950; Richard Lewis, the Don Ottavio of the Festival's first *Don Giovanni* in 1948, frequently throughout the sixties, and of Fischer-Dieskau on many occasions from 1952 to the present. From the beginning with almost all the soloists, attending eight of the first ten Festivals and many thereafter was the *Unashamed Accompanist*, Gerald Moore.

On 31 August 1952 Dietrich Fischer-Dieskau chose for his first appearance in the Edinburgh Festival to sing, in the Freemasons' Hall, Schubert's *Die Winterreise*. The accompanist was Gerald Moore. Twenty-two Festivals later, in 1974, Fischer-Dieskau sang again *Die Winterreise* with Daniel Barenboim. Some critics who had attended both performances, or other early performances of the Cycle by Fischer-Dieskau, said that there was a subtler registration in the voice in the 1974 performance. It is possible, but without the help of recordings from the earlier period doubtful, if memory could carry such distinction. What can be said with the utmost confidence is that the 1974 recital conveyed the gravity, tenderness, and pathos of the songs and their lyrical beauty with such superb artistry as to put the performance beyond criticism. It is very probable, of course, that the dedication of Fischer-Dieskau to his art over the years – and therefore his dedication to a quality of living – brought to the more recent interpretation a profundity beyond the reach of any young artist, no matter how brilliant, and with this was retained the freshness that belongs in sorrow or joy to Schubert's *Lieder*.

"The special feature of Dietrich Fischer-Dieskau's recitals", a comment in the 1974 Souvenir Programme runs,

is the care with which he compiles his programme. Sometimes he will build these around a single composer, at other times, he will choose groups of songs by different composers, not haphazardly assembled but intelligently linked so that one group of songs relates or sheds light on another. Thus, this year he is bringing to Edinburgh a programme of Schoenberg, Webern and Krenek, composers connected by their Viennese origins ... and by the important contribution to German song made by them between about 1900 and the present.

In another Festival concert Fischer-Dieskau sang Mahler's *Songs of a Wayfarer*.

The supreme artistry of Fischer-Dieskau, and of others who put their talents at the service of fine music, is, it seems to me, the appropriate answer to the promotion of 'star' personalities, whose motivation appears to be the promotion of self. Be it Schnabel or the Chilean pianist Claudio Arrau – whose exquisite clarity of execution and interpretation graced many Festivals from 1950 – the direction of their whole endeavour is towards the character of the music. So we are left with that benefaction and its, sometimes, profound implications.

At a glance 1950 suggests it was the year of the pianist, for besides marking Arrau's and Clifford Curzon's first appearances at the Festival, there were also Casadesus and Marguerite Long, but, of course, it was the year of the commemoration of the bicentenary of the death of Bach, as well as Sir Thomas Beecham's and Carl Ebert's famous production of *Ariadne auf Naxos*. Nevertheless it is worth noting that Claudio Arrau's first recital in the Festival began with Mozart's Rondo in A Minor, K. 511, after which he played Beethoven's Sonata in E Flat Major, Op. 81a (Les Adieux), and that on 1 September 1950 Clifford Curzon made his first Festival contribution in Brahms's Concerto for Piano and Orchestra in B Flat, No. 2.

But for the fact that due admiration has been given in other chapters in this book to Clifford Curzon, more detailed attention would be paid to him here. His elegant figure strides through the history of the Festival, cascades of notes flowing from his fingers with such an impression of ease that it is all done by nature, not by art. Never more so was this impression created than in the 1970 Festival – the Festival of the bicentenary of Beethoven's birth – in the Fantasy for Piano, Orchestra and Chorus, Op. 80, the last item in the last concert. The first work in this Beethoven concert was the Piano Concerto No. 5 in E Flat Major, Op. 73 (The Emperor). In it exhilaration (indeed exaltation), threat, robust energy, the descent into gloom and the majestic rising into singing tones – all were present, with those apprehensions and glories for which there are no words, in the interpretation of Clifford Curzon.

7
Opera

Opera is festival. It, the art that combines arts, exhilarates as no other art does. Since 1947 the King's Theatre in Edinburgh has echoed to more bravos than in the entire history of concert-going in Scotland. The most expensive of the Arts, film excepted, it is also the most responsive on both sides of the footlights. Curtain calls and cat calls tend to be the rule – there is not very often a lukewarm reception. And while like other arts it crosses national boundaries, one of the pleasures of the Edinburgh Festival has been the occupation of the King's by a variety of nations. With the companies have come their national supporters as if to emphasise this is an international festival, not a cosmopolitan one.

By its history and geography Edinburgh makes a peculiarly appropriate setting for opera. It was a happy chance that Edinburgh's first Festival Director was an opera man, and even more fortunate that Rudolf Bing was General Manager of Glyndebourne. Naturally he brought that Opera with him, encouraged and with the permission of the founder patrons of Glyndebourne, Mr and Mrs John Christie. There was no other company in Britain in 1947 capable of giving performances of opera of the standard required by an international festival. As it was, Glyndebourne was gathering itself together after the war. In the 1930s Fritz Busch and Carl Ebert had achieved the highest standards in performances of Mozart operas. It was, therefore, right that a new audience, at the outset of the Festival, should hear *Le Nozze di Figaro*, a production for which Glyndebourne had been famous in pre-war years. "It was", according to R.H. Westwater in *The Scotsman*, "the finest experience of the week."

Glyndebourne also presented Verdi's *Macbeth*, the first production in Britain of which they had given in 1938, so that a new musical experience was available for the great majority of the audience in Edinburgh. In any case, after the war years – what more invigorating renewal could there be than Mozart and

Verdi? Ernest Newman in *The Sunday Times* commented that "though necessarily falling short in a theatre without the stage resources and apparatus and training of Glyndebourne it had merits. Carl Ebert's production was superb," he wrote, and he was equally full of praise for the soloists. He singled out the sleep-walking scene. "The sleep walking aria is a truly remarkable piece of work to which there is no parallel musically or psychologically anywhere else in Verdi."

I remark the detail because it draws attention to the contrast between this work and the tone of the Mozart, and it relates to the astuteness of the selection of operas throughout the Festival, this often despite the limitations of repertoire possible on the King's stage.

The following year Glyndebourne presented a new production of *Cosi fan Tutte*, "which approached closer than any production I have seen to perfection in the staging of this airy fantasy", according to Dyneley Hussey in the Festival Souvenir Programme of 1951.

In 1949 the talk of the Festival was another, then little-known, Verdi opera, *Un Ballo in Maschera*. Little wonder. The production itself by Carl Ebert was a marvel and it was matched by superb vocal performances, the music being under the direction of Vittorio Gui. Then in 1950 Beecham came. It was his year.

"M. Jourdain would have been in his element last week", ran the comment in *The Listener*. "On Monday he could have enjoyed not only a comedy and two operas rolled into one but simultaneously with the aid of a second receiver, Verdi's *Requiem*. And then there were the fireworks, preceded by an assembly of all the military bands in Edinburgh playing Handel under the direction of a real baronet."

The climax of the real baronet's week was not in the midst of fireworks and military bands but with M. Jourdain, admirably played by Miles Malleson and the Glyndebourne Opera, while conducting for the first time in nigh forty years *Ariadne auf Naxos*, preceded by a shortened version of Molière's *Le Bourgeois Gentilhomme*.

The evening began with what Ernest Newman in *The Sunday Times* called "a quintessential study of Monsieur Jourdain, with a curious strain of pathos and wistfulness running through its nonsense", and then the Royal Philharmonic Orchestra, "a thing of constant beauty and expressiveness" under Sir Thomas Beecham. That human beings should produce so much beauty of

sound – for the singers were equally praised – and yet be liable to folly and mishap, for this was the context in which M. Jourdain put the opera, is strange. And so out into the Edinburgh evening air, with the knowledge growing in us, even as the music and scene faded, that this was a rare thing that had happened, so rare that though Glyndebourne brought *La Forza del Destino*, one of Verdi's masterpieces, to Edinburgh the following year, I shall not dwell on it.

The new production was mounted to commemorate the fiftieth anniversary of the death of Verdi. It brought together again Fritz Busch, who had been away from Glyndebourne, and Carl Ebert for the fifth Edinburgh Festival. When a festival manages to become a meeting place for old professional friends, then the music is bound to benefit, and when this happens many times in Edinburgh then the performance cannot simply be yet another performance. As with performers in other music, certain singers were returning to Edinburgh – amongst them Ian Wallace and Owen Brannigan.

Glyndebourne missed a year at Edinburgh and then returned in 1953 with their first modern opera, *The Rake's Progress* by Stravinsky, the libretto being by Auden. It was another success. In 1954 in association with the Edinburgh Festival Society Glyndebourne Opera presented "a turning point in contemporary music for the theatre", as Günther Rennert referred to *The Soldier's Tale* in the Souvenir Programme. The cast is seven instrumentalists – who sit on the stage – a narrator, two actors and a dancer. Stravinsky's drama shifted the focus. A tale was told that might be enacted in any given place.

In opera the Festival was moving towards more experimental areas, without omitting from the programmes the mainstream of operatic interest, as was evident from Glyndebourne's programme the following year which offered *Forza* again, Verdi's *Falstaff* and Rossini's *Il Barbiere di Siviglia*. After 1955 they were to return to Edinburgh once more – in 1960, when they brought with them the Scottish bass David Ward to sing Lord Walton in *I Puritani* by Bellini. It was David Ward's first appearance at the Festival where he was to distinguish himself in Wagner. In that latest Glyndebourne appearance novelty was sustained by the British première of *La Voix Humaine*, a lyric tragedy in one act by Jean Cocteau with music by Poulenc, and in the same programme gaiety by *Arlecchino*, a Capriccio in One Act by Ferruccio Busoni.

Just how international was the Glyndebourne company which

performed *Arlecchino* was stressed by the singers listed in the programme with their nationalities in brackets. The cast list was headed by Ian Wallace (Scottish) as Ser Matteo del Sarto, a master tailor, and followed by Arlecchino who was sung by Heinz Blankenburg (American). Thereafter came Welsh, Argentinian, German, Irish and English singers. The producer Peter Ebert was the son of Carl Ebert, who earlier in the week had produced Verdi's *Falstaff*. The music fraternity at the Festival was wide enough to be global, yet traditional enough for a father to pass on his skills to his son.

In 1952 the first opera company from the Continent made its contribution to the Festival. How long after the war it would take to restore the quality and prestige of the great European opera companies was a matter of speculation. Indeed the mere fact that Edinburgh had not been bombed was an argument in favour of risking a festival there. Yet by 1947 Günther Rennert, Intendant of the Hamburg State Opera, had produced *Peter Grimes* in Hamburg, to be followed by *The Barber of Seville* in Berlin and *Fidelio* in Salzburg. This was the company which came to Edinburgh with a repertoire of six German operas that ran from Mozart, through Beethoven, Weber, Wagner and Richard Strauss, to Hindemith. The majority of the principal singers belonged to the Hamburg Company and others were on long contracts with it. By such means the Hamburg Opera could maintain the standard and character of its long tradition. It was founded in 1678. Audiences were quickly made aware of its special character, though they must also have recognised that one problem had not quite been solved by 1952 – the condition of the decor.

Harold Rosenthal headed his article in the Souvenir Programme on the Hamburg State Opera on the occasion of the company's third visit to the Festival in 1968, 'Hamburg – Where Opera is Theatre'. This aspect, the drama in opera, was, I recollect, felt markedly in the productions of 1952. This was in the tradition, but it may well have been re-enforced by the productions, with the exception of Weber's *Der Freischutz*, being directed by Günther Rennert. Like Carl Ebert, he directed first for the stage and has directed films. He also directed T.S. Eliot's *Family Reunion* in Berlin in 1951. With Ebert, Rennert was in the vanguard of the movement which has developed opera into total theatre, by which is meant theatre enjoyable throughout in all its aspects.

Distanced by time, events simplify themselves. Hamburg

Opera opened their first Edinburgh season with Beethoven's *Fidelio*. First I recollect the impact of the chorus. Again when the Hamburg returned in 1956 I recollect the dramatic impact of the chorus again. Not that the chorus was felt as separate from the drama but as a powerful re-enforcement. It deepened the dark in *Fidelio*, and strengthened the sense of inevitability in Stravinsky's *Oedipus* in 1956. The opera which aroused most curiosity in the critics was *Mathis der Maler* by Hindemith. It was written in 1934. Several concert performances had been given before 1952, but its first stage performance in Britain was given in that year. Its fineness and tensions were less readily appreciable than the long-accepted thunders of Beethoven. The presentation of this opera was an example of the seriousness of the Festival policy to go beyond what were known as box office attractions. In 1952 Hindemith's Five Pieces for Strings was played by the Stuttgart Chamber Orchestra and his new song-cycle, 'Weihnachts Motetten' sung by Irmgard Seefried. In a small measure this anticipated Lord Harewood's policy of featuring composers. Bach had been featured in 1950, but that was a bicentenary.

The 1956 visit of the Hamburg Opera Company, on the occasion of the tenth anniversary of the Festival, caused much confusion of judgement in the minds of the critics. The Music Critic of *The Times* had no doubt that

> Richard Strauss's *Salome* was by far the best thing the Hamburg State Opera has done during its visit to Edinburgh . . . The whole fascination of Wilde's libretto the attraction made stronger by the leverage of repulsion, closed its grip, while the music, still astonishing after fifty years, wove itself, strand by strand, motif by motif into a texture that felt as though it would soon have smothered us if Salome herself had not been first smothered by the soldier's shields, and then curtains fall.

And there was unexpected drama in the cast when the *prima donna* was indisposed and the role of the Princess of Judea was undertaken at short notice by a young singer Helga Pilarczyk, and performed with the greatest success and acclaim. Then there was performed that other opera about a barber, *The Barber of Baghdad* by Peter Cornelius, a light opera of the 1850s. The papers were agreed that in this absurd comedy the men's voices carried the day. Of the performances in *The Magic Flute* the *Daily Telegraph* commented on the "high standard of singing" while *The Times* said it was "competent rather than brilliant". Inevitably there were references in all the papers to the problem

of achieving the desired visual effect on the small stage of the King's Theatre. The opera on which the critics were most divided is the one which remains most vividly in my mind, Stravinsky's *Oedipus*.

"Not everything in this generally conservative festival", wrote the Music Critic of the *Manchester Guardian*,

> is a collector's piece, but the Hamburg Opera's second programme at the King's Theatre tonight was something of a rarity . . . This was the Cocteau–Stravinsky *Oedipus Rex*, a staged oratorio, in Latin . . . with statuesque solo contributions from the principals who wear metal masks, and from a narrator, talking English on this occasion, to point the moral and adorn the tale. Hamburg's performance . . . was rather coarse grained, for it is hard to balance so much sound in a small theatre; but it was impressive, not to say explosive.

This was, in fact, the first staged performance of the work in Britain. The Critic of the *Guardian* had the advantage of me since he had seen *Oedipus* in Paris with the composer conducting and Cocteau himself in a dress suit as the Announcer. But while aware of limitations in the presentation of the Announcer in Edinburgh, his presence did more than adorn and point the moral. The freakishness and feebleness of modern man was emphasized in contrast to the massive, powerful effect of a body politic which sang of inevitable doom in a world of majestic, terrifying forces indifferent to the fate of the individual. Coarse-grained the effect of the chorus might have been, but it was memorable, the more so because of the new perspective on the classic drama that was cast by the presence of the figure in the dress suit. The perspective in some ways was similar to the rendering of *The Soldier's Tale* where the principal means of achieving the effect of the drama, the instrumental ensemble, were visible on the stage and were therefore involved in the tale, at least as human observers. Here was the Festival educating as well as giving intense pleasure.

By the time of the third visit of the Hamburg Opera in 1968 Rolf Liebermann had been appointed as Intendant or General Director. He had put his emphasis on modern works but the operas performed in Edinburgh by the Company were Wagner's *The Flying Dutchman*, and two Richard Strauss operas. *Elektra* and *Ariadne auf Naxos*. That they had benefited by Liebermann's approach to opera as 'theatre' was perhaps evident in the appointment of the late Wieland Wagner as producer and designer of *The Flying Dutchman*. The movement of the choruses

was related to the darks and lights cast on their features – the women's chorus in Act II came out of the dark and sat at their spinning wheels gently, even mysteriously, lit. The music seemed to rise out of that dark and return to it. So that the symbolism of Wagner was brought closer to the texture of the whole opera and was the more effective.

The character of the achievement of La Piccola Scala, the opera company from the Teatro Alla Scala, Milan, was of a very different order from that of Hamburg. Suddenly in 1957 Italian sunshine took over. The previous year, it is true, the Germans had brought *The Magic Flute*, but it was the doomwatch *Oedipus Rex* that left its mark.

It was not an Italian festival, yet in the Festival Club, in restaurants, in Princes Street, those demonstrative conversations that are conducted as much by hands as words were very evident. The opera began in the streets in the enjoyment of living and continued on a somewhat larger scale in the King's Theatre, where were sung *Il Turco in Italia* by Rossini, *L'Elisir D'Amore* by Donizetti, *Il Matrimonio Segreto* by Cimarosa, and lastly but first in the programme, *La Sonnambula* by Bellini. All conveyed the lustre, the warmth, the unqualified spontaneity, the lyrical–dramatic gifts of the Italians, but it was *La Sonnambula* which turned us all into demonstrating Italians, for in it there blazed the star, Maria Meneghini Callas. She sang Amina. All of us were carried away except the critics – who properly had to keep their heads.

"Though her tone above mezzo forte is often painfully hard," wrote Martin Cooper in *The Daily Telegraph*, "her repertory of vocal colour restricted . . . she captivated the audience by the agility of her florid singing and the strength of her personality." The reservations about tone or pitch are forgotten. Andrew Porter in *The Financial Times* wrote, "Of all singers she possesses in the highest degree the ability to create a role . . . Who but Callas 'can show in every gesture, in every glance, in every sigh a certain stylisation, and at the same time realism such as we find in some paintings by Albani, some idylls by Theocritus?' " Andrew Porter is quoting from the poet Romani and applying the comment to Callas. The Critic of *The Financial Times* then continued, "By standards of straight theatre her acting might be thought over mannered, but it is superlative great acting for the lyric stage."

As for the reaction of the audience, Christopher Grier, then Music Critic of *The Scotsman*, noted, "Callas . . . inflamed the

audience to a fever of enthusiasm without parallel in the history of the Festival operatic annals." Then having taken the Festival by storm, Madame Callas first failed to attend a press conference and then left the Festival without completing her engagements. She was billed to sing five performances and she sang four – at the final performance she was replaced by Renata Scotto. Various stories were put about – she was ill and there was a doctor's certificate; it was a publicity stunt; she was furious. It was apparently very much in the tradition of the temperamental *prima donna*, but in fact she was exhausted to the point of being unwell, to which the doctor's certificate testified. And of course the demands on her were enormous.

That, it might be observed, is the penalty of her kind of success. One small episode threw a different light on her. She recorded an interview for a BBC radio programme. Later the producer discovered there was nothing on the tape. With great apprehension he made his apologies and, hardly daring, asked for another interview which Madame Callas gave with great good humour and without demur.

The attention paid to Callas should not obscure the quality of the company for, as Christopher Grier wrote, "Exciting and moving as Madame Callas's performance was, she did not swamp her colleagues and the cast was very strong." Besides, the Italians brought a fresh breeze to the Festival. *La Sonnambula* had not been heard in Britain for fifty years, *L'Elisir D'Amore* had the charm of poetry – as well it might since the libretto was written by the poet Felice Romani; and the others added their gaiety.

The following year the Stuttgart State Opera made their first appearance. Comparison with Hamburg's performances in German operas two years previous was inevitable for critics and initially these were to Stuttgart's disadvantage. However, Stuttgart produced two momentous occasions in performances of *Tristan and Isolde*. What Sir Neville Cardus wrote about nationality making itself felt in orchestral performances – he was referring to interpretations of Tchaikovsky by Russian orchestras – may apply to a greater degree to the interpretation of music dramas, where the psychology of human situations is a central issue. The power of Wagner and the monumental character of his dramatis personae relate to some aspects of the German temperament, just as the volatility and eruptive passions of the Latins have specially fitted them for the rapid emotional switches of their opera.

Visitors to the 1958 Festival had the opportunity of comparison

at the King's for in the last week of the Festival there was *La Vida Breve* by De Falla with an entirely Spanish cast, with Victoria de Los Angeles singing Salud. At previous festivals she had sung in chamber concerts always to great effect; her singing had such style, such luminosity, as to make her performances especially memorable and so it was on this occasion. A second opera was included in the programme by De Falla, *El Sombero de Tres Picos*, in which Antonio and his Spanish Ballet Company took part. This was a very Spanish evening.

In the beginning and the end the music alone matters not the origin of the company but its ability and its direction. In 1959 the Royal Opera from Stockholm presented a *Walküre* that was "Impressive and Deeply Moving" according to the headline in *The Scotsman*.

The company also included *Un Ballo in Maschera*, translated into Swedish and re-set in its original historical context at the court of Gustav III, King of Sweden, from which Italian censorship had originally driven Verdi's libretto.

It was, however, the native, modern opera *Aniara* which provided debate. This work, with music by the Swedish composer Blomdahl, is based on Harry Martinson's epic poem about a space-ship bound for Mars. The occupants are emigrants fleeing from a radioactive earth. On the voyage the passengers recall the horrors they have left behind and speculate about their future. One voice, which contains many voices, is an instrument which picks up messages, amongst them being mingled the voices of Hitler, Mussolini and Pasternak. *Musique concrète* and electronic tapes are other components in the voice of Mima, the instrument. Most of the vocal music is traditional, as befits those who originate on earth.

The singing was the more effective in the context of the 'scrambled' sounds from Mima and orchestral music which used serial writing when appropriate. One critic referred to the performance as a "thought provoking experience" and "intensely moving". Christopher Grier raised the question, "Is the deliberate diversity of styles too distracting for the ear which seeks some inner unity of idiom?" and went on to write that it did not worry him. I felt the lack strongly. The absence of a personal style left the mind too free to speculate on the issues. I think it was the kind of opera situation which required a strong controlling idiom, but the Royal Stockholm Opera Company are to be respected for including in their repertoire for the Festival a

new work requiring considerable resources and demanding imaginative attention from the audience. The Royal Opera Stockholm returned to Edinburgh in 1974.

The Royal Opera House, Covent Garden, made its first appearance at the Festival in 1961. It was then entering its fifteenth season. After a career of mixed fortunes and directions it had achieved a deserved reputation. In 1947 Karl Rankl, who had been musical director at Wiesbaden and Prague, and had worked under Weingartner and Klemperer, was appointed to Covent Garden with a view to building and giving direction to the new company. In 1953 he became a conductor of the Scottish National Orchestra. His operatic experience did not appear relevant to his Scottish appointment, nor did Alexander Gibson's, when he was appointed conductor of the Scottish National Orchestra in 1959, he having come from Sadlers Wells. Scottish Opera could not have been dreamed of. The matter is remarked because these appointments implied a predisposition in the direction of opera, and because without the experience of London opera, it is doubtful if, when the opportunity to create Scottish Opera arose, it could have been taken with such well-founded confidence as it was. What is more, while events in the Festival are promoted for themselves, one can never tell what benefits will generate from them.

The policy of the Royal Opera House at Covent Garden led to the formation of a company of dependable singers of quality. There had been doubts about the policy, for the engagement of star performers ensured large audiences, while it appeared that the less spectacular procedure might fail for lack of public support. By the time, however, the Royal Opera had found its way to Edinburgh, it was accommodating 'star' performers within the context of the style of the company. Yet the nature of opera is, for by far the greater part, to delight in spectacular dramatic moments. The performance of the Covent Garden Company struck the right balance in the 1961 Festival. Their performance of *Lucia di Lammermoor* was memorable, but the truly unforgettable moment was the mad scene in which, to sum up all the rave notices, "Joan Sutherland soared to tremendous heights."

The most captivating production was *A Midsummer Night's Dream*, the music by Benjamin Britten, the libretto by Britten and Peter Pears. He came to the music for *The Dream* after setting many English poems. The inheritance of the English countryside

and the literature that sprang from that soil and blossomed from Spenser to Tennyson was his. And Britten's *Dream* caught it all – all the virtue and innocence and good humour and the exquisite delicacies of a faery country from which Britten's ear already heard "elfin echoes". All this was in his *Dream* without losing the robust comedy of the "rude mechanicals". To compose within the limits of 'mere English' and so to delimit the term as to make it the dream of Moscow, to where it went, was the achievement of a great musical imagination. This opera was also the signal for the Festival to embark on an annual Britten opera, culminating in his being featured with Schubert in the 1968 Festival.

In 1962 from the National Theatre of Belgrade came the Belgrade Opera and Ballet. After the gentle quality and pastel shades of Britten's *Dream* the Festival rejoiced in the primary colours of a Slav country where folk customs were put on display at every national occasion. Their opera and ballet drew their strength from the East. *Prince Igor* was the first opera to be seen and with its Russian princes and princesses, boyars, warriors, Polovtsian soldiers and Khans, in addition to a large cast of soloists, the King's Theatre could barely contain the spectacle. *Prince Igor* was followed by the *Love of Three Oranges* by Prokofiev, and it too sported a considerable chorus of "tragedians, comics, simpletons, physicians, courtiers, servants, soldiers and romantics" and a ballet consisting of "harlequins and clowns, knights, monsters, drunkards and devils." *Khovanshchina* by Mussorgsky was another opera, rich in exotics, to be performed. It was as if the legendary Eastern past with all the trimmings had walked straight into the Scottish present without any attenuation by modern processes. The modern music by Prokofiev and by Shostakovich – for Mussorgsky's *Khovanshchina* was in a version by Shostakovich – seemed to be art and part of this past.

The content of the Belgrade Opera Ballet's had similar riches and indeed the heroic legend of *The Four Sons of Aymon* which was let loose at Murrayfield Ice Rink by the Ballet du XXe Siècle from Brussels showed that the organic imagination of the Director of the Festival, Lord Harewood, had been at work. An exhibition of Yugoslav Modern Primitives in the National Gallery of Scotland added to and intensified the colourful, racy experience of this Festival.

'Rediscovering the Roots of Theatre' was the heading of an

article in the Souvenir Programme on *The Four Sons of Aymon*. Exchange the word 'theatre' for 'opera' or 'ballet' and the title would be equally appropriate to the productions from Belgrade, but that the growth and flourish of vivid bloom was also displayed. The terms of reference of an article by John Jardine, the British Council Representative, in Belgrade on the Opera and Ballet, also in the Programme, indicates the special character of Belgrade.

"The Opera is at its best in the Slav operas", he writes.

Its *Prince Igor* with Cangalovic is one of the most exciting to be staged today, and when one sees *Khovanshchina*, also being given in Edinburgh, one wonders why it is so seldom performed elsewhere – perhaps there are few choruses which can do it justice. They have taken to Prokofiev with exhilaration ... The ballet, too, is perhaps happiest when dancing to the Russians, carrying on the inspiration and traditions brought to them by Margaret Froman, Nina Kirsanova, Kniaseff and Romanoff in the early days when there were no ballet schools other than the village greens.

One senses the roots of festival – of music, of poetry, of painting; it is a celebration of the virtue of life, of creation, of The Creation. In the midst of this kind of art was planted a work the opposite in kind, concerned with the betrayal of innocence and therefore with the betrayal of life. I refer to *The Turn of the Screw* by Benjamin Britten, wherein is witnessed the death of innocence by the corruption of evil. There is much beauty and very little sunshine in this opera, and in this it reflects truly the character of the story by Henry James, which provides the plot. Belgrade opera explodes and throws up hundreds of brilliant stars. It is a firework in the sky. But Britten's work was no less compelling – certainly not at the 1962 Festival with Britten conducting some performances and Meredith Davies others, and with a cast headed by Peter Pears and Jennifer Vyvyan as The Governess. But the compulsion was different. *The Turn of the Screw* sucked one into a centre, from which as daylight receded one was made increasingly aware of the fragility of innocence. The opera was presented by The English Opera Group.

The following year The English Opera Group returned with *The Rape of Lucretia* by Britten in which Kerstin Meyer sang the title role – sung originally by Kathleen Ferrier in 1946, at Glyndebourne. The English Opera Group also presented Gay's *Beggar's Opera*, with music realized from the original airs by Benjamin Britten. Three companies, in fact, shared the 1963

Festival. The Budapest Opera and Ballet had the special purpose of contributing a Bartók programme to the series featuring Bartók. The names themselves – *Prince Bluebeard's Castle, The Wooden Prince, The Miraculous Mandarin* – were reminders of the previous year's celebrations. The company that held the centre of the operatic stage was Teatro San Carlo from Naples, and once again the King's Theatre became an Italian opera house. Verdi's *Luisa Miller* opened the proceedings. After the opera-cum-ballet productions of the previous year, the Italians seemed to be saying, "let us return to operatic singing – the gesture in the voice, in accord with the gesture of the body." Their second offering, however, *Adriana Lecouvreur* by Francesco Cilea, ran to spectacle with Amazons and shepherdesses and ballet. Inevitably in the confines of the King's there was constraint on the activity, though there was no restraint in the applause.

Don Pasquale returned opera to more customary paths and Fernando Corena as Don Pasquale and Renato Capecchi as Dr Malatesta were commended particularly for their performances. In his article in the 1963 Souvenir Programme, Harold Rosenthal reminded us of a touching connection with Neapolitan opera. The theatre in Naples had been damaged by bombs. Help in getting the theatre reopened in 1943 was provided by members of the British Forces. From then till the end of the war it it estimated that over one and three quarter million members of the allied forces attended performances at the San Carlo. In May 1946 the bombed foyer was reopened. A plaque on one of the walls commemorates the part the soldiers played in "Keeping alive the flame of its traditions, rising to a new life and entrusting to the wings of song this message which united in brotherhood and hearts of the people of all nations – Naples, May 1944–46."

This reference is outwith the story of opera at the Festival, but in these days when art of quality is often banished from the scene – or given scant attention by the mass media, Press and broadcasting, on the grounds that such works are of minority interest – it is necessary to draw attention to the fact that it is *some* minority, with, one might add, an intensity of interest that far outstrips the transitory enthusiasms or inattentive custom listening of the multitude.

1964 was the year of Janácek, especially in opera, and in works that showed the other side of the mid-European character, operas, penetrated by sorrow, that grew in stature as tragedy deepened. Whereas in German and Italian operas the narrative of

events exercised a controlling interest, Janácek looked for situations whereby sorrow and resistance to despair, courage and humour could be portrayed. *Katya Kabanova*, with which the Opera of the National Theatre of Prague opened at the Festival, is based on the play *The Storm* by Ostrovsky. Like a sudden storm there are outbursts of fury in it followed by passages of great tenderness. Not surprisingly, Dostoevsky stirred Janácek's imagination and the libretto of Janácek's last opera is made from *The Journal from the House of the Dead*. The House of the Dead is a prison for convicts in Siberia. In the episodes which Janácek took from Dostoevsky the prisoners tell of the crimes they have committed, and violence breaks out, frequently followed by spasms of laughter. Into this rough place comes the political prisoner. Against howls and screams – and the music is keyed to extreme pitches of those who are less than human – is put the human quality of the gentle prisoner, and through this character the compassion of Janácek flows to the miserable cast-offs of society. "In every creature a divine spark", he wrote on the score of the opera.

It is music written for humanity's sake, made in a country that was to be very cruelly oppressed not many years after Janácek's death in 1928. This then was the great central contribution of the National Theatre of Prague, central to Janácek, that is to say, for the company also performed the British première of *Dalibor* by Smetana, the British première of *Resurrection*, an opera by Jan Cikker based on the novel by Tolstoy, and the charming fairy tale opera *Rusalka*, by Dvorák. They opened with this smiling work.

The operas that followed reminded audiences of the greatness of Czech opera. This kind of music, perhaps to some extent all great music, has behind it the impetus of a community. The community, in the case of the National Theatre of Prague, as the name implies, was the nation. "The life of the Czech people lies in music", said Smetana. Today his words are borne out by the strength and quality of the National Theatre which has two independent orchestras, two choirs, a large corps de ballet – also independent – and some seventy soloists, along with the corresponding number of conductors, producers and stage designers. About five hundred productions of more than fifty operas are given each year, and of these roughly half are reserved for Czech works.

I have taken the information from an article by Pavel Eckstein

in the Souvenir Programme of 1964. It is a formidable effort for a small nation to put into theatrical art, but the reward is the expression of the true glory of the nation, a glory in which Edinburgh shared in 1964, through the operas and other Czech performances. The National Theatre from Prague returned in 1970. Again works by Janácek made their peculiar impact. Gerald Larner in the *Guardian* referred to "a fine performance" of *The Makropoulis Affair* and went on to remark, "It is a splendid example of creative economy. Though the details of the dispute over the will are not easy for an English audience to grasp, the shape and structure of the work have their own powerful effect."

Janácek's operas are embedded in social realities so that when they run to fantasy they retain the urgency of actual experience, so that delightful country life piece *The Cunning Little Vixen*, with its amusing animal impersonations, is far removed from the superficial whimsy of a Disney cartoon. The National Theatre also performed two Smetana operas, *The Bartered Bride* and *Dalibor*, previously presented in Edinburgh in 1964, each in appropriate contrasting styles. The former flowed in an easy vernacular style; the latter was monumental and static.

The opera in 1965 was more of a mixed bag than that of the previous year, with a mixture of nationalities evident in the productions of *Don Giovanni* and Haydn's *Le Pescatrici*, in which the Edinburgh Festival Society collaborated with the Holland Festival. In these operas the Netherlands Chamber Choir joined with the New Philharmonia Orchestra to support distinguished principals. The English Opera Group returned to present Britten's *Albert Herring*.

The greatest interest was in the first appearance of the Bavarian State Opera from Munich, which has specialized in the production of operas by Richard Strauss since 1952. In 1964, the centenary of Strauss's birth, the company presented twelve of his operas at the annual festival in Munich. One of these, *Intermezzo*, was given its first stage performance in Britain at the 1965 Festival – and a delightful occasion it turned out to be. The critics had more reservations about the second visit to the Festival of the Stuttgart State Opera in 1966 than they had in 1958, but these were not entirely due to faults in the company. On the earlier occasion Edinburgh, even then, was seeking an opera house other than the King's. Eight years later the King's was still the same size and the companies were torn between made-down versions of large-scale operas or presenting operas

simply because they fitted into the limited accommodation. There was the case of the great romantic opera *Lohengrin*, static for the most part but there are combats in it, and it requires considerable forces. The forces were there, but they looked congested. When in full voice we could forget the congestion – and after all the oratorio elements are to the fore in *Lohengrin* – but it was difficult to make visually impressive, and it may well be that some of the criticism directed against Wieland Wagner, grandson of the composer, by the critics because it was too static, were unfair since the visual scale could not be realized.

At any rate when the company presented *Wozzeck* by Berg there were no reservations about its success. "This", said Ernest Bradbury in a broadcast in 'Arts Review',

> had all the swift, incisive and bitter purpose that we expect from a setting of Buchner's bitter play, which was written, fantastically as early as 1836. On the surface it's a tale of callousness, oppression and sordid infidelity. Beneath, it pulses with compassion for downtrodden humanity. And it's this mood that is so marvellously underlined by Alban Berg's music.

In this production music and drama became one thing. The atmosphere of threat, pending disaster, and swift movement was admirably realized in the sets, in the stage management, in the appearance of the characters, and in the singing. It was one of the finest Günther Rennert Productions. There was similar praise for the production of another opera by Berg, *Lulu*, the producer and designer being Wieland Wagner.

1967 was the most memorable year for opera as far as Scotland was concerned for it was at this twenty-first Festival that an international audience was introduced to Scottish Opera. This is not the place to tell how Scottish Opera came about, though before I come to its place in the Festival and the importance of the Opera in Scotland, the great debt to Alexander Gibson, its only true begetter, must be acknowledged. Alas, the characteristic of too many Scottish ventures in the Arts has been that they have gone off at half cock and that they have set their sights too low while proclaiming their great consequence. The style, procedures and achievement of Scottish Opera from its first performance proclaimed that it knew its objectives and that certain of those had been realized when the first note was sung. But praise comes better from south of the Border.

Peter Heyworth, in his article 'Scottish Opera Arrives' in the Festival Souvenir Programme, reckoned that in the history of

opera in Britain, 1963, the date when Scottish Opera was launched, is as important as 1934, the date of the foundation of Glyndebourne. No more need be said on that score. The article continues:

The first and most obvious merit of Scottish Opera is that it provides performances on a high general level of a remarkably wide and boldly chosen range of works in a part of the world that until recently has enjoyed less than its fair share of these pleasures. Clearly the most important thing about Scottish Opera is what it does for Scottish life. But its achievements are of far more than regional significance. To put it baldly, opera in Britain will only thrive when it has put down secure local roots, and here Scotland, together with Wales, has led the rest of the country.

By opera in Britain I don't mean merely the provision of operatic performances, but the development of our singers, producers, conductors and – not least – composers. Scottish Opera is ... likely to play an increasingly crucial role at Edinburgh ... The array of competing festivals is now manifestly putting such a strain on available resources, that it is not always easy for the Festival Director to lay his hands on the productions he wants, and this is a difficulty that is likely to grow more rather than less pressing in the coming years.

It is here that remarkable progress made by Scottish Opera under Alexander Gibson has opened up an opportunity that Peter Diamand has been quick to seize. For the first time in recorded history there is in Scotland a company capable of putting on operatic productions on a level that is compatible with Edinburgh's artistic aims, and as a result 1967 sees Scottish Opera's debut at the Festival with a new production of Stravinsky's *The Rake's Progress*. This invitation to appear at a Festival whose standards are international is not a mere doffing of the hat at the altar of nationalism. It has been earned by what the company has already achieved.

Scottish Opera opened at the Festival with *The Rake's Progress*. "This", said Christopher Grier,

was a capital choice on several counts. Because it is an important and enjoyable opera of the 20th century; because it is by Stravinsky; because it happens to fit comfortably into the King's Theatre – that was proved many years ago when Glyndebourne produced it in Edinburgh; because it is essentially an ensemble opera rather than a vocal trampoline for a few star singers. This last point is vital for the success of Scottish Opera, like that of Sadler's Wells, is based on team work and a sort of communal zest.

Moira Shearer, Robert Helpmann and Terence Longdon in Stravinsky's *The Soldier's Tale* in 1954

Janet Baker as Dido in Scottish Opera's production of *The Trojans*
at the 1972 Festival

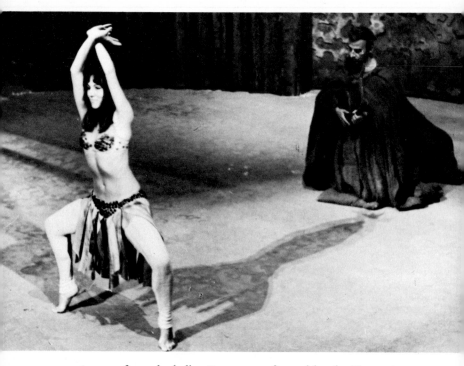

A scene from the ballet *Spartacus* performed by the Hungarian
State Ballet at the 1973 Festival

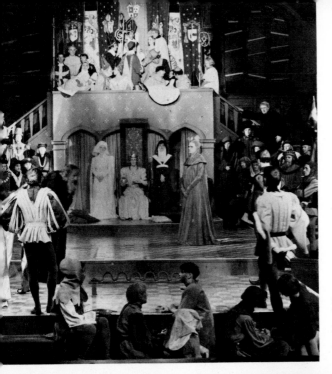

The Thrie Estaites,
as directed by
Tyrone Guthrie
in 1948 (*left*) and
Bill Bryden in
1973 (*below*)

Eileen Herlie as Medea in
John Gielgud's production
of the Euripides play at
the 1948 Festival

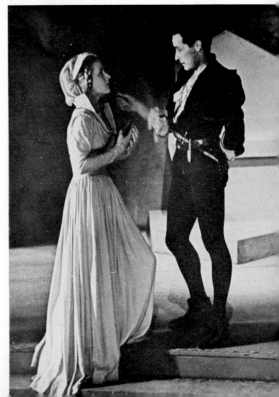

Eleonore Hirt as Ophelia
and Jean-Louis Barrault
as Hamlet in the French
version of Shakespeare's
tragedy at the
1948 Festival

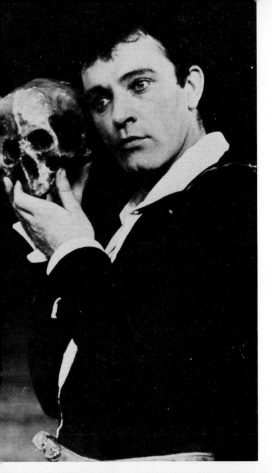

Richard Burton as Hamlet
and Fay Compton as
Queen Gertrude, in the
Old Vic production of
Hamlet for the 1953
Festival

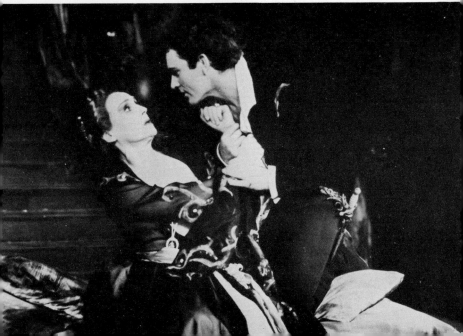

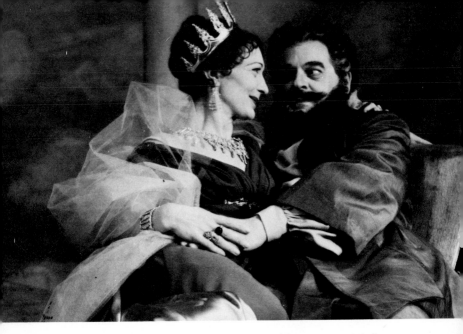

Sonia Dresdel and Walter Fitzgerald in James Bridie's
The Queen's Comedy in 1950

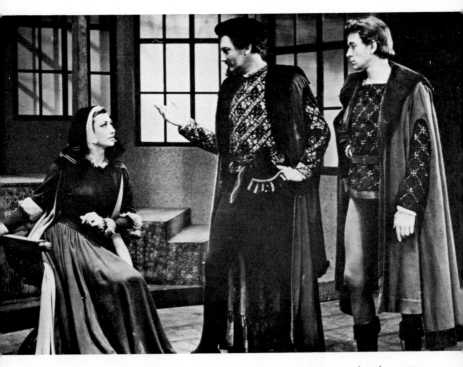

Heather Stannard, Andrew Faulds and Tony Britton in *The Player King*
by Christopher Hassall, which had its premiere at the 1952 Festival

Paul Rogers and Isabel Jeans in T. S. Eliot's *The Confidential Clerk*
in the 1953 Festival

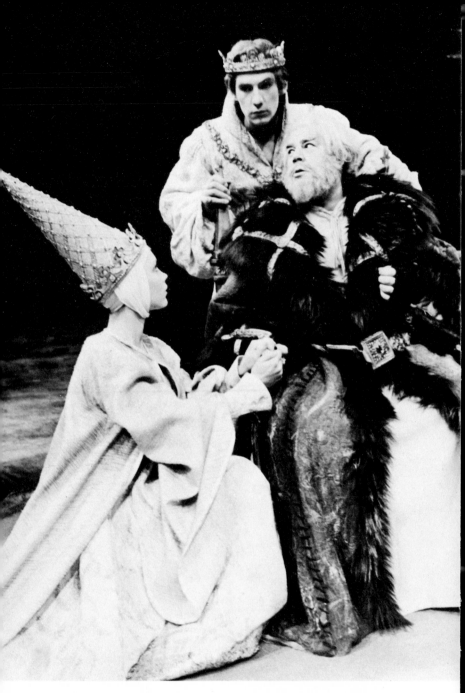

Ian McKellen, who made his name as Richard II with The
Prospect Theatre in 1969

The review ended with the remark: "The chorus work was first rate, the orchestral playing crisp and alert."

The reference to the chorus work draws attention again to the splendid contribution of Arthur Oldham, the Chorus Master. Scottish Opera also presented successfully at the Assembly Hall Stravinsky's *The Soldier's Tale*. While I defer to others with a less vested interest in Scottish Opera, I cannot refrain from applying one word to the chorus and to the production of *The Rake's Progress* and to several other productions – impact. An air of decision and direction, over and above the high quality of the singing, has been one of the marks of the company. The purpose of the work is recognized and then the full force of musical intelligence has been bent to the realization of the given end. In other operatic works of the 1967 Festival, which were presented under the title Edinburgh Festival Opera, Bellini's *I Capuleti ed i Montecchi* and *Orfeo ed Euridice* by Haydn, the Scottish Opera Chorus was warmly praised for its contributions by the music critics.

To the 1968 Festival, Scottish Opera contributed *Peter Grimes*, Benjamin Britten being one of the two composers featured in that Festival. In 1970 they undertook the more adventurous task of presenting *Elegy for Young Lovers* by Henze. The composer produced the opera and the scenery was designed by Ralph Koltai. The conductor was Alexander Gibson. I mention the three names because whatever the verdict of posterity on this strange and mysterious work with its combination of illusion and realism, its presentation as a single experience – the harmonizing of lighting and set, the movement of figures on the stage, and the music enveloping all was a delicate achievement.

In the previous year, 1969, the opera came, properly, from Florence, for this Festival was focused on Italy. The visit of the Teatro Communale from Florence in 1969 demands recognition even though every opera in their repertoire at the Festival was not rapturously received. Malcolm Rayment, in the *Glasgow Herald*, while praising the company for allowing the Edinburgh audience to see Malipiero's *Sette Canzoni* on a stage for the first time in Britain, took exception to the quality of the singing. He had reservations also about the success of *Il Prigioniero* by Dallapiccola, but Florentine opera had its triumphs. Donizetti's *Maria Stuarda* made a powerful impression. Lelya Gencer's performance of Mary Stuart and Shirley Verrett's of Elizabeth were agreed as very distinguished. But it was the arrival of Tito

Gobbi as producer and singer in *Gianni Schicci* by Puccini that gave another historic moment to the Festival.

The tale of the avaricious relatives waiting for the death of the old man and their attempts to circumvent the terms of the will, which is to their disadvantage, is as old as human nature. Domiciled in Italy it is pervaded by the sense of place and natural oddity. To this place and situation Tito Gobbi as Gianni Schicci brought the shabbiest and most lovable rascal who was apparently willing to solve everyone's problems. Vocally and visually he became the part.

In Scotland we have many such tales. We have a rich vernacular speech, a high sense of the ridiculous, but we have no musical idiom to take account of the tales. And so, *pace* Scottish Opera, we have no Scottish Opera and cannot have until we write ourselves large in song. Our composers have tried. There have been operas recently by Iain Hamilton and Thea Musgrave. As was perhaps inevitable, Hamilton's *The Catiline Conspiracy* bore no relation in its idiom to his birthplace. When the subject matter is traditional Scottish, as is Thomas Wilson's opera, which is based on James Hogg's *Confessions of a Justified Sinner*, factors come into play which would seem to demand recognition of peculiarly Scottish characters in the idiom of the music. The first performance of the work has not been given at the time of writing.

Although, to the present date, no Scottish opera has been presented in the Festival, Scottish Opera has continued to play an increasingly important part in the programmes. To the Festival's twenty-fifth anniversary, 1971, for which a brilliant operatic bill ws provided, Scottish Opera made a major contribution. Handicapped as was the company's production of *Die Walküre* by the limited size of the stage of the King's Theatre, the performances of Charles Craig as Siegmund, David Ward as Wotan and Helga Dernesch as Brunnhilde, aided by other good performances of William McCue as Hunding and Leonore Kirchstein as Sieglinde and admirably supported by the Scottish National Orchestra under their conductor, Alexander Gibson, gave the opera the true Wagnerian scale. The following year the same handicap, but more severe, met Scottish Opera when it undertook the very arduous *The Trojans* by Berlioz.

Whereas the conveying of the idea of large scale through visual means is consequential to Wagner, *The Trojans* simply requires accommodation, for, in addition to a considerable

number of soloists, it demands a ballet company and a wooden horse. The 18½ feet high wooden horse had made its first appearance at the King's Theatre in Glasgow in 1969, when Scottish Opera gave the world première of the uncut Berlioz opera. No matter what the facilities, the production of *The Trojans* is an enormous and hazardous undertaking, about which there had been so much doubt that cut versions only were presented for many years, even in Berlioz's centenary year in the production in Paris. Of Hector Berlioz, Gounod wrote: "On peut dire de lui, comme de son heroique homonyme, qu'il a peri sur les murs de Troie." The first production in Britain in English, in 1935, was staged in Glasgow, under the direction of the venturesome Erik Chisholm. This he did with amateur forces. Then in the fifties John Gielgud was the producer in the Covent Garden version. This was acclaimed, but the production of Scottish Opera in Glasgow in 1969, conducted by Alexander Gibson and produced by Peter Ebert, revealed, possibly for the first time, the majesty and the richness of the work. Of this production Frank Spedding said in a broadcast:

> Alexander Gibson's reading of this vast score had a sustained vitality and control which command unstinted admiration; and there is no doubt, either, that in Arthur Oldham, Scottish Opera has a phenomenal chorus-master ... For Janet Baker's performance as Dido only the word 'great' will do, and there are surely not many performances of this stature to be encountered in a lifetime.

The tribute applies equally to the production at the Edinburgh Festival in 1972, in which Janet Baker gave another 'great' performance in this, the same uncut version, which ran for nearly six hours – including a necessary long interval. There were changes in major solo roles. Cassandra, sung with great conviction in Glasgow by Ann Howard, was sung by Helga Dernesch, who properly dominated the first act. Aeneas, another key part, successfully sung by Ronald Dowd in Glasgow, was sung in Edinburgh by Gregory Dempsey. However, one other significant member of the cast was the same – the wooden horse of Troy. After Glasgow it went to Augsburg for Peter Ebert's German version of *The Trojans* – a similar production to the Glasgow one, and then back to Scotland, to stand successfully 18½ feet tall on the stage of the King's Theatre. (In Glasgow on its first appearance it went through the floor boards.)

Two years later, in 1974, Scottish Opera returned to the

Festival with *Alceste* by Gluck. The production in its delicacy and colour was a reminder that the Company had made its name in the interpretation of operas with the fluency and formality of Mozart. Elegant, happy and beautiful — Alceste was that. There was rare singing of the difficult role by the young Romanian soprano, Julia Varady. The part had been offered to Janet Baker and when she felt unable to undertake it there was disappointment. This was unnecessary, for Julia Varady acted as well as she sang, matching the gesture of the voice with appropriate movements. Her seriousness, with an equally serious interpretation of Admetus by Robert Tear, carried belief, sometimes where credibility was strained as when a large, but somewhat podgy, Hercules made his entry. As with *The Trojans*, the Scottish Opera Chorus had a decisive, thrilling effect. The Scottish Theatre Ballet did what they could in a too restricted space on the King's Theatre stage.

One agreeable aspect of the abilities of the Scottish Opera Chorus — as with the Edinburgh Festival Chorus — is its availability for projects which involve a combination of operatic resources. Thus in 1971, the year of the prodigal operatic bill, Edinburgh Festival Opera collaborated with Maggio Musicale Fiorentino to produce Rossini's *La Cenerentola*. Under the baton of Claudio Abbado were the London Symphony Orchestra, the Scottish Opera Chorus, and soloists of the highest calibre, including Renato Capecchi as Dandini, Teresa Berganza as Angelina, Luigi Alva as Don Ramiro, and Paolo Montarsolo as Don Magnifico. It was a sparkling affair. But 1971 was also the year of two productions by Deutsche Oper, Berlin, *Melusine* by Aribert Reimann and *Die Entführung aus dem Serail* by Mozart. The policy of Deutsche Oper has been, at least since 1961 when the company took over its new opera house, to select its casts entirely on merit and appropriateness for the parts without respect for the origins of the singers. The policy may to some extent have been a reaction against the subjection to the German nationalism suffered by the company during the Hitler régime. At least it is a guarantee of high quality and a disinterestedness on behalf of music.

The comment is not intended to imply restrictive policies in other German opera companies. In 1972 Deutsche Oper am Rhein brought to Edinburgh *Rappresentazione di Anima e di Corpo*, by de Cavalieri. While Scottish Opera was presenting its first performance of *The Trojans* on 24 August in the King's Theatre to a full house (booked out from the first day of ticket sales),

Deutsche Oper am Rhein was presenting its first performance to a large audience in St Mary's Cathedral of an equally remarkable work. This allegory of the journey of man displays him in his vanity and humility, in the pleasures of life and in mortification. The processions of the hierarchy of the clergy, the dancing, in the dance of courtship of natural man, the subjecting of man and woman to temptation and the possibilities of bliss and damnation, are portrayed and sung, so that the audience feels involved in a dialogue of life and death. The costumes were beautiful and meaningful for they told of the butterfly in its momentary enjoyment and of the skull beneath the skin. Alberto Erede conducted the Bochum Symphony Orchestra, a Corps de Ballet from Deutsche Oper danced, and an international cast presented the allegorical figures. The singing and dancing belonged to a different order of experience from *The Trojans*. It was a different astonishment.

The same company showed its quality in the more conventional opera of *Die Soldaten* by Zimmermann. William Mann, in an article in the Souvenir Programme, remarks on the "most enviable operatic repertory of any company known to me in the world." He explains how this was possible for the Deutsche Oper am Rhein, first because it is a collaboration of the two cities Dusseldorf and Duisburg, and second because they have built up an effective repertory company of singers to which are added distinguished soloists from elsewhere when required.

There were also performed in 1972 by Teatro Massimo, Palermo, *Attila* by Verdi, *Elisabetta, Regina d'Inghilterra* by Rossini, and *La Straniera* by Bellini. Having remarked that 1971 was a vintage year for opera at the Festival, one is in some difficulty to find a year which is not memorable. In 1973, in the absence in London of Scottish Opera, the Festival had recourse to a bringing together of many talents, under the title Edinburgh Festival Opera, in *Don Giovanni*. The conjunction of Peter Ustinov as Producer/Designer and Daniel Barenboim as Conductor was adventurous. The cast, with Roger Soyer as the Don, Geraint Evans as Leporello, Luigi Alva as Don Ottavio, Heather Harper as Donna Elvira, Alberto Rinaldi as Masetto, Peter Lagger as the Commendatore, and Antigone Sgourda as Donna Anna, was very strong, but what would Ustinov do to Mozart, and was it wise to allow Daniel Barenboim, inexperienced in opera, to try his hand in the Edinburgh Festival's first operatic production *da solo*?

In the *Guardian* Gerald Larner wrote:

The Edinburgh Festival has staked a lot on mounting its own production of *Don Giovanni* – a lot of money and a lot of reputation too. Peter Diamand and his colleagues would look rather silly, if, after all the controversial years of buying operatic productions from elsewhere, they themselves could do no better at far greater expense. Was the festival director wise in appointing Daniel Barenboim, who has never worked in opera before, as conductor? And was it commercial or artistic instinct that led him to engage Peter Ustinov as director and designer?

At the first performance on Monday the musical events can only have enhanced Edinburgh's reputation. In fact, there has rarely been such a well-prepared musical performance at the King's Theatre.

This Festival also heard Benjamin Britten's *Death in Venice*, which was also acclaimed: "Britten's new opera – his most painful, resourceful expression of sophisticated passion and many-layered surrender – has come to Edinburgh for two performances", wrote Gillian Widdicombe in *The Financial Times*.

A shame that only two were feasible, for *Death in Venice* is one of those superficially ambiguous, complex operas demanding and deserving time and thought for just appreciation. It does not seek to stun, as did the *War Requiem* or shock, as Tippett did in *The Knot Garden*; and has nothing at all in common with the shallow pretty-picture world of Visconti's film of the same name; its theatrical power is far removed from the world of grand climax, finger-tip lyricism, blatant emotions.

But that ironic, restrained theatrical power is enhanced, if anything, by the transfer of the English Opera Group's excellent production from the open stage of The Maltings to the intimate surroundings of the King's Theatre . . . the small theatre allows the singers to communicate without strain those passages of half-knowing, half-innocent suggestion . . . led by a truly great performance by Peter Pears as Aschenbach, haunting ones of his many sinister roles by John Shirley Quirk, and fine playing by the English Chamber Orchestra conducted by Steuart Bedford.

For the inward look of psychological drama the intimacy of the small stage and auditorium of the King's Theatre had its advantage, but for the more characteristic operas, extrovert and rejoicing in display, the conditions on stage had to be overcome. The Hungarian State Opera and Ballet Company, which made up the complement of performers at the King's in 1973, brought to Edinburgh the passion, colour, and elation one has come to expect from eastern and southern Europe, where folk elements

energize their arts. Szokolay's *Blood Wedding*, based on Lorca's tragic drama, was well staged and sung with intensity. In Bartók's *Bluebeard's Castle*, the other operatic contribution, the production and design put a strong emphasis on the symbolic aspects of Bartók's opera to the disadvantage of the drama. There were, of course, no problems of staging, but the ballet *The Miraculous Mandarin*, which followed the one-act opera, required for the happy realization of this inventive production more width and depth than the King's stage provided. Nevertheless the verve and sense of mystery was conveyed. It was an exciting evening.

1974 demanded more adjustments to the limitations of the stage by the Royal Opera, Stockholm, the sole visiting company that year, than one had any right to expect, yet so ingenious was the production that the considerable handicap seemed at one point in the opera, *Jenufa*, to have become an advantage. There not being room on stage for the set, the chorus, dancers and principals, additional staging had been built which projected into the auditorium over the heads of part of the orchestra. On this peninsula some of the very touching moments were enacted. Here Elisabeth Söderström as Jenufa commiserated over her unhappy love affair, while the companionable world of soldiers and workers bustled on the main stage. Elisabeth Söderström was splendid, acting and singing so that she created a credible person. But the whole production of Janácek's opera worked to this effect – acting and singing seemingly natural, and not in any way less so by its transmutation into a Swedish opera.

The performance of Richard Strauss's *Elektra* marked the return to Edinburgh in a major role of Birgit Nilsson. In 1959 she sang Brunhilde. In 1974 her *Elektra* in its pathos and terror took command of the house. She rose above the sonorous orchestra, which with singers made one too aware of the enclosed space of the King's. But this presentation was true tempestuous theatre, Greek tragedy writ large as fierce, dangerous women strode the stage. As Klytemnestra, Barbro Ericson was melodramatic, and yet right. The scale of the tragedy is large, the great doors and angular set suggested the inhumanity of the principal characters, yet within this scope, dialogues were set going in which humanity appeared – as in the duets between Chrysothemus (Berit Lindholm made much of the role) and Elektra, and again at the great moment of recognition, when Orestes meets Elektra Erik Saeden looked, and bore

himself, as if years and weather had worn him. He belonged in vocal attributes as well, like the women, to those fated by the gods. The conductor was Berislav Klobucar, the producer Ann-Margret Pettersson, per production being based on Rudolph Hartmann's original.

As if to show they were capable of more agreeable, less intense effects, Royal Swedish Opera presented smoothly and elegantly Handel's *Il Pastor Fido*.

In twenty-eight Festival seasons Edinburgh has entertained such a range of companies and nationalities in opera, has seen such developments and successes, as could never have been imagined at the first Festival in 1947. There remains one necessity – the new opera house.

8

Ballet

For seven years of the first decade of the Edinburgh Festival, Sadlers Wells provided the central ballet contribution. In the first year with Constant Lambert as Musical Director, Margot Fonteyn and Frederick Ashton as principal dancers, choreography by Nicolai Sergüeff, the Designer Oliver Messel and Ninette de Valois as Director, it was surely right to offer at the Empire Theatre a dream ballet. Sadlers Wells ballet opened with *The Sleeping Beauty*. The following year with Robert Helpmann and Massine in the company as choreographers the repertoire was considerably extended, paying a token of respect to Scotland in the presentation of *Miracle in the Gorbals* and reaching into another area in the production of *Job*. To the uninstructed layman, what tends to remain from the earliest ballet at the Festival is the sensation of an exquisite evanescence. *Les Sylphides, Le Lac des Cygnes*, first shown at the Festival in 1949 by Les Ballets des Champs-Elysées, float in the mind. In fact this is an incorrect recollection for Sadlers Wells Ballet, the resident company and Sadlers Wells Theatre Ballet presented programmes of great diversity.

One of the objects of the formation of the Sadlers Wells Theatre Ballet was to seek out new choreographers. One of these was John Cranko. Two contrasting works by him were seen at the 1952 Festival – the gay *Pineapple Poll* and the grim *Sea Change*, the designer of the latter being John Piper. In 1952 the repertoire included *The Rake's Progress*, the music by Stravinsky, and *Blood Wedding*, based on Lorca's drama. Elements of guilt and ritual were increasingly present. After so much innocence the experience was salutary.

On the occasion of the tenth anniversary of the Festival a rich, varied and high quality of diet was provided by Sadlers Wells Ballet. In the last week of the Festival a new element was introduced – The Ram Gopal Indian Ballet, whose repertoire

included classical and folk dances. The content of Sadlers Wells
suggested how far the company had taken account of the
increasing range of interest in ballet of Festival audiences. In the
1952 company was a young Scot, Kenneth Macmillan. By 1956
his work as choreographer was attracting critical attention. The
article on ballet in the Souvenir Programme of the tenth Festival
commented:

> Noctambules, the third major ballet of Kenneth Macmillan (who was
> born in Dunfermline) is likely to be the most contentious work of
> ballet presented during all the Festivals to date. His skill and
> invention as a choreographer have put him head and shoulders
> above contemporaries of the same generation. His is an original
> talent such as the English system of ballet rarely throws up, and
> Noctambules with its nightmare atmosphere, its riotously impressive
> score by Humphrey Searle and Nicholas Georgiadis' weirdly
> fantastic settings gives opportunities to a whole handful of young
> dancers to create remarkable and unusual characters.

With others, I confess I found Noctambules more impressive than
contentious.

The programme at the Festival which Sadlers Wells may wish
most to be remembered, and the wish was true for many, was
given in 1954, on the occasion of the twenty-fifth anniversary of
the death of Diaghilev. It was entitled Homage to Diaghilev and it
consisted of Le Tricorne, the choreography by Massine, Fokine's
L'Oiseau de Feu, and Massine's La Boutique Fantasque. A
demonstration of the dance was given by an array of noted
dancers – several of them young dancers – as a testimonial to the
great master without whom it is doubtful if ballet in Western
Europe would have developed. It was a testimonial worthy of
Diaghilev. Dame Ninette de Valois wrote of him in the Souvenir
Programme of 1954:

> I think that today's homage to his monumental achievement during
> the first quarter of the century may serve as a timely reminder and
> have a stimulating effect on us all for a long time to come. In the last
> twenty-five years England has had to concern herself with every
> fundamental aspect of the classical ballet. This of course was not
> ever a problem of the Diaghilev Ballet; the birth of his branch of
> the Russian Ballet was made possible in substance by the work of a
> great ballet tradition of Russia's own making. But it would seem
> that every art must renew itself in some form of rebirth, and this
> Diaghilev most surely achieved for the traditional ballet of Russia.
> One day, such a moment in history may well be ours, and a 'rebirth'

will spring from our own tradition. May we hope and pray that this will happen under the guidance of someone whose genius will be akin to that of Serge Diaghilev.

The special contribution of Sadlers Wells was to make Festival audiences acquainted with classical ballet tradition and modern variants on it. But the idea that a rebirth could be possible from within the tradition, or any variants on it, seems to me to fail to understand the necessity of relating the art to the changing structure of society. Without some such association, ballet will not take into itself the concerns of society, and if it does not do that the dream will be a fading one.

The experience in the dance which the Festival provided in the second decade bears out this point. In the first decade of the Festival the sense of there being a rebirth arose from such ballets as Macmillan's *Blood Wedding* and *The Rake's Progress*, but most strongly from certain of the ballets of Les Champs-Elysées Company in 1949, whose Artistic Director, Boris Kochno, had worked alongside Diaghilev and who had won the support of the finest artists in Paris, among them Cocteau.

On *Le Jeune Homme et la Mort* Arnold Haskell commented in the Souvenir Programme of 1949: "What can one write of Cocteau's 'shocking', deliberately shocking, modern tragedy, danced to Bach's Passacaglia in C? The nobility of the music and the squalor of the tragedy contrast and then meet in a moving apotheosis." Arnold Haskell was impressed by the variety of modern ballets and the choreography of them presented by this young company. "These were", he wrote, "truly the shock troops of contemporary ballet."

There was indeed a vivid fiery life at work in Les Ballets de Champs-Elysées that was allied to that sophistication which allowed the retention of 'classical' ballet while extending its vocabulary to take account of contemporary attitudes in society. One was the more aware of this sophistication after the visit to the 1951 Festival of The Yugoslav Ballet. What captivated in their case was the vigour and athleticism of the male dancers. They were male dancers without the apparent refinements of the French or English companies. They registered their strongest effects in their variants on their native folk dances. Joyous as were some of the 'folk' ballets, they did indicate the limitations of the vocabulary of dances confined to expressing modes of life of peasant societies.

The visit of the American National Ballet Theatre in 1950 had

pointed a way to developing an art which, while based on classical ballet initially, began to absorb American subjects into the dance. It was not a socially committed dance that they sought to develop, but the company was interested in catching the tone and the gestures that related to American customs. As Charles Payne stated in the Souvenir Programme: "When American artists began to create, their works were in the classic tradition but were distinguished by an unmistakably American flavour. Eugene Loring's choreography for *Billy the Kid*, Leonard Bernstein's score for *Fancy Free*, and Oliver Smith's scenery for *Fall River Legend* for example, were as American as baseball or the fourth of July." The company in *Fall River Legend* and *Fancy Free* did express the innocent confidence in American society which has been severely shaken since then.

Within the first decade of the Festival one dance company, the Azuma Kabuki, caused a reappraisal of the idea of ballet entertainment. This Japanese company, whose style and dance interests were based on the Kabuki Theatre of Tokyo, demanded an appreciation of slow, detailed bodily movement which led to a pose. Beautifully costumed and with stories to tell, the exposition of the Kabuki tradition witnessed to formalities that had found the right groupings, movement and order over a period of 300 years. It was this aspect of the dance, I believe, which made its more lasting effect. The great skill of the company, which was directed by Masaya Fujima with whom was associated his wife Tokuho Azuma, gave the impression of having grown inevitably out of social custom. Tokuho Azuma had, in fact, inherited the Azuma School of Dancing from her father Uzaemon XV, a famous dancer–actor. He was what would be called in Scotland the head of the clan, Ichimura, which traced its beginning to the early days of Kabuki.

The visit of the Azuma Kabuki in 1955 may now be related to the performances of Noh in 1972 by the Hosho Noh Company from Tokyo. Both arts, dance and drama, by a rigorous formality, while being born of feudal or hierarchical society, expressed unchanging human situations and relationships. Herein was their perennial attraction.

The Royal Danish Ballet also paid their first visit to the Festival in 1955, so that a comparison between the inheritors of the two very different traditions was possible. The Danish company is the second oldest ballet company in the world. Two ballets of the repertoire, *Napoli* and *La Sylphide*, were presented as originally

produced a hundred years previously. *La Sylphide* gave the rare opportunity of seeing the romantic image of the Scots translated into ballet, from the impression of Scottish character which Sir Walter Scott's novels had made on Europe. What, in the twentieth century when presented anew on the stage, is shown as banal, maudlin and vulgar, appeared charming, fresh and delicate.

Yet fascinating as was *La Sylphide*, the achievement of *Romeo and Juliet* in the production of Frederick Ashton was remarkable. In the Souvenir Programme for 1955, Sir Frederick Ashton wrote:

> I have great respect for tradition in ballet, and believe that all progress must be based on our noble and classical principles of dancing technique which have been laid down for us by the great ballet masters of the past in a more unhurried age, but these principles cannot remain stagnant; they must be enriched by the individuality and personal approach of the choreographer and dancer... No ballet company has a solid basis without the traditions of its old ballets presented with care and respect.

This was the point of beginning of Ashton's choreography in *Romeo and Juliet*, but he brought to his production his affection for the lyric grace of Shakespeare's play, and he used to great advantage the robust dancing of the Danes. The combination of these qualities gave a new strength and vitality to a ballet which has sometimes lacked these qualities in English productions, which have given much attention to the idea of the romantic dream.

Ballet opened strongly in the second decade of the Festival with three companies. The Grand Ballet du Marquis de Cuevas returned, giving a first performance in Britain of the *Song of Unending Sorrow*; there were also the Royal Swedish Ballet and Les Ballets Africains de Keita Fodeba, which brought a new rhythm to the ballet scene. The names of their ballets tell that tale – *Call of the Tom Tom, The Water Carriers, Cultivation, Lions and Panthers, Market Scene*. Here was a move to another source of human culture. 1958 provided the opposite experience when the Festival Society presented twelve specially commissioned ballets. It was an adventurous and interesting experiment, a display of quality and invention that ranged from the most delicate sensibility to an interest in the mathematics of design and movement. *Secrets* brought together the choreography of John Cranko and the music of Alban Berg, *Dreams* – Dmitri Parlac

and Alban Berg, *La Belle Dame sans Merci* – Andrée Howard and Alexander Goehr whose experiments were to create controversy in later Festivals.

In 1959 Ballet continued strongly. The National Ballet of Finland was the main provider of classical ballet along with Les Ballets Babilée, but it was the contribution of Jerome Robbins's 'Ballet U.S.A.' that revitalized the art. Here experiment was the outcome of necessity. *Moves*, a ballet in silence, created such a strong visual concentration that one felt a dimension had been added instead of one having been removed. The sense of the theme mattering above all came through so markedly that the manner of the performance became a bi-product. The title *N.Y. Export – Op Jazz* defined the style and the intention. America got into the ballet from the beginning.

When arms reached up to the skies, they were skies hung with trumpets. The design was by the American artist Ben Shann, an artist very conscious of the social condition of the United States. But realism was not confined to the American company. One of the more memorable occasions of the 1959 Festival was Jean Babilée in *Le Jeune Homme et la Mort*. The image of the young man hanging in the moment of death in the shabby room remains over the years.

The 'sixties were more variable in the strength of the ballet. The high standard, however, of 1959 was maintained in the Royal Ballet with Ninette de Valois as Director and Frederick Ashton as Associate Director and Principal Choreographer. In that year there was a wide range of interest. Besides the Royal Ballet, there were Susana y José from Madrid, the Little Ballet Troupe from Bombay and the Ballets Européens de Nervi. The provision for Ballet in 1961 was less generous but significant. Elizabeth West brought her Western Theatre Ballet to the Empire Theatre for the first time. All ballet, of course, requires devotion, but there was something so dedicated and so fresh about her young company – they had triumphed over difficulties – that I sought her out and interviewed her for my radio programme, 'Scottish Life and Letters'. I recollect thinking that there was not much connection between Western Ballet and my Scottish programme, but I wondered if in the future there might be in Scotland a fully professional company run on the lines of Western Ballet. Through the training of Marjorie Middleton in Edinburgh and Margaret Morris in Glasgow, Scotland had provided dancers of ability to the major London

companies. I did not know that not long after the tragic death of Elizabeth West, her Ballet company would become Scottish Ballet. One dance from the 1961 programme made a particular impact – *The Seven Deadly Sins* by Brecht with music by Kurt Weill.

If from this year onwards there were fewer companies at the Festival in any single year, the range of balletic interest increased. In 1962 there was a second visit from a ballet company in Yugoslavia (the first was in 1951), the Belgrade Opera Ballet. It presented a repertoire which showed the influence of Russian ballet, though the Slav roots in folk dance were evident. The repertoire included *The Miraculous Mandarin*. In 1963 Budapest Opera Ballet presented this same ballet – in so far as Bartók was the composer of its music, they had a special claim on it. But the triumph of this year was from the west in Martha Graham and her Dance Company. Richard Buckle wrote of her in the Souvenir Programme:

> With her Nefertiti features, slight, strong body and lambent personality, Graham has always been an electrifying performer, and she is still the star of her superb company. As a choreographer her powers seem to increase with every new creation. Of the works which she is giving in Edinburgh, not one that I have seen fails to be an extraordinary and overwhelming theatrical experience. *Seraphic Dialogue* is a Gothic vision of Joan of Arc; *Embattled Garden* is a comedy of sexual intrigue set in the Garden of Eden; *Phaedra* is a frightening study of lust; and the full-length *Clytemnaestra*, with its 'pure sound' music by Hakim El-Dhaab, is the grandest and most terrible reconstruction of a Greek tragedy to be staged in the post-Freudian world. Martha Graham turns dancers into heroes and gods.

So the United States had shown Edinburgh audiences by 1963, especially through the two companies of Jerome Robbins and Martha Graham, how new meaning and a new seriousness could be put into ballet made outside the traditional ballet sources of eastern Europe or Paris. The Jerome Robbins Ballet gave new life to a traditional story by locating it in the West, updating it, and relating it to urban experience. Martha Graham, when young, reacted against classical ballet. It did not apply apparently to the situations that mattered. She began from herself, studying those movements of her body which she saw as related to the permanent human condition. Her ballet *Appalachian Spring* suggests a location – and indeed the ballet is firmly based there – but her reading of the situation generalizes it. Ballet

companies from the United States since 1963 have generally been more committed to political attitudes than those seen in Edinburgh previously. Their commitment has brought a passion amounting to fervour, as with the Alvin Ailey Dancers.

The New York City Ballet under its renowned Artistic Director, Balanchine, does not belong to this category. The range of interest of this company is very wide, though it has specialized in ballets to Stravinsky's music. One of the outstanding ballet experiences of 1967 was *Apollo* – music by Stravinsky, choreography by Balanchine. Now some forty-seven years old it remains one of the accepted masterpieces of twentieth-century ballet. One of its subtleties is its treatment of myth, paying due homage to the ancient gods and at the same time revealing unchanging human psychological characteristics and their tendency to create unchanging patterns of human behaviour. Balanchine was equally successful in novelties. The ballet *Bugaku* is Japanese in origin and in it Japanese customs are translated into a sequence of ballet scenes.

In 1968 the Alvin Ailey Company, on the limited space of the Church Hill Theatre stage, protested their political faith. This was Edinburgh's first experience of dance used by the American black to draw attention to the inhumanity and injustices practised against him. It was a shift from the ballet of ritual celebrations to a ballet of protest. But besides giving the première of *Knoxville: Summer 1915*, the company also presented *Icarus* and other ballets where legend and rite played their parts. The directness and expressiveness of their dance movements came through all. The flexibility and power of the dancing had an immediacy of effect which, after experiencing the Alvin Ailey troupe, made European companies appear curiously detached, even non-committal.

In 1970 Edinburgh was visited by one of the major ballet companies of today – The Nederlands Dans Theater. "Since its inception", the programme notes read,

the Nederlands Dans Theater has been devoted to the expanding and evolving of the choreographic art by the conscious breaking down of the barriers between classical ballet and modern dance, together with the execution of a programme of intense creative activity, each eleven month season producing ten to twelve new works. The repertoire is chosen and created with a respect for the tradition behind us, a vital interest in the forms and innovations of today and a concern for continued growth in the future.

Statements of policy are one thing, their realization another, but the beautiful and exciting achievement of the Nederland's Company was a true outcome of their admirable theory. Their .classical discipline was matched by the sense of an abounding freedom, a freedom which did not lose touch with the idea of traditional dance standards. All the ballets in their first programme had been composed within three years of their presentation in the 1970 Festival. The music for the ballets in Edinburgh was mainly by composers of this century, including Hindemith, Schoenberg and John Cage, but the music for the ballet *Brandenburg*, as might be expected, was by Bach – the Second Brandenburg Concerto in F Major. Whether the music was ancient or modern, there was no sensation of disjunction of sensibility between the ballets. Their style had the purity of fine abstract painting. If the Alvin Ailey dancers seized the emotions, the Nederlands Dans Theater enlivened the mind with an endless variety of inventions.

The return of the Royal Danish Ballet in 1971 gave similar evidence of the possibility of developing new ballet on the basis of the classical tradition. On their previous visit to the Festival the Danes had performed *La Sylphide* and other ballets as they had been choreographed a hundred years ago by Bournonville. In 1971 the Company performed *The Life Guards on Amager* and *Conservatoire*, both ballets being composed by Bournonville. The Scots gave to the Danes in the nineteenth century the romantic picture of themselves as gallant kilted warriors and infinitely sweet and 'fey' ladies, out of which the nations of Europe made opera and ballet. But the Danes also gave a romantic picture of themselves and especially of the most gallant, pure and most disciplined soldier ever invented. He became a toy soldier in Hans Andersen and an admirable, upright ballet dancer, against which the tender, willowy, forms of narrow-waisted sylphs floated. Out of this male and female opposition the Danes made images for ballet. The severe disciplines of the soldiers on parade found their way on to the ballet stage – and for that matter on to the Castle Esplanade at the Edinburgh Tattoo.

Such disciplines and such a tradition might have inhibited development. In his article (*see* page 125) Sir Frederick Ashton told how he was attracted to the Royal Danish Ballet because of its being well founded in the classical tradition and at the same time responsive to new ideas. These new ideas were shown to advantage in new works by Roland Petit, Paul Taylor, John

Cranko and Fleming Flindt, the Director of the Royal Danish
Ballet. In every respect this return visit to Edinburgh was a great
success. The first performance was attended by the Crown
Princess Margrethe of Denmark and her husband, later by the
British Prime Minister, and the company played to packed
houses.

In 1972, one must record there was no further development in
ballet, while noting that the sole dance company, the Ensemble
National du Senegal, gave four performances at the Lyceum of
traditional dances from their country. The throbbing drums, the
whole body responding, then continuing in an action that seems
to be inexhaustible, the undertones of threat from the
inexplicable, induce a kind of excitement that African dancing
only provides. The vocabulary of the dance, to a European,
seems limited, but within the limitation very effective, as
appreciative audiences found.

There were no new developments in ballet in 1973, though
there was the welcome return of the Hungarian State Opera and
Ballet Company, with the same musical director, Janos Ferencsik,
who had appeared with The Budapest Opera and Ballet in 1963.
The ballet consisted of *The Miraculous Mandarin* and *Spartacus*,
music by Khatchaturian, choreography by Laszio Seregi. The
attraction of *The Miraculous Mandarin* is readily understood.
Bartók's music is thrilling and it calls for the visual illustration.
The theme combines the suggestion of mystical, traditional
powers and modern skulduggery. The drama is intense, and in
addition it is seen to advantage in the company of Bartók's opera
Bluebeard's Castle, as it was in Edinburgh in 1973. It could no
longer shock as, I recollect, it seemed to do in 1962 and 1963, but
this production had the benefit of a superb performance from
Vera Szumrak as the girl, who runs into trouble with the
Mandarin, Viktor Fulop. He conveyed hints of powers beyond
chicanery, giving his abrupt movement implications of evil. The
Hungarian contribution to the Festival, whether it be through
the music of Bartók, ballet, or opera – such as *Blood Wedding*, has
taken the audience into areas which The Royal Danish Ballet, for
instance, does not seek to explore.

The energies that are released through the music of Bartók's
music dramas, opera or ballet, imply man's rootedness. They
emerge out of Hungarian soil, no matter from where the tales
come. It was a great pity that *Spartacus* had nothing of this quality,
and that for all its spectacle and virtuous idea, it worked only at a

superficial level. Here, it seemed to me, was a nostalgic romanticism which led to the creation of a ballet which was contrived. It lacked the spontaneous life that flowed through *The Miraculous Mandarin*.

For lack of a home in Edinburgh, and perhaps for other reasons, ballet has lacked consistency of appearance at the Festival. It has had great variety and been truly international, coming from Japan, India, Africa and from many countries in Europe, and it has given the most novel experiences of the Festival. It may be that the lack of a theatre for ballet has led to the seeking out of small companies and one-man shows, many of which have been the glories of the Festival. It may be that the circumstance has tested the ingenuity of the directors of the Festival and in this they have never been found lacking, least of all Peter Diamand. These remarks are a prelude to my contention that in the 'seventies the most significant and the liveliest contribution to ballet may be found in those companies or individuals who work on the fringe of the art.

On occasion the company may be a large one as was the Ballet du XXe Siècle of the Theatre Royal de la Monnaie, Brussels. Their production *The Four Sons of Aymon* in Murrayfield Ice Rink in 1962, a tale of heroes and magic directed (or rather created) by Maurice Bejart, has been referred to as total theatre, and should perhaps be put in the category of drama, but dance and mime are its genesis and genius, and there are only two speaking parts. "*The Four Sons of Aymon* is", wrote Maurice Bejart in the Souvenir Programme, "like life itself, tender, uncouth, ridiculous, tragic and blessed. One might use the words 'total theatre' since the whole heart of man pulsates within this circus ring, itself a symbol of the universe."

"It is", wrote Piers Haggard, who with Christiane Haggard translated the narrators' parts into English, "an exciting tale spectacularly performed on a huge scale, with an enchanted castle and a gigantic 'wonder horse'. But it is more than a 'legende heroique'; it is both a reassessment for our times of the old legend and an imaginative exploration of the nature of heroism."

The tale of heroes and magic was based on a play by Hermann Closson, who had taken the story from French romances of the Middle Ages. Because the meaning or meanings of the drama is largely achieved by visual means, as at the opening when four enormous figures in armour, fifteen feet tall, stride into the arena, and then after the figures are raised, four young men are seen,

there is a claim that the play is ballet. The four men are the real sons of Aymon. Their human struggles form the action of the drama, a drama which revealed itself in the combination of music and movement. Piers Haggard concluded his article with these words:

> But Bejart rediscovers the ancient sources of theatrical delight. Like the great masters of the Greek drama, the Japanese 'No' and above all, the Peking opera, and unlike the analytical dramatists of our age, Bejart uses *all* the resources of the theatre to body forth his theme. The emotions of his characters expressed concretely in the rhythms of the drum and the stylised movement of the dancer, affect us more immediately than wordy self-revelations. They evoke a sensual response and hence the mental one. Total theatre calls upon total man.

This is heady stuff, but it was a heady experience. I doubt the idea that analysis was absent from the presentation. I make the remark because I suspect that every mentally exciting modern art creation has analysis built into its synthesis. The Festival from 1962 onwards demonstrates the point, especially in individual or small group performances. In 1962 there was *What Next*, an entertainment from Prague in which objects flowed and changed positions, talked without words to each other, built up and collapsed, as if they had something to tell the audience and as if the invisible men who moved them, and who came from Prague, were unimportant. This was put on as a late night show at the Lyceum. Then in 1966 the Polish Mime Theatre from Warsaw, under its Director Henryk Tomaszewski, used mime creatively of course, but also with an implied commentary on both domestic and legendary situations. This was an accomplished company as was the Paul Taylor Dance Company from the United States, though they perform firmly within the category of ballet. The focus of these comments is on the outsider, the clown who, however comical, has the sadness of living outside society.

Marcel Marceau came to the Festival as a mime soloist with his company in 1953, although it was not his first visit because he had played Arlequin in Jean-Louis Barrault's production of the mime *Baptiste* at the Lyceum in the 1948 Festival. He returned in 1967. His art raises questions – why should a man walking into a wind when there is no wind, or climbing stairs where there are no stairs, be completely fascinating to watch? Absurd he certainly is, and therefore laughable, but the image of Marcel

Marceau remains as if he was the only man we had ever seen performing these inevitable actions. Then he went on from there to be a man who made masks and moments of recognition offered themselves. "It is the form of dramatic expression which seems to me as being closest to Man" – so wrote Marceau. His words apply with peculiar aptness to what was for me and many the most surprising event of the 1974 Festival.

Before we reach that event, the touching, humorous, and subtle performance of Ladislav Fialka in *The Button* at the Church Hill Theatre in 1969 claims attention with Marceau's comment in mind. The company, Theatre on the Balustrade, directed by Ladislav Fialka, with ten actors, also performed *The Fools*. The title itself has the warrant of tradition. The dark garb, the pale features, the spare movements, the rightness of movement of the company so that they are a unity – all this divorcing them from the muddled world – resulted in the making of their beautiful world, which existed on the boards of the Church Hill Theatre, and now only in memory. When the clown or fool or the dancer appears glittering or white out of darkness, when they appear as features only, and then disappear into their dark again, they express the given condition of man. Fialka and his troupe belonged to this category of entertainers.

A moving theme, as the Bat-Dor Dance Company from Israel had in *And After . . .* or in the opening dance of their first programme *From Hope to Hope*, is no guarantee that the dance form will contain and express the strength of feeling in the situation which prompted the creation of the dance. *And After* was created in memory of a young dancer of the company who was killed on the Golan Heights. This talented, highly disciplined, athletic company with the added intensity of a personal situation did create the sense of desolation and they did develop drama from this, yet without the sense of achieving an inevitable form. In other dances the style and form became one. Dedication and ability came together in *Requiem for Sounds*, a ballet by Gene Hill Sagan. Their art, based on classical ballet, is not bound by it. Rather it becomes a tool for the expression of protest, challenge, grief or joy, themes in their case that are the outcome of living in a society whose existence may be threatened. The other ballet which was presented at the Lyceum Theatre while the Bat-Dor were at the Churchill Theatre was of a very different character.

The Kathakali Dance Troupe belong to that tradition of dance

from India in which the studied, exact movement of hand, neck and foot demand attention. A long tradition has determined the style; the tales on which the dances are sustained are traditional, and the spectacle – the richness of dress and ornament is spectacular – has been predetermined by custom. The music is mainly drum and cymbal and with this the floating Eastern voice attractive and strange to Western ears. The effects are immediate, but the registration of the various themes in the tale as in the scenes from the 'Mahabharata' cycle, such as the gambling game, the attempted humiliation of Princess Drapaudi and the triumphant climax takes account of a wide range of attitudes and feelings, ranging from broad comedy to serenity. This was theatre, not a presentation of ritual.

The surprise of the 1974 Festival was at the Churchill Theatre, where the Mummenschanz Company performed. The company consists of Andres Bossard, Bernie Schurch, and Floriana Frassetto. Neither their programme nor the Souvenir Programme tells what the company does or is. Once seen, this reticence is understandable. A programme note goes as far as saying: "It is difficult to describe this essentially non-verbal spectacle in words . . ." But there is no spectacle in it, nor do the trio enlist the aid of music. In any case they do not appear to perform. In fact they become.

They became in the first item a large brown object, initially not unlike what used to be called a pouffe. The object is beside a cube, which was about twice its height. The object apparently finds it necessary to surmount the pouffe. It attempts to do so by extending itself and by flowing like a wave up a cliff. It has not the necessary strength or skill to achieve its objective. The audience begins to will the object to get on top of the cube, sometimes sighing as it falls back, clapping and laughing as it gets on top. The identification of audience with the object and with the forms of higher life which have other objectives and problems is explicable only at a psychological level. What they were witnessing was the evolution of species from the unicellular life, the amoeba, to multicellular. The empathy that grew throughout the first part of the programme stemmed from the sensation, not knowledge, that the audience had an intimate though inscrutable association with the basic forms of animal life.

The second part of the programme dealt with 'higher' life. It ended with two members of the clan, *Homo sapiens*, altering and destroying each others' faces. This was done by instant sculpture,

the masks which the two actors wore being composed of a plastic material. Previously in another item they had picked each other's brains. The performances were brilliant. Of Marceau's statement on mime – the Mummenschanz Company might take the credit of proving it.

The implied comment of the company was on Man – not political, or social or dreaming man, for the presentation of themes based on those aspects of the human condition one requires the more extensive resources of ballet. One hopes that a home in Edinburgh will be found for ballet once again. Then no one will grudge the loss of the Empire to bingo.

9

Theatre

The drama in the first year of the Festival made clear the policy — works of agreed excellence were to be the staple presented by companies whose merit was beyond doubt. The international barrier of language was at a discount, at least as far as our nearest European neighbour was concerned. So from France came La Compagnie Jouvet de Théâtre de l'Athenée to present very properly Molière's *L'Ecole des Femmes*, the play which had for long been one of the company's outstanding successes, in which Jouvet played Arnolphe. They also put on the stage of the Lyceum the delicate fairy-tale fantasy *Ondine* by Jean Giraudoux, a modern work on the production of which Jouvet had collaborated with the author before his death in 1944. This was a hint of the increasing number of modern and new plays that were to proliferate on Festival stages over the years to come. So inevitably there was the assured success of the Old Vic productions of Shakespeare, beginning in 1947 with *The Taming of the Shrew* and *Richard II* and a range of near misses, successes and occasionally disasters amongst the new plays. There were some mischances even with Shakespeare, perhaps to the credit of the Festival, for these were due to experiments in production which were intended to show that new approaches to the old master were possible.

That year saw the first appearance of Jean-Louis Barrault with Madeleine Renaud in their company's production of *Hamlet*, Marivaux's *Les Fausses Confidences*, and the mime *Baptiste* from the famous Marcel Carné film *Les Enfants du Paradis*. They returned in 1957 with a repertoire of Anouilh and Claudel and in 1970, twenty-four Festivals after their first appearance, with the New York Chamber Soloists they spoke poetry and excerpts from plays on the stage of the Assembly Hall. It was in 1948 that Eileen Herlie gave an impressive performance in *Medea*, which was produced by John Gielgud. She set going the long list of

Greek productions, whose apogee if not its end was Elsa Vergi's performance as Medea in modern Greek in 1966.

In 1949 the range of the Festival's dramatic interests was becoming increasingly evident. The Dusseldorf Theatre Company put on Goethe's *Faust, The Thrie Estaites* continued at the Assembly Hall, while Scottish theatre added another laurel to this achievement in Robert Kemp's charming adaptation of Allan Ramsay's *The Gentle Shepherd* with late-night performances in the elegant Georgian Hall of the then Royal High School. Here had been found another space which suited the character of the play as no conventional theatre could.

The most discussed and the most significant dramatic success in 1949 was T.S. Eliot's play *The Cocktail Party*. It was the reverse in its terms of reference to the racy play of the people, *The Thrie Estaites*. The polite drawing-room manners of London society seemed an improbable means of entertainment under the hand of the serious poet, but Eliot breathed life into dried skins and through the direction of E. Martin Browne and excellent performances by Irene Worth as Celia, and Alex Guiness as Sir Henry Harcourt-Reilly, won amusement and concern for this comic tragedy. I recollect attending a cocktail party immediately after the first performance of the play at which opinions were very diverse. The Scottish dramatist James Bridie thought that novelty had been too much sought after, others that the horrible death of Celia was too much for the tone of the play. Into this situation came the author of *The Cocktail Party*, smiling gently as if he had nothing to do with the disturbed opinions. I remarked that I found his *Cocktail Party* was a good deal clearer in meaning than this one. He said — "I hope so." I remark the matter because the gathering of people after performances to discuss plays and music, authors, critics, musicians and those who go to listen has been one of the features of the Festival.

Eliot's play went on to be talked about and to make its particular impact in London and New York. After discussion with the Director, E. Martin Browne, Eliot, however, modified the text so that there was less emphasis on Celia's death by crucifixion, on the grounds that the detail was drawing more attention to the episode than was desirable.

Perhaps a new play from England demanded one from Scotland. At any rate 1950 gave Festival audiences two new Scottish plays — *The Queen's Comedy* by James Bridie, and *The Atom Doctor* by Eric Linklater. Neither of these plays had the

strength of motive that informed the lively inventions of previous writings – Bridie on the stage and Linklater in witty, boisterous novels – but both were good examples of the Scottish comic muse. Duncan Macrae's Vulcan in *The Queen's Comedy* had that deflationary character which puts gods in their places. Sonia Dresdel as Juno gave wit and presence to Jupiter's consort, while James Gibson provided the most Scottish Neptune that ever inhabited the ocean.

There was a similar localizing of character in *The Atom Doctor*. Yet nothing is more liberating from locality than the play of wit and fantasy of Linklater. The vein is especially Bridie's and Linklater's and it is also an aspect of Scottish writing which largely was lost after the Reformation. When a Scottish playright does without it altogether he becomes a solemn owl, as was demonstrated in a third Scottish offering at the 1950 Festival, *Douglas* by the Rev. John Home. The poet Gray extolled the tragedy. It had, he wrote, "retrieved the true language of the stage, lost for three hundred years," but neither the acclaim of the author of the 'Elegy Written in a Country Churchyard' nor the admirable performance of Dame Sybil Thorndike as Lady Randolph ably assisted by Sir Lewis Casson, Douglas Campbell, Laurence Hardy, Lennox Milne and James Gibson, could make it more than an interesting curiosity.

Infinitely livelier and more attractive was Ben Jonson's *Bartholomew Fair*, in its first public performance for 220 years, given by the Old Vic on the open stage of the Assembly Hall, the property of the Kirk that had unfrocked – metaphorically – the Rev. Mr Home for writing a play and for having it put on the stage. And now the Kirk had admitted to its premises a public fair, although this was a mere pageant compared to the directness of speech and sex interest of the play of the previous year – *The Thrie Estaites*.

In 1951 the Festival presented two Anouilh plays, *Le Bal des Voleurs* and *Le Rendez-vous de Senlis* performed by Le Théâtre de L'Atelier from Paris, a company which had specialized in Anouilh since 1937, while Peter Brook directed a memorable *Winter's Tale* with Sir John Gielgud as Leontes, Diana Wynyard as Hermione and Flora Robson as Paulina. Quality in drama was further assured by Peter Potter's production of *Pygmalion* with Margaret Lockwood as Eliza Doolittle.

The Festival might well have rested content with this kind of insurance, but the following year the pattern was enlarged to

include two new plays, *The River Line* by Charles Morgan and *The Player King* by Christopher Hassall. At the time these plays held the attention, but they did not have that deeper originality which made them for all time, so that what may be best remembered in the drama of that year was the wonderful tenderness of Claire Bloom's Juliet at the Assembly Hall on the kind of stage for which the play was written. Her performance shone the brighter in the earthy robust production by Hugh Hunt. There was another lively production on the same stage, *The Highland Fair* by Joseph Mitchell, adapted by Robert Kemp and directed by Tyrone Guthrie. It had colour and vigour but it was no *Thrie Estaites*.

Claire Bloom returned to the Assembly Hall in 1953 as Ophelia. She shared the honours in a good *Hamlet* production with Richard Burton. T.S. Eliot's second Festival play *The Confidential Clerk* was more readily accepted than *The Cocktail Party*. It had more the build of a good play, and yet the memory of it has faded. It did not disturb as did the previous play. Nor did it have the final serenity of *The Elder Statesman*, the play that was yet to come. Also that year there was Le Théâtre National Populaire with Molière's *L'Avare* and a stunning performance by Jean Vilar as Shakespeare's Richard II.

French theatre was to hold the Festival stage for three successive years, each more rewarding than the other. In 1954 La Comédie Française gave us the play every secondary schoolboy knows and yet cannot know, *Le Bourgeois Gentilhomme*. Here was the whole delightful, absurd thing with Scottish contributors in the Saltire Singers under Hans Oppenheim, a Festival Chorus, Chorus-Master Richard Telfer with dancers from the Scottish Ballet School directed by Marjorie Middleton and at the heart of it all Louis Seigner magnificently, bumblingly ambitious as M. Jourdain.

The following year we had Edwige Feuillère in *La Dame aux Camelias*. If by this time we did not know Gallic wit, charm and tenderness, we never would. Into this scene one Scottish production fitted neatly: Robert Kemp's *The Other Dear Charmer*, his play about Burns's "soujourn in Edinburgh and his ill-fated love for 'Clarinda'." This was the Gateway Company's first contribution to the official Festival. Robert Kemp, whose scholarship and sensitive imagination had made possible a superb adaptation of *The Thrie Estaites* and an adaptation of the eighteenth-century pastoral *The Gentle Shepherd*, now brought

these gifts to bear on an original play placed towards the end of that century, and played in his adopted home-town, Edinburgh. He caught the civilized tone of eighteenth-century Edinburgh and through the genuine Scots speech of all the characters – none more true to the locale than George Davies who played the serviceable part of Lord Craig – a different view of the Scots was made known to visitors than that usually encountered in entertainments exported from Scotland. But the achievement of the play was not in its documenting. The love affair that was presented through Tom Fleming as an intelligent, robust yet frequently embarrassed Burns and through Iris Russell as the charming but self-indulgent Mrs Maclehose (Clarinda) is realized in the imagination. The little Edinburgh society in which we find ourselves, populated by such redoubtable women as Mirren played by Meg Buchanan and Miss Nimmo played by Lennox Milne (whose abilities were recognized by her appearing in eight out of the first ten Festivals), reflected the larger society which promoted the values which made possible the Festival itself. The play was alive because the tensions, tendernesses and absurdities of the lovers emerged from their characters, but the sense of its truth came from the author's ability to give the principal characters a social context.

Shakespeare, however, remained central in the productions with *Macbeth* at the Assembly Hall, and *A Midsummer Night's Dream* at the Empire, with more gossamer and faery than is usually possible, on account of the dancers. Moira Shearer and Robert Helpmann playing Titania and Oberon, aided by a *corps de ballet* and the Scottish National Orchestra playing Mendelssohn's enchanting score. The comic balance was restored by Stanley Holloway as Bottom. Nor was this the end of the drama, the play that opened the Festival at the Lyceum being *The Matchmaker* by Thornton Wilder. This play was a prelude to the Festival's major drama commission the following year.

The discovery of the Assembly Hall and the creation of an apron stage in it by Tyrone Guthrie, which suited his production of *The Thrie Estaites*, presented new opportunities for drama and new problems. Obviously it was right for Shakespeare, though there were difficulties in getting the voice to the four corners of the rectangular Assembly Hall. Pageants and choruses could be readily displayed, but the intimacy of the modern play was another matter. One solution was to commission a play. So Thornton Wilder's *A Life in the Sun* was written for this stage. It

is significant that the plot and characters were drawn from Greek legend and myth. In the central act the story tells how Admetus, mortally ill, receives news that if someone dies for him he will recover. Alcestis makes this sacrifice for her husband. This was a device whereby unanswerable questions about life and death, about the problem of communication between God and man, could be restated on a modern stage made for statement rather than for conversation. The producer was Tyrone Guthrie. He returned in 1956, the year of the tenth anniversary of the Festival, with The Stratford–Ontario Festival Company – the company of the theatre which he had been instrumental in creating.

The Stratford–Ontario Theatre was Guthrie's second great experiment with the apron stage. Edinburgh was the first, and now by bringing the Stratford Company from Canada to Scotland he was repaying the debt he considered he owed to Edinburgh. Certainly the Edinburgh experience was the basis for the Stratford development. The two plays presented in Edinburgh were Shakespeare's *Henry V* and *Oedipus Rex* by Sophocles in the translation by William Butler Yeats. *Henry V* was produced by Michael Langham. I recollect to this day the drama of the approach of the actors, the trumpets and the flags – the use of the flags a drama in themselves. In this setting the Agincourt speech from Christopher Plummer's Henry came out of the panoply of military romance into the audience as it could not do from the proscenium stage. It was right in those conditions. *Oedipus*, produced by Tyrone Guthrie, had as the Greek king Douglas Campbell whom Guthrie had cast as John o' the Common Weal in *The Three Estaites* – another gift from Edinburgh to Canada, now returned.

Behind the joyous entertainment and heightened drama which the late Sir Tyrone Guthrie dispensed – he died in May 1971 – lay an awareness of the function of play acting which he related to his religious view of life. At the conclusion of his autobiography, *A Life in the Theatre* he wrote:

Just as the sacred drama of Holy Communion is non-illusionary, so is the sacred drama of *Oedipus Rex*, where the actor, also originally a priest, impersonates a symbol of sacrifice . . . The same principle can be applied to all drama: and in all drama, even the most frivolous, I think that there is some attempt to relate the participants to God . . . The theatre is the direct descendant of fertility rites, war dances and all the corporate ritual expressions by means of which our primitive ancestors, often wiser than we, sought to relate themselves to God,

or gods, the great abstract forces which cannot be apprehended by reason, but in whose existence reason compels us to have faith.

The passage might well refer to Thornton Wilder's *A Life in the Sun*, but, of course, it related directly to Guthrie's production of *Oedipus Rex*. It was performed in masks, for as the producer said: "... we endeavour to perform the tragedy as a Ritual", and he went on to suggest that he saw the play as "the ceremonial re-enactment of a sacrifice." These words on paper might give the impression that pageantry might take over from drama, but this was far from being the case. We left the theatre of the Assembly Hall at once elevated and shocked by the terror and majesty that life can bring. This 'proper purgation', to quote Aristotle on tragedy, has been made available by many of the great Festival experiences.

In 1956, the tenth anniversary of the Festival, offered the richest dramatic fare and the widest ranging to that date. There were plays by Goldoni, Pirandello, (in Italian), Shakespeare, Shaw, Bridie, and Dylan Thomas, as well as Yeats's adaptation of Sophocles' *Oedipus*. Guthrie's production of *Oedipus* was the first production of Greek drama on the Assembly Hall stage. There was one previous production of Greek drama in the Festival at the Lyceum, John Gielgud's *Medea*, with Eileen Herlie as Medea in the adaptation by the American poet, Robinson Jeffers. With hindsight one can see that despite the outstanding performance of Eileen Herlie and Gielgud's impressive production, Greek drama could achieve effects on the apron stage of the Assembly Hall that were not possible in the Lyceum.

This was evident when in 1974 the Abbey Theatre from Dublin presented Yeats's adaptation of *Oedipus* in the Lyceum. The settings and costumes were impressive, the chorus-speaking admirable, the direction by the Greek producer, Michael Cacoyannis, giving the sense of inevitability in the steady development of the drama proper to Greek tragedy, and yet the audience was far less involved in the tragic events than in Guthrie's production at the Assembly Hall. The diminished power was, of course, not entirely due to the different venue. The principals in the 1974 production simply did not carry the drama as did Guthrie's actors; nor, for that matter, was there any comparison between the astonishing powers unleashed by Elsa Vergi as Medea in the Piraikon Theatre production of the play in Greek at the Lyceum in 1966; not that any of the productions of Greek drama in English had such power. The desolation and

grandeur of Michael Cacoyannis's direction of his film version of Sophocles' *Elektra* was also seen in the Festival in Film House. One should note another triumphant adaptation, already referred to, in the 1956 Festival, Stravinsky's *Oedipus Rex* at the King's Theatre.

The problem of style confronted the directors of the first professional stage production of *Under Milk Wood*. Written for radio by Dylan Thomas in 1954 under the encouragement and direction of Douglas Cleverdon, it was adapted and directed by Douglas Cleverdon and Edward Burnham for the 1956 Festival. Inevitably one recollected the whispering, gossiping, musical voices, the engaging intimacy, the sense of evanescence, and the rapidly changing scenes of the original production, and waited with some apprehension for the radio play's appearance within the confined location of the stage. Yet the production was successful – the materialization of the voices brought colour and warmth, and the bustle of village life. Sensibly the words still dictated the tone – there was no attempt to dramatize the text – and while the confidentiality was much diminished, the eccentric characters gained a new vigour and attractiveness. This was a praiseworthy experiment.

Just how important a great theatrical tradition can be was demonstrated at the Lyceum in the two productions of The Piccolo Teatro, Milan. The brilliant display of *commedia dell'arte* by the company in Goldoni's *Arlecchino: The Servant of Two Masters* gave a sense of happy improvisation, within the context of expertly calculated moves, gestures and characterisation. When clowning becomes poetry and the poetry runs to fun, then the spirit of Ariel and Puck have mingled. Such was the performance of Marcello Moretti as Arlecchino; Giorgio Strehler directed the play, so that it ran and floated. His direction was equally true in the other Italian contribution, Pirandello's *Questa Sera Si Recita a Sogetto*. "Tonight We Improvise", stated Pirandello, and his implication was there, and not only on the stage. He was concerned with the question – where lay the reality? He invited the audience to enter into this question with him, seriously and with concern. The play was as introvert as was *Arlecchino* extrovert.

This was the Festival's first glimpse of the quality of Italian theatre. Later it was to enjoy in fuller measure that happiness of spirit allied to great virtuosity in opera and music as well as in drama.

Just how far wrong it was possible to go on the stage of the
Assembly Hall was shown the following year, 1957, in *The
Hidden King*. It was even the wrong kind of failure, for this
costume play by Jonathan Griffin was written in a careful,
academic verse without a hint of life in it. The distinguished cast
headed by Robert Eddison as Dom Sebastian, King of Portugal,
Robert Speaight as Dom Diogo de Brito, and Micheal
Macliammoir, Sebastian Shaw, Ernest Thesiger, Pauline
Jameson, Rosalind Atkinson and Clare Austin, with their skills
gave it an impressive send-off, but they could not give it reality,
or the feeling of life. The motto for the Festival should be to risk
on the side of too much life, not too little. In fairness such failures
as have been in the Festival, and in the nature of the case this
generally means drama, have been adventurous failures.

The English Stage Company's production of Sartre's *Nekrassov*
was a different matter. Produced by George Devine, the talents
of Robert Helpmann as Georges de Valera and Harry H. Corbett
(alas now better known as the son of Steptoe) as Jules Palotin,
were put to better services. With the return of the Compagnie
Madeleine Renaud, with Jean Louis Barrault in *La Répétition* by
Anouilh, the quality of French theatre at its best was present
again. It is not inappropriate to remark on another style of acting,
after the reference to France – the performances by the
Edinburgh Gateway Company in *The Flouers O' Edinburgh* by
Robert McLellan. Historically Scottish and alive with racy
vernacular, one recollects, amongst the vigorous, genuine
portrayals of Scottish characters by Lennox Milne, Tom Fleming,
Walter Carr, Bryden Murdoch, John Young and Nell
Ballantyne, the stylish performances of the late Duncan Macrae
and the late George Davies. The producer of the play, James
Gibson, was another who brought distinctive life to even slight
sketches of Scottish characters.

Nor was this the end of the acting talents on display in the 1957
Festival, for Anton Walbrook, Moira Shearer, Eric Porter, Peter
Bull and Prunella Scales appeared in *Man of Distinction* by Walter
Hasenclever at the Lyceum.

In 1958 two plays were of especial interest, each in marked
contrast to the other. Of the première of Eliot's *The Elder
Statesman*, T.C. Worsley wrote that it was "a most interesting
play full of fascinating sidelights on human behaviour and
beautifully written. It creates its own world and that is what style
is for." There is a detachment in this favourable comment which

correctly suggests that the play did not compel attention as did *Long Days Journey into Night* by Eugene O'Neil. John Grierson commented on it in 'Arts Review':

> ... it is gloomy like the *Brothers Karamazov*. It is sordid like Strindberg. It is Dudley Digger walking out of his pub in *The Iceman Cometh* to take his impossible walk round the block. It is for me very beautiful – very moving and one of the theatrical experiences of my life, for which I expect to be always grateful ... These people, these Tyrones, they bicker, they backbite ... take the skin off each other, they lie, they are totally disreputable, but all I can remember is that they talked to each other and really loved each other, and if they doped and drank as a result, it was in the profoundest cause of all – which is to live and live abundantly, even if you are supposed to be doing it all wrong. O'Neil is, above all, a man of the theatre. There is a sort of dramatic breathing in every space he leaves, every absence he registers – or so I think – with his fog horns out of *Anna Christie* all over again. But above all with all his concentration on the hurts of life, the disappointments, the illusion of age and disintegration – it is the inner kindness of life that he finally asserts and why his tragedy comes to you as though it were a blessing which is the way all tragedy must.

If Festival drama brings this quality of experience, then all the failures are worthwhile – which should not imply there are many. Indeed while O'Neil was sounding doom at the Lyceum, the human comedy of *Twelfth Night* was being sung with such innocent bliss at the Assembly Hall by the Old Vic Company with Barbara Jefford as Viola, Joss Ackland as Sir Toby Belch, Judi Dench as Maria, John Neville as Sir Andrew Aguecheek and Richard Wordsworth as Malvolio, that mortality was not on the horizon.

The drama of 1958 provides a perspective from the brow of Parnassus, from where one can admire the merits of Schiller's *Mary Stuart*, smoothly translated by Stephen Spender – another play of that bountiful year – without giving it the highest status. It allows us to admit the loveliness of O'Casey's *Cock-a-Doodle-Dandy*, presented in 1959, while regretting its falling far below his masterpieces *Juno and the Paycock* and *The Plough and the Stars*. We also look down – though the metaphor becomes presumptuous – on the well-intentioned 1959 Scottish Repertory productions at The Gateway Theatre, which had varying successes.

Life is one quality Linklater plays, novels or essays are rarely

without. His words jump off the page, yet the premiere of his *Breakspear in Gascony* as given by the Perth Repertory Theatre revealed just this lack. Linklater's *Atom Doctor* in 1950 was as lively as Bridie's *Queen's Comedy* of the same year, but *The Baikie Charivari*, Bridie's last complete play, had the sparkle of the master of fantasy-realism. Henry Donald had this to say of it in 'Arts Review':

> Bridie writing on three or four different levels at once, reanimates the story of Punch and Judy and extracts from it a commentary on post-war British life which is often mordantly satirical and ultimately profound, wise and compassionate. Amidst all the wit and sparkle and originality, he gives the reality of evil its proper substance. The whole thing is a triumph, with half a dozen performances of the highest class, while young Mr Iain Cuthbertson carried off the long and difficult part of Pounce-Pellott with an authority, warmth, humour and attack, which probably makes this the finest piece of sustained acting the present Festival has given us.

The director of this success was Peter Duguid, the company — The Glasgow Citizens. Least venturesome of the Repertory productions was Dundee's *Candida*, but it was directed with that sense of true theatre which characterized the majority of Raymond Westwell's productions.

On paper at least, 1960 was the year of historical personages — Mary Stuart and John Knox at the Gateway Theatre in Bjornson's *Mary Stuart in Scotland* translated by Elizabeth Sprigge, and *The Wallace* by Sydney Goodsir Smith, which had its première at the Assembly Hall. The former was worthy rather than exciting, the latter rose to a height in what Eric Linklater described as "the magnificent final scene".

Till that scene the apron stage of the Assembly Hall had been more a liability than a benefit. The description of the play in a sub-title as 'A Triumph in Five Acts' suggested it was written in a high style, and indeed its opening with chroniclers delivering to the audience the condition of the nation first in Scots and then in English suggested the play would be suited to the Assembly Hall, but there were many conversational scenes, without much style, and a charming, tender love-scene which demanded an intimacy which that stage could not give without the words ceasing to be audible. Sydney Goodsir Smith had used blank verse throughout, and this formality was useful in helping to give the play shape. The blank verse in Scots had a vitality lacking in the English which was necessarily used by English characters. If the play

could not be rated a success throughout, the acting of Iain Cuthbertson as Wallace made up for deficiences. It was magnificent.

The Wallace had a stronger motivation than nostalgia or the desire to celebrate the hero who made possible the restoration of a Scotland freed from the threat of invasion by the old enemy. It related to the growing awareness in Scotland of the continuing cultural distinctions of the Scots, Sydney Goodsir Smith having himself contributed to the Scottish literary revival of this century. Whatever the merits of the construction of Bjornson's *Mary Stuart in Scotland*, it remained a reconstruction of an historical interpretation. On the other hand, while for those Scots preoccupied with the thought of a Scotland reasserting herself culturally if not politically, *The Wallace* was at the centre of the drama in the Festival, for others it was the première production of *The Dream of Peter Mann* by Bernard Kops, a morality about the ultimate effect of egotism and greed, described in a broadcast by Alexander Scott as "one of the most lively, self-assertive works to reach the theatre for years." For a more subtle insight into the motivation of the human heart, the Old Vic Company in *The Seagull* by Chekhov, in celebration of the centenary of his birth, bore the palm. Directed by John Fernald with studied care, there was a rare performance by Tom Courtenay in the part of Konstantin.

For sheer liveliness and exuberance that year, there was nothing to touch *Les Trois Mousquetaires* with Roger Planchon, who adapted the Dumas tale, and his spirited company. This carefree air prospered on the 1960 Festival stage with the addition of three late-night entertainments, *Beatrice Lillie, Les Frères Jacques* and *Beyond the Fringe*.

The Fringe at the Edinburgh Festival requires a history to itself, a considerable one, for it has grown from a few shows, some of them little more than devices whereby students might find an opportunity to attend the 'real' Festival, to a vast enterprise containing the excellent, good, bad and indifferent. Unlike the official Festival it does not need to worry about a few failures and indifferent shows. Drama on the Fringe takes risks with new plays by unknown writers, by experimental techniques and in outrageous comment. The results have been increasingly to raise the standards till critics have in recent years been giving the drama on the Fringe as much attention, and sometimes more favourable attention, than the official Festival. The achievement

of the Fringe has been mainly in the spoken word.

So far from the Directors of the official Festival regarding the Fringe as a rival, they have kept a weather eye for what might be promoted to their Festival. Some might argue that the official Festival might well have incorporated more from the Fringe. One is apt to forget that what is now acceptable generally on the stage of the 'legitimate' theatre – how oddly the designation sounds today – even a few years ago would be questioned, and not necessarily for moral reasons. The watchword 'standards', the maintaining of which all would agree is essential to the justification of existence of the Edinburgh Festival, might be used as a device for excluding elements which do not conform to accepted patterns.

That Robert Ponsonby gave house-room in the Festival to the free-speaking witty boys Jonathan Miller, Alan Bennett, Peter Cook and Dudley Moore in their show in 1960, indicated a willingness in that Director to taking at least a small risk. One effect was to send these performers and commentators on official pomposity and folly on their way to international success. More significantly, their acceptance in the official programme stressed that there was to be a place in the Festival for comment, in this case satirical comment. In fact as early as 1957, the year after his appointment as Director, Robert Ponsonby engaged Anna Russell to make fun of the art at the heart of the Festival, music. In 1959 Michael Flanders and Donald Swann made their gentler, but diverting, deflationary comments in their show *At the Drop of a Hat*. Then in Ponsonby's last year as Director, *Beyond the Fringe* made its spirited, witty assault on the 'Establishment'. The credit for the show, Robert Ponsonby commented later, "the Festival Society and I were *ultimately* most happy to accept."

Comment, of course, is always present in drama, more evident in new plays, whether or not their subjects are contemporary. During Lord Harewood's reign comment was invoked directly in his *Writers' Conference* and through *Poets in Public*. Indirectly it was felt strongly in 1961 in John Osborne's play *Luther*, the one outstandingly successful aspect of the play being Luther's appeals and his expositions to the audience of where he stood. The tract in the play was again evident in the very different context of *The Seven Deadly Sins* by Brecht, a music drama, with music by Kurt Weill, presented in a translation by W.H. Auden, by the Edinburgh Festival Society with the forces of The Western Theatre Ballet, The Scottish National Orchestra, and singers

under the baton of Alexander Gibson. The enjoyment was in the art, but the audience was left in no doubt that though the sins were traditional the deadliest sin was belief in worldly success. The music drama is a morality against capitalist society.

Once the mind is set in this perception of the dramatist's motive, one is liable to see the whole varied drama contribution to the 1961 Festival as an exposure of the vanity of human wishes. While l'Association Française d'Action Artistique was presenting, in association with Jan de Blieck, *Le Misanthrope* incomparably in the original tongue at the Lyceum, the Edinburgh Gateway Company was offering Robert Kemp's adaptation of another famous Molière, *L'Ecole des Femmes*, in another incomparable tongue, under the title, *Let Wives tak Tent*. The gloss of the manner of the French was lost and with it subtleties, but the play in Scots had its own high style and a rare range of authentic Scots eccentrics as characters, who were rooted in a society as confident in its identity as were the French. In the play Duncan Macrae showed how appropriate his formal style of acting was for the seventeenth-century comedy, a style which was successfully adopted by Walter Carr who took over the part of Mr Oliphant. Tribute must also be paid to Effie Morrison, effective in the smaller part of Alison, if for no other reason than to remember that this talented actress who died in the autumn of 1974 had more rewarding roles than her famous Mrs Niven in the television series *Dr Finlay's Casebook*.

The determination to do all that could be done to raise the status of drama at the Festival, without respect as to where the blows of new drama might fall, seemed to mark drama policy in Lord Harewood's first year as Director. *August for the People* by Nigel Dennis, which was specially commissioned by the Edinburgh Festival Society, was advertised in the 1961 Souvenir Programme: "It is a satire on The Establishment, with special reference to stately homes and their owners, the Press, and the people who visit them." The English Stage Company presented the play, and the leading role was taken consummately by Rex Harrison as Sir Augustus Thwaites. The play, as might have been expected, was more diverting than deadly. The British première of *Sappho* by Lawrence Durrell, with Margaret Rawlings as Sappho, made no claims for itself. It had the ready attractiveness of all Lawrence Durrell's writing.

The deepest and deadliest play in the 1961 Festival was written over 360 years previously, Marlowe's *Doctor Faustus*. The Old

Vic Company presented *Faustus* at the Assembly Hall with Paul
Daneman as Faustus. The Assembly Hall, where the Church of
Scotland holds its annual General Assembly, was the very place
.for a play invoking spirits from heaven and hell. Michael
Benthall, the director, aided by Michael Annals, the designer,
had done their best to take account of the dimension of the play
by building a ramp ascending to heaven or descending to hell, as
required. By shrewd cutting of the dross of horse play, which
evidence suggests Marlowe did not write, the focus on the
aspiration and the despair of Faustus was sustained. The mysteries
beyond human comprehension were suggested with dignity in
angelic and demonic portrayals. In Paul Daneman's portrayal of
Faustus was seen a man who reached to heaven, but who was
pulled down to hell.

Thirteen years later *Doctor Faustus* appeared again at the
Festival, when the Royal Shakespeare Company presented the
play at the Lyceum. Once again the same designer, Michael
Annals, was called upon to suggest visually the dimensions made
explicit in the writing. Globes of the world were on the floor,
and the ceiling rose in domes like an observatory through which
might be seen the sky. Through this set that great actor Ian
McKellen strode restlessly, in a flurry of zeal casting aside the old
learning. It was an enthralling opening as we caught the surge of
Marlowe's lines. Yet at the end the vivid, intense, utterly
convincing performance seemed to have been achieved at the
expense of a dimension, as we watched Faustus, a weary old man,
crouch in a chair. The polarities of heaven and hell, majesty and
terror had gone. Looking back from 1974 to 1961, the production
of that year seemed to have a dreamlike quality. In places at least
the 1974 production had the sharpness and tragic feeling of our
times.

This is to anticipate. Lord Harewood's first year as Director
was memorable for drama as it was in other departments. There
was one other fine production presented by the Old Vic,
Shakespeare's *King John*. This was the alternative play to *Faustus*
in the Assembly Hall. Once again the Assembly Hall flowed with
a sense of pageantry under the direction of Peter Potter. King
John was played by Maurice Denham.

1962 was a year of varied interest in drama rather than of
memorability. Dylan Thomas's *The Doctor and the Devils*, a play
about the resurrectionists in Scotland, covering some of the
ground already covered by Bridie in *The Anatomist*, displayed

Scotland's richness of talent in eccentric characterisation, the cast being headed by Leonard Maguire as Dr Knox. *Young Auchinleck* by Robert Maclellan at the Gateway Theatre had an honest solidity in its character portrayal, but it did not set the heather on fire, nor for that matter did the première of Christopher Fry's *Curtmantle*. But on the edge of drama (already referred to under ballet) there was *The Four Sons of Aymon*, presented by the Ballet du XXe Siècle of the Théâtre Royal de la Monnaie from Brussels, at Murrayfield Ice Rink, which had the scale and fantasy recaptured with even more gusto in the adaptation of Ariosto's *Orlando Furioso* by the Teatro Libero Rome at Edinburgh's other ice rink at Haymarket in 1970. These joyous surprises which lit up the Festival more splendidly than the fireworks displays at the end were much to the credit of the Festival directors concerned for bringing to the burghers of Edinburgh such exotic bonuses.

The biggest fuss in the 1963 Festival had a tangential connection with drama and was of no consequence. I refer to the 'happening' at the Drama Conference in the McEwan Hall, in which a naked female was glimpsed momentarily in one of the upper tiers of the Hall. I mention the incident only because it drove the true matter of discussion out of the minds of many people. Infinitely more dramatic and exciting was the British première of *Exit the King* by Ionesco in which Alex Guinness played the King with an absorbed strangeness that rivetted attention on his crumbling regality. Of the other plays, The Chichester Festival Theatre Company's *Saint Joan* came off best. Its pageantry and inquisitorial scene suited the Assembly Hall, as the British première of *The Rabbit Race* did not. "It was", Harold Hobson said, "full of problems, but the kind of risk a festival should take." *All in Good Faith* by Roddy Macmillan, a Glasgow pathetic-comedy, was completely successful within its amusing limits, whereas the much more highly intentioned Ibsen's *Little Eyolf*, although fascinating in places, seemed to get lost in symbolism.

1964 was a year of extremes. On the Assembly stage was the intolerable impertinence of Joan Littlewood's adaptation of *Henry IV* in which she successfully did down Shakespeare by cutting the most memorable passages, by allowing her actors to gabble, and by failing even to present successfully the low life scenes at the Boar's Head. Fortunately the Bristol Old Vic compensated by showing that the linguistically-minded play *Love's Labour's Lost* could be vastly entertaining and beautiful. It

may be that some of the issues that were of moment in Shakespeare's day were sacrificed to those twin virtues, but the sweetness and effervescence remain. One performance cannot be forgotten – Russell Hunter as Costard. One waited for every appearance of the big-eyed, simple-minded rustic who will not be suppressed, and yet his fooling never ran beyond the general tone of the play.

There was also the ageless – so everyone said – Marlene Dietrich at the Lyceum, all glittering and highly polished, still exerting the charms of youth. I confess I wondered in a horrible Scottish way – was this quite proper? In any case something more important was going on outside the official Festival at the Pollock Hall, where Bettina Jonic was starring in the Traverse Theatre production of *Happy End*, lyrics by Brecht, music by Kurt Weill. Brecht's use of the pop world material of his day – film thugs straight out of the Bowery, cigar-puffing get-rich-quick merchants, dames from the speak easies, and the made-to-match religious pop of the Salvation Army, with Weill's music drawn from the same quarter, made an implicit ironical comment on the world of Marlene Dietrich. Weill used the brash, vigorous trumpeting and Brecht the cartoon figures of vice and virtue in a sophisticated play, which allowed the display of Bettina Jonic's character singing. The piece came off.

But the elevation of Traverse Theatre Productions to the stage of the Assembly Hall in *Macbeth* in 1965 under the auspices of the official Festival proved to be one of those errors of judgement which should not have been made. Why the Traverse was not introduced to the Festival proper in a play and place more akin to the character of their agreed achievement and environment was hard to understand. Rhetoric and formality was not their way of life. At least they attempted to interpret Shakespeare in their own way. Fortunately the plays at the Lyceum were of a different order. *The Amen Corner* by James Baldwin, set in the meeting house of a negro sect of Holy Rollers and in the house of their pastor, Sister Margaret, is about problems of morality within the sect. Based on the strong emotional tide of gospel songs, the play was carried to its climax of concern about what loving means by Claudia Macneil as Sister Margaret. She took into herself all the problems of the close-knit ‘community. She wept and raged with her whole body and mind. It was a great performance; her sympathetic approach to material as naive as that used in *Happy End* did not lead to crudity.

Perhaps it may be as lasting a play as the alienated Brecht. There was, of course, nothing but attraction in the production of *I Due Gemelli Veneziani* by the Teatro Stabile di Genova, which followed *Amen Corner*. It was brilliant *commedia del arte*. There was sparkle too in Shaw's *Too True to be Good*. Little wonder. In the company were Dora Bryan, George Cole, Kenneth Haigh and Alistair Sim.

In the 1962 Souvenir Programme, Irving Wardle wrote: "Edinburgh, tirelessly international on its other frontiers, has been inclined with drama to present the best of what is on its doorstep. Work rarely comes from farther afield than Paris . . . with the result that the Festival's dramatic side has been in danger of turning into an outpost of the West End." That complaint has long since been answered. Mr Wardle wrote as one who was well aware of the special difficulties of planning the drama of the Festival. Some of his suggestions have been accepted and fulfilled.

The fun of Italian theatre in 1965 was followed in 1966 by the profound, enthralling experience of Greek tragedy in modern Greek performed by the Piraikon Theatre from Athens. The desolation and intensity of the great tragic figures, *Electra* by Sophocles and *Medea* by Euripides, were conveyed in performances by Elsa Vergi with such power that it was almost impossible to believe that we did not know the language. The Greek theme was sustained in performances of *The Trojan Women* by Euripides, translated into English by Ronald Duncan from Sartre's adaptation. Satisfactory as was Flora Robson's rendering of Hecuba and Jane Asher's Cassandra, the absence of a ritualized style made one the more aware of the new marvel the Festival had conferred on those fortunate enough to see the Piraikon Theatre. By way of a complete contrast The Edinburgh Civic Theatre put on Douglas Young's adaptation of *The Birds* by Aristophanes, translated into a lively Scots with the title *The Burdies*. Duncan Macrae made his last appearance at the Festival in this play, directed by Tom Fleming. It was a daring venture that fell short of success, despite much amusing character invention and enormous effort. The same year the Assembly Hall housed another success in Pop Theatre's *Winter's Tale* with a fine Hermione in Moira Redmond and an attractive Autolycus in Jim Dale. Also in 1966 there was one of those modest testimonials to humanity that might be overlooked, *The Little Men* by Sholem Aleichem at the Church Hill Theatre.

Certain festivals seem to pick up themes or interests from others. "The dominating theme in the theatrical productions of this Festival," wrote Harold Hobson referring to 1967, "which seem to me to reach a high and exciting standard, is that of racial relations and rivalry. This is stated quite clearly in the negro production of Eugene O'Neil's *The Emperor Jones* at the Lyceum Theatre." Harold Hobson went on to note that race relations were also the crux of Barry Bermange's *Oldenberg* at the Church Hill Theatre. Just as three years previously, Claudia Macneil brought great emotional drive to the part of Sister Margaret in *The Amen Corner* so James Earl Jones created an immense Emperor Jones, warm yet frightening, and finally pitiable in his destruction. The sense that the disturbances set going were manifestations of greater power, normally held under in day-to-day relations between men, was a communication that arrived on the stage through the racial character of the cast as well as through the skills of their performances. The requirements for *Oldenberg*, in which a couple wait for the arrival of a lodger of that name sweating themselves into violence before his arrival in case his racial origin is one thing or another, are a balance of performances involving comedy, pathos and rage within the context of English suburban attitudes. The play was beautifully realized by Roger Booth and June Jago as the couple and James Culliford as Oldenberg.

The drama of 1967 was perhaps the most consistently interesting of all the Festivals and of the highest standard. At the Assembly Hall was a brilliant Jim Dale, wholly diverting and engaging in a new adaptation of Molière's farce *The Tricks of Scapin*, directed by Frank Dunlop for Pop Theatre with as much imagination and timing as he had directed Shaw's *Too True to be Good* two years previously. He also directed an engaging *Midsummer Night's Dream* at the Assembly Hall. At the Lyceum the quality was maintained in Richard Cottrell's direction of *The Cherry Orchard* for Prospect Productions. To put an adaptation of E.M. Forster's *A Room with a View* as a second offering from Prospect Productions was a good idea, but the flavour of the novel was hardly conveyed and it did not seem to adapt naturally into a play form. This year the Close Theatre Glasgow made its first contribution in the *Triple Image* by Olwen Wymark, while the Traverse presented *Tom Paine*, an experimental play with members of La Mama Troupe, New York. At the Gateway Theatre the range of the drama was further extended in the mimes of Marcel Marceau.

There was less consistency in the drama of 1968, but Glasgow Citizens' production of *The Resistable Rise of Arturo Ui* by Brecht, was outstanding. In the play the gangsters of the U.S.A. are identified as the hierarchy of the German Nazis, and the gross, cruel, empty men of the U.S. become the monsters of Hitler's Germany. The most absurd monster Arturo Ui-Hitler was made all too credible in Leonard Rossiter's dazzling portrayal. The injection of this imaginative social realism into the Festival has given the Festival drama renewed life. The Alvin Ailey Dancers were also at the 1969 Festival. They too were concerned with injustice.

In the company of these productions the Abbey Theatre's production of *The Playboy of the Western World* seemed tentative, while Trinity Square Repertory Company's play about Oscar Wilde in prison, *The Years of the Locust*, by Norman Holland was touching and yet no more than a fading document.

The remark is not intended as social criticsm, for the Traverse came into its own again this year with their production of O'Neil's *Mourning becomes Electra*. In O'Neil the evils lie deeper than the cruelty of men. The first performance of Valerie Sarruf as Lavinia in her shrill, controlled tones suggested there were uncontrollable destructive forces beneath. There was a similar assurance in the direction of the play by Gordon McDougall. Also at this Festival at the Assembly Hall were *When We Dead Awaken*, Ibsen's last play, whose symbolism could not be effectively suggested in that environment, and *Hamlet*, the performance of which part by Tom Courtenay let loose a flood of critical denunciation. He had one strong supporter in Harold Hobson in *The Sunday Times*, who considered the critics had suffered an attack of critical blindness. He had nothing but praise for Caspar Wrede's production of the play as well. The controversy, the variety of style and achievement all pointed to the healthy condition of drama at the Festival.

At one period in the history of the Festival, those whose principal interest was in drama took it for granted that conditions were such that you simply could not expect great – or near-great – dramatic events from year to year. One can indeed look back over the years and nominate a scatter of remarkable productions, but as one approached the end of the sixties groups of plays claim attention for their merit and contemporary relevance. 1969, however, was different. It is remembered for two of the great Festival successes in the Assembly Hall – Ian McKellen in the name parts of Shakespeare's *Richard II* and

Marlowe's *Edward II*. Every critic acclaimed the authority and brilliance of these performances and the appropriateness of the direction by Richard Cottrell and Toby Robertson. There was so much applause for these events that it tended to obscure other very distinguished performances, though less demanding, elsewhere. As remarked in the chapter on ballet, that year Ladislav Fialka brought his Theatre on the Balustrade from Prague to the Church Hill Theatre where he and his company conveyed by gesture and movement, pathos, humour and elegance with the greatest eloquence. In the charming Saint Cecilia's Hall Dame Sybil Thorndike captivated audiences by her informal and apparently spontaneous poetry readings, in which she included Scottish ballads, a reminder, she said, of her Scottish background.

At the Lyceum, The Scottish Actors' Company made a brave start to their Festival appearance with Ibsen's *The Wild Duck*. There has long been a theory that Ibsen was a natural for the Scots. Many of his characters in their serious moralizings, in their industrious businesslike approach to life, were, it seemed, almost Scots already. Yet the achievement of the play was no more than honest. How far wrong the social concern approach can be was evident in *Would You Look at Them Smashing all the Lovely Windows*, a play by David Wright which dealt with the events and consequences of the Irish Easter Rising. Unlike Brecht the events were not fused in the imagination. This undigested condition regrettably applies to *Zoo Zoo Widershins Zoo*, an up-to-date play which the critics agreed would last no longer than that. John Arden's *The Hero Rises Up* was also light but of very different quality, being a musical dramatic affair based on episodes in the life of Nelson. The Festival had one dramatic surprise, the quality The Nottingham Playhouse Company drew from Shaw's first play *Widowers' Houses*. For all that this was Ian McKellen's year.

The goings on at the Assembly Hall in 1970 were another exhilaration, thanks again to William Shakespeare, but of a different kind. John Neville's Benedict in *Much Ado about Nothing* will long be remembered, as will Sylvia Syms as Beatrice. The Prospect Theatre Company's production, directed by Toby Robertson, was a swashbuckling affair, made all the more so by the transfer of the setting, without warrant, from Messina to "a Spanish Colony, sometime before the end of the Nineteenth Century." The efforts of the alterations warranted the sacrifice of

a little truth. They allowed a display of colour in design, arrogance in gesture and movement and a play of pistols with bangs, all of which added to the gaiety of the nations who attended the Assembly Hall. Unlike the previous year's performance there, there were others of equal excellence and to deeper purpose.

The Royal Lyceum Company, Edinburgh's Civic Theatre, making its second appearance in the Festival – its first under Clive Perry – with Richard Eyre as Director, presented *The Changeling* by Thomas Middleton and William Rowley. "*The Changeling*", T.S. Eliot wrote in 1927, "is Middleton's greatest play." Eliot's essay established its literary merit, but it had to wait till 1959 for its first professional performance on the stage in this century, given by the Royal Court Theatre. There was, therefore, an element of risk in the selection of the play by Clive Perry for one of his two productions for the Festival. The result demonstrated that the Edinburgh Civic Theatre had achieved a standard of production and performance that at lest equalled any of the productions mounted elsewhere. The contributions of the Edinburgh company thereafter, though Edinburgh audiences had seen their like before, could be considered on the level of achievement of Scottish Opera. Twenty-four festivals after 1947, Scotland had two resources in music and drama which visitors dared not omit from their programme – otherwise, strictly speaking, they had not know the Edinburgh International Festival. The test was in the execution.

Those who saw *The Changeling* will not readily forget the superb performance of David Burke – the most outstanding in the Festival, I believe – as the simple-minded, disfigured, betrayed man, De Flores the servant, saying before his death, "I loved this woman in spite of her heart." And after him the rest remark on how they are changed by the experience they have undergone. And so were we, the audience. Perhaps for the time being we were a little larger in our charity. Here dramatically I should end, but this was a remarkable dramatic Festival.

The Lyceum had opened with *Peace* by Aristophanes in German. This down-to-earth fantasy which moves wilfully to heaven and back again has as its central character the comic hero Trygaios, played with a nice mixture of confidence and bewilderment by Fred Duren. The National Theatre of the German Democratic Republic brought us into another diverting world, far removed from the twentieth century which still had a

lot to say about the unchanging follies of men.

There was throughout the production an affectionate tone, which made its effect peculiarly engaging – a quality rare in satirical contemporary plays where rage and despair tend to predominate. Author and producer gave the impression of accepting as fact that the follies of man would continue no matter what social or political remedies were produced.

Meanwhile at the Church Hill Theatre the Leeds Playhouse Company unfolded a world of threat and madness in Pirandello's *Henry IV*. It was well done, though I did not find it as spine-chilling as the Pitlochry Theatre's production a few years previously. There were two new plays. *Boswell's Life of Johnson*, by Bill Dufton, Toby Robertson and Ian Thorne, was a sequence of scenes based on the writings of Boswell, Johnson and their circle. It was presented by the Prospect Theatre Company very agreeably with a first-rate Dr Johnson in Timothy West. I thought more time should have been given to Johnson in Edinburgh and in Scotland, in view of the location of the play, being close to his biographer's Edinburgh home. Boswell's lodging is just outbye the back of the Assembly Hall in the Lawnmarket. The opportunity of giving us this kind of intimacy was largely missed, and the feeling that the authors were more closely acquainted with London than Edinburgh remained.

The other new play, *Random Happenings in the Hebrides* by John McGrath, presented by the Royal Lyceum Theatre Company, dealt with the impact on an island community of the changing social patterns of our day. It was lively and diverting and its comment on the application of politics to the life of the community was to the point. The play had a mixed reception from the critics, largely perhaps because the author crowded so many random happenings into his second act that the main issue was obscured and its serious tone lost.

It would not do to end this review of Festival drama in 1970 on a qualified note. All the evidence was of higher standards achieved, of great variety of interest, of witness to the international character of the Festival – an internationalism that began with Scotland and spread to Germany, Greece and most gloriously to Italy, for from Rome to the Haymarket Ice Rink came Teatro Libero's production of *Orlando Furioso*. This was an entirely novel experience in theatre, of which those present became well aware, as Orlando and his cohorts charged through the audience (who were scattered throughout the arena) on high horses. These were splendidly draped structures on wheels. This

was audience participation with a vengeance. Confusion seemed
to abound as the story was told from several platforms, and
though caught up in the adventures, bullied and pleaded with by
heroines and witches, and chivvied by friars and magicians, yet as
the show proceeded one became aware of a scheme of things that
sustained the glittering, imaginative display. It was Festivalia,
Fiesta, Festa – all in one. I doubted if we would ever see the like
again.

A great new success, such as was *Orlando Furioso*, in the Festival
tends to create the problem of what next, particularly when its
form of presentation has suggested a means of exploiting a new
venue. The situation had similarities to that of the Assembly Hall
after the run of *The Satire of the Thrie Estaites*. *Orlando Furioso*
could not be equalled, but it was followed by a high-spirited,
enjoyable entertainment provided by that man for all seasons,
William Shakespeare, in the form of *A Comedy of Errors*. The
audience found itself, for the occasion, in a circus tent, in the
arena of which the play was generally enacted, though the
lodging of Denise Coffey, who played Adriana, was perched
above the audience and Ian Trigger, looking like a Scotch comic
in a kilt, had many comings and goings up and down the passages
between seats. When we heard from Adriana that she was in a
hurry because she had to get the mince, we knew that
Shakespeare was being left behind, literally if not in spirit, for
there is a deal of inconsequentiality in *A Comedy of Errors*. In any
case Denise Coffey was excellent as a fussy Edinburgh housewife,
while Edward Fox as Antipholous of Edinburgh brought a
properly judged sense of superiority to the role. Frank Dunlop as
director of this Young Vic production was responsible for the
glorious romp. Yet the fun was achieved at a price. Shakespeare
had written a comedy, not a farce.

To judge by the response of the audience, the adaptation was
an·unqualified success. With Scotch farce at the expense of the
Scots, visual jokes at the expense of the Tattoo, the speech of
Leith to the fore whenever possible, the official Festival had
backed a winner, and the people flocked to see it. Those who
knew the play, however, considered that too much had been
thrown away to justify this kind of production. The liberties
taken were, perhaps, more akin to what might have been
expected of the Fringe. If this is so, then a useful distinction of
function may have been made, but comment is reserved on this
matter for the last chapter.

Of Shakespearean production, one thing is assured, there is no

single mode of presenting the play, though there are many wrong ways. In 1971 the severity of the production of *King Lear*, presented by the Prospect Theatre Company in the Assembly Hall and directed by Toby Robertson, contrasted with the rip-roaring *Comedy of Errors*. The focus was visually on bleakness, Lear and others in sack-cloth. In a play of light and dark, where the location is the soul of man, this it seemed was a proper approach, but the final test of Lear is with the actor. Timothy West in the part was true to the idea of Lear as head of the family responsible for the good rule of the tribe. The pathos of a man forsaken grew as the play developed, but for the majority of the critics, the earth did not tremble with this Lear in his agony of spirit. They may have been wrong. Endless debate about dramatic productions is true to the spirit of festival.

The debate continued over *Alice in Wonderland* presented by the Manhattan Project. Regrettably the three productions of the Long Wharf Theatre Company, *You Can't Take It With You* by Moss Hart and George F.S. Kaufmann, *Solitaire* and *Double Solitaire* by Robert Anderson, were agreed as not being of Festival quality. On the other hand the Bulandra Theatre Company from Bucharest at the Lyceum was hailed as a delightful discovery. Some critics has reservations about *Carnival Scenes*, a comedy by I.L. Cariagle – it traded in a fairly clumsy slapstick, redeemed, I thought, by robust, authentic peasant characters – but Georg Buchner's *Leonce and Lena* enthralled all. It was an exquisite fantasy which yet related to its origins. It was intimate, I felt, with the community behind it.

It was not by chance that the first play to be presented at the Lyceum at the twenty-fifth Festival was a new Scottish play, *Confessions of a Justified Sinner*, an adaptation of James Hogg's novel by Jack Ronder. The novel witnessed to the doppelganger tradition of Scottish fiction which runs from Hogg, through Stevenson and George Douglas Brown to Lewis Grassic Gibbon. Behind it was a community which saw life split into the evil and the good, and in the case of Hogg's great novel saw human kind as souls elected to heaven or to hell. The drama did not find a stage form adequate for revealing the dark splendours and power of the novel but the play demanded serious attention. Jack Ronder's adaptation made one feel he was in earnest about the issues raised in the original. It may simply be that the stage is not the place for this novel. It had already been proved a success on radio. Curiously there was one dramatic success in a genre akin

to this on the stage of the Traverse, though not in this year nor in the Festival — Tom Fleming's solo presentation of Hugh MacDiarmid's long poem, *A Drunk Man looks at the Thistle*.

In 1971 Tom Fleming with Lennox Milne and Richard Todd in *A Singular Grace* provided the Festival's spoken word bicentenary tribute to Sir Walter Scott. This was a pious anthology without the fire of life in it, which was certainly not the fault of the performers, nor of the original author, but the piece was never fused in the imagination of devisers of the programme, John Carroll and Royce Ryton. Nevertheless such was the interest in Scott and such was the quality of the performances of individual items, that the production was well received.

By public demand the Young Vic's *The Comedy of Errors* returned to the Haymarket Ice Rink in 1972. Some of their spirit of levity found its way into their other production, *Bible One*, in which *Joseph and the Amazing Technicolour Dreamcoat* was the second part. This might have been regarded as a take-off of the Bible story of Joseph, but the sprightly and innocent tone, sustained in the music by Andrew Lloyd Webber and the lyrics by Tim Rice, as well as in the script and performances, spread happiness around the circus tent, which was again housing *The Comedy of Errors*. The first part of *Bible One* was a performance of the Genesis Creation story in the Wakefield Mystery Plays version. Attractive as it was, and with Paul Brooke as very agreeable God, I was aware here of the simulation of innocence.

The achievement of innocence, whereby every gesture conveys meaning, demands more than good acting and intelligent production. Whereas the Young Vic were attempting to re-create a tradition from which European theatre had been separated for hundreds of years, as has European civilization, the Hosho Noh Company from Tokyo gave the impression of never having been divorced from their material, and its original style. Each gesture seemed to signify the grief or joy or other emotion of a community. When, for instance, the desolated mother in *Sumidagawa* hears her son cry from the grave across the river, she (or rather he, for the part is played by a man) lowered her head and put up her hand to her face, as if to shield it from the impact of the terrible knowledge. She did this for herself and for all desolated mothers, and in so doing gave the play a status and function beyond entertainment. The production of the Mystery Plays by the Young Vic had no lesson to teach us — one hoped it

might have – but the Noh players gave the audiences access to a different rhythm of life than that which was known to them, a rhythm which demanded patience for it to be heard. Once the discipline of, in many cases, inordinately slow development was accepted, the reward was serenity and enjoyment.

No greater contrast could be imagined than that between the production of the Noh plays and the Glasgow Citizens' production of Marlowe's *Tamburlaine the Great* at the Assembly Hall. The arrogance and pride that were fundamental characteristics of Tamburlaine's world were made evident before the play began by actors assembled outside who scrutinized with hostile eyes the audience as it entered, while inside was a spectacle of splendour and cruelty – Tamburlaine's flags hung from the galleries as if over his conquered territories, skeletons were bound to the wooden pillars that support the Assembly Hall, and once the action got going, blood spouted from victims and the Elizabethan motley erupted. Philip Prouse's design could not have been bettered, while Keith Hack's management of his forces, so as to bring out the energy and turbulence of the participants, was reminiscent of Guthrie himself. He had, however, one very odd trick – three actors playing Tamburlaine. Whatever theoretical justification there was for the device, there surely must be one majestic Tamburlaine, as there must be a rich, musical voice to speak such a line as "To entertain divine Zenocrate" and others, but there was neither, only torrents of blood, in which such quality as is in the play was drowned. Whatever Glasgow Citizens' Theatre does it always has impact, not necessarily the impact which the author of the play intended. *Twelfth Night*, their other production on the Assembly Hall stage, is, I think, bound to lose its way if Viola and Cesario are played by one person, as they were in this production. Here too, I felt, there was the imposition of a pattern instead of an interpretation.

The theatrical event which excited most curiosity in 1972 was the formation of the Actors' Company. Their motto, as stated in the 1972 Souvenir Programme, is "All for one, one for all", wherein also was stated, "This is to be a genuine co-operative, in which decisions are made through mutual discussion." And again: "The names will appear in alphabetical order. This is to express the relative importance or unimportance of the individual." The egalitarian principal of the company, which appeared in the Festival with The Cambridge Theatre Company,

was expressed in their first production, *Ruling the Roost* by Feydeau, Ian McKellen appearing as the Page Boy, and Edward Petherbridge as the Manager of the Hotel Ultimus. The piquancy of the playing of the smaller parts was a revelation, not that the players in the more major roles were a whit behind, for the Actors' Company has considerable resources with Robert Eddison, Frank Middlemass, Tenniel Evans, Moira Redmond and Felicity Kendall, to name a few at random. Yet so elusive is perfection that, despite Richard Cottrell being translator and director of the Feydeau and despite the warmest approbation by the audience, I left wondering if the special Feydeau style, in which the characters come alive in jerks and starts, sometimes as if wound up like toys had been achieved. But perhaps the expectation was excessive idealism. There could be no disputing the effectiveness and the quality of the production and performance of Ford's *Tis Pity She's a Whore*.

The deliberately experimental element in the Festival was continued in *Moby Dick* by Mario Ricci, after Melville. This was presented by the Gruppo Sperimentazione Teatrale Rome. This affair of billowing sails and repetitive effects drove a number of the audience from the Church Hill Theatre. I have to admit this was the only occasion in twenty-eight Festivals that the present writer had the sensation of sticking it out, though of course there have been longueurs in other shows. *The Tramp* by Arthur Spilliaert, presented by Théâtre Laboratoire Vicinal, Brussels, also aroused reaction, but of a more questioning kind, as did their other offering, *Luna Park*. The Festival's annual report of the debate about both productions, for there were defenders of *Moby Dick*, commented with a nice detachment: "no doubt a healthy reaction in the exploration of new Festival ground."

If there were grounds for self-congratulation in the drama of the 1972 Festival, Michael Billington of the *Guardian* had no doubt that there was none in 1973. ". . . I seriously wonder", he wrote in the Arts *Guardian* of 28 August,

> whether it should not drop drama altogether from its schedule rather than continue to treat it as a secondary art. . . . Better still the drama festival should become, like the Film Festival a separate entity, with its own committed and enthusiastic director (someone of Frank Dunlop's vision and energy is needed).

Such radical criticism made, as it were, in the heat of the fray, understandably, does not take account of the many considerable

dramatic achievements of the Festival nor could it anticipate the imaginitive selection of drama in the 1975 Festival which included four new plays.

While drama was the main target for criticism in 1973, principally on account of its reduced content, complaints were also made about the absence of a major art exhibition. The Director, Peter Diamand, also made his complaint. Rising costs were making the maintaining of high standards impossible without the allocation of more money. Before the Festival there had been newspaper reports that unless the money was forthcoming Mr Diamand would not take up his new contract which was due that year. On top of it all the question of the future of the opera house remained unanswered, which answer was not in the hands of the Festival Society. The Society, however, did decide to present its own opera, and the decision reduced the amount of money for spending on other projects. Nevertheless drama had its successes in 1973. It had also in critical terms, failures, by which is meant that the plays were well patronised, though not applauded by reviewers.

There was general agreement that the Actors' Company's production of the *Wood Demon* by Chekhov was a success, in which Ian McKellen gave an imaginative and touching performance as the Wood Demon. Congreve's *Way of the World*, directed by David Williams, was updated to Edwardian times. This, in my view, regrettable fashion, which is still with us, nearly always results in greater losses than gains. The logic of such time changes should be to update the language as well, for there are social implications in the original idiom and implied gesture in it which root the play, especially if it is a comedy, in its period. The incongruities of language and situation in this *Way of the World* were noted and complained about. But if one must choose another period, certainly the Edwardian was the best.

With their lunch-time presentation of a double bill, *Flow* by Gabriel Josipovici and *Knots*, a dramatisation made from R.D. Laing's book, the company scored an undoubted hit in Edinburgh and later at the Shaw Theatre in London. Allen Wright wrote in *The Scotsman* of the two plays: "Once again the Festival has outsmarted the Fringe. It is a long time since it set a standard for late night revue which was *Beyond the Fringe* in every respect, and now it has done the same for lunch-hour entertainment. This presentation by the Actors' Company is in a class of its own."

Perhaps the unofficial aspects of the official Festival have not been given sufficient credit. Had, for instance the Mummenschanz Company turned up on the Fringe in 1974 with its extraordinary mime, instead of appearing in the official programme, the adventurous character would have been hailed as yet another evidence of the lively theatre to be found outside the establishment. On the other hand one is, I think, rightly more critical of failure in the official Festival. Standards are expected. Thus the disappointment in Georg Buchner's *Woyzeck* presented on two afternoons and a morning at the Assembly Hall by the Young Lyceum Company was understandable. The presentation of *The Knife* by Ian Brown, a tense little drama about corporal punishment, at lunch-time sessions, was warmly received. *Don Juan in Love*, a late-night show given by members of the Prospect Theatre Company, belonged characteristically to that genre, and so was very acceptable to audiences. Russell Hunter's *Rabelais* in its informality and in its audience participation – Rabelais assisting with the serving of the wine provided for all customers – would surely have been marked down as Fringe, had one not seen it advertised in the official programme. In any case this was an admirable piece, more admirable than Russell Hunter's portrayal of Lord Cockburn, as *Cocky* on the Fringe, the previous year, when all was given over to risibility and a little pathos, with nothing left of the dignity and mental power that were basic ingredients in his Lordship's character. Where there is a great original, be he Scott, Lord Cockburn, or Rabelais, one expects from the official Festival a degree of responsibility to that original, not necessarily expected of the Fringe. Let it be said that Russell Hunter's Lord Cockburn was a virtuoso performance and vastly entertaining.

I have strayed into the enormous unfenced field of the Fringe on account of the remarks by Michael Billington. My comments do not seek to justify the drama contribution to the Festival that year, which must take its stand on more consequential drama than late-night or lunch-time shows. In 1973 the Royal Lyceum Company mounted a new production of *The Thrie Estaites* by Sir David Lindsay, the fifth to appear on the Assembly Hall stage. The text was adapted by Tom Wright and the play directed by Bill Bryden. The result was to make one very aware how beautifully shaped had been Robert Kemp's version and how superbly Guthrie had handled the drama so that it rose to climaxes, let them subside and then rise again. That great musical

rhythm had gone. There were many commendable performances and a sense of release from some of the constraints which had shielded the audience from the bawdier parts in the original, and it had an abounding vigour, but one hopes that if *The Thrie Estaites* is again undertaken, which surely it must be, a more critical scrutiny will be given to the text and production than was given in 1973.

One production redeemed, if anything could, the drama of that year. Shakespeare's *Pericles*. Presented by the Prospect Theatre Company, directed by Toby Robertson, with Harold Innocent as Antiochus and Derek Jacobi as Pericles, set in a brothel at Mytilene it astonished by its realization of a dreamlike, sometimes nightmare, character. Decadence, squalor, luxury, were the elements in which the characters were enmeshed — but through it also ran a wit and irony, so that these characters were seen in a changing perspective. The complaint that there was simply not enough drama in 1973 was remedied in 1974, as was the criticism of the drama that it failed to be international.

In 1969 Ian McKellen was on the stage of the Assembly Hall as Shakespeare's *Richard II* and again as Marlowe's *Edward II*, both under the auspices of the Prospect Theatre Company. He returned to the Festival in 1972 with the Actors' Company and again in 1973. In 1974, as Doctor Faustus, with the Royal Shakespeare Company, he was on the stage of the Lyceum. Comment has already been made on this *Faustus*, but putting the performance alongside McKellen's other Renaissance drama achievements on the stage of the Assembly Hall, one is left wondering whether that location had to do with the more appropriate stature of the portrayals. In the Assembly Hall in 1974 the Actors' Company presented Molière's *Tartuffe*. It would have fitted more happily into the Lyceum, but that was impossible for the Lyceum was occupied by the Kathakali Dance Troupe. The critics had doubts about the production; the audience, to judge by the reception of the play, had none. There was general approval of the portrayal of Tartuffe by Charles Kay. He suggested a cold perfection in appearance, through which there came to the surface, as the play developed, his sinister hypocrisy.

The other presentation of the Actors' Company at the Assembly Hall, *The Bacchae*, was applauded by all. Here was a company style, a speaking of the words as if they were of more importance than the person speaking them, so an air of expectancy was created that allowed for the modulations of

anxiety, and fear. Criticism was made that the production failed
when orgiastic dancing was called for, but a tale was told as if it
held meaning for today.

This play had those virtues which this company exists to
promote. Whereas the 'star' system is liable to create conditions
in which plays become vehicles to be adapted to the personality
of the star, and so exploited by the actor, The Bacchae was
presented as if the tale being told was of greater importance than
the speaker; so the audience found itself listening with baited
breath to the narratives of the First Messenger, spoken by
Windsor Davies, and of the Second Messenger spoken by
Charles Kay. That expectation was engendered from the first
appearance of Dionysus. The attraction and strangeness of Mark
McManus in the part was of that order which made the great gap
of time and beliefs between Euripides and modern, urban man
disappear. The strangeness of the god became the strangeness of
living itself, just as the anxious wisdom of Cadmus spoken with
discretion and apparent concern by Robert Eddison became the
anxiety and understanding of any man who had over his years
sought understanding. This success was achieved without any
updating or eccentricity.

As if to show the company was capable of quite different
success, they followed The Bacchae with Jack and the Beanstalk, a
pantomime in which the actors displayed talents for mime,
dancing, the playing of instruments, singing, acrobatics and
clowning. In the midst of this surprising tour de force, one became
conscious of the symbolic relationship between the folk tale of
Jack and the Beanstalk and ancient Greek drama. Nothing could
have been a greater contrast than the display and fun of the
pantomime with The Bacchae, the play burdened with doom for a
people; but both were a company success, both directed with
consummate skill and understanding by Edward Petherbridge.

. A programme note for The Bacchae states: "So in its first two
years, the Actors' Company has become an efficient yet
experimenting organisation capable of instigating imaginative
programmes and carrying them out. There is the spirit of family,
of a genuine ensemble." This is no more than the truth. The same
programme note acknowledges: "Encouragement and support
came from the Edinburgh Festival Society who gave the unborn
company its first engagement." The Festival Society has
frequently encouraged wisely – according to music critics – the
music in the Festival. By the nature of the case, the backing of
successes in drama is more difficult, and failures in this art are not

necessarily due to lack of money. In 1974 the Festival Society supported the Young Lyceum Company's production of *The Fantastical Feats of Finn MacCool* by Sean McCarthy at the Haymarket Ice Rink. This spectacular affair was hardly brought off. There was any amount of invention and fantasy, but not enough drive, and while Tony Haygarth as Finn MacCool had the kindliness and the warmth of the giant, he had not the scale in his acting to help carry the impossible part through. Nevertheless it was a worthy experiment, and the critics were as genial as they could be about it. Michael Billington, no doubt pleased to see the Haymarket Ice Rink in use again, commented: ". . . it struck me as an effective crowd-puller marred only by its uncertainty of tone."

There was another experiment on a small scale, the Performance Group from New York at the Cambridge Street Studio with *The Tooth Of Crime* by Sam Shepard, a play about the rise and fall of a rock singer. The main attention was on the other visiting companies from Eire, the Abbey Theatre in Yeats's version of Sophocles' *King Oedipus*, and from Sweden, the Gothenburg City Theatre in *Gustav III* by Strindberg.

King Oedipus at the Lyceum put a yet stronger emphasis on Greek theatre in the Festival. In opera there were *Alceste*, Gluck's version of Euripides' drama, and *Elektra*, the Strauss opera based on Sophocles' play, and there was the Actors' Company's *The Bacchae*. The Abbey Company faced a strong challenge. Their director, Michael Cacoyannis, came with a high reputation as a film director as well as a director of plays. As suggested (*see* page 142) despite the virtues of this production, one was more aware of the intention to project character on a grand scale than of the achievement of scale. The Festival provides opportunities, but on account of its twenty-nine years' history it also provides a measure. No English version could match the Greek of Elsa Vergi's *Elektra* which the Piraikon Theatre brought from Athens in 1966.

Not to know Swedish was a greater handicap than ignorance of modern Greek, though in the latter case the instantaneous translation earphone was helpful, for the concerns of *Gustav III* by Strindberg were political and personal, not archetypal. Regarded as Strindberg's best historical play, concerned with ideas less personal to Strindberg than in plays such as *Miss Julie*, by which he is better known, the Swedish company's production was an opportunity to see Strindberg's dramatic handling of the

collision between the idealism of the eighteenth-century liberal thinkers, "all men were born free and with equal rights", and the vested interests. The King declared himself to be "the first citizen in a free country". The settings and costumes were very attractive. The drama was in ideas that were put to the test by actions. "Could there be an enlightened tyrant?" The question is put at the end of the play.

The circulation of ideas was regarded by Matthew Arnold as an essential for the survival of civilization. Such a circulation was the main achievement of the 'age of enlightenment' in Edinburgh. There is therefore a particular satisfaction to be able, by virtue of the presenting of Strindberg's *Gustav III*, to conclude this chapter on the spoken word at the Festival, with the foregoing reference.

10

The Exhibitions

It is strange to consider that no provision was made for the visual arts in the first Festival. The original Edinburgh International Festival of Music and Drama did not include in its official plans that area of the Arts in which it was to have as outstanding successes as in any of the other: some might say, more outstanding, for the organizers succeeded in bringing together collections of paintings by individual artists of such a representative character as to present the achievement of the artist in one show for the first time. One thinks immediately of the Cezanne and Monet exhibitions. It may be it was the first and last time. The difficulties of mounting a large, representative exhibition of the work of a major artist, born within the past 150 years, are now almost insuperable, on account of costs and the reluctance of owners to lend. Yet the one-man show of the considerable artist gave the Festival its international renown for exhibitions. An enthusiast may visit various galleries so that he may become acquainted with the work of an artist – and some galleries have comparatively representative collections – but to enter into the growing mind of the artist, to feel the impact of his painting personality, can only be experienced when the range of his works is displayed – and displayed well – in one gallery. This was the rare benefit of the great Edinburgh Festival exhibitions.

The official Festival exhibitions began at the heart of humane greatness in 1950 with Rembrandt. It was hung in the National Gallery of Scotland. It was not a large exhibition, yet R.H. Westwater wrote of it in *The Scotsman*: "These thirty-six paintings give a complete picture of the whole development of Rembrandt's prodigious genius." It is difficult not to indulge in superlatives, though these contrast oddly with the subjects which Rembrandt painted. 'A Young Man Reaches for his Cap' runs the title of one, but the young man caught in the simple unconsidered act shows the fresh innocence of all young men; he

becomes humanity caught in the act, held momentarily in light – Rembrandt's visual equivalent to time – before the shadows grow in the features of Rembrandt's men and women, as they grew in Rembrandt. The range is all within the human compass. One might go in the exhibition from the tenderness of 'Girl at a Window' painted in 1645 to the patient reading of character in 'Old Man', painted two years before Rembrandt's death in 1669, and in so doing you run with the course of the great master's life, from the brave vigours of youth to the humbling of age by experience and time. Like Shakespeare, who died when Rembrandt was aged about ten, the more he reads the minds and hearts of others, the more he becomes another, the more he is himself.

"Human kind", wrote T.S. Eliot in the *Four Quartets*, "cannot bear very much reality." Rembrandt looks with dispassionate humanity into the realities of the changing human condition, knowing that in each human situation he is there. His terms of reference for his paintings from the New Testament are the same as for his depictions of people of his own day. It might be that the great tenderness of 'The Rest on the Flight into Egypt' carries a gravity less frequently evident in other paintings of about 1630, but when one looks at 'Rembrandt's Brother' with the light gently recorded on the features, the features nonetheless reporting the wearing of life in a face that states its kin with the painter, then one must acknowledge Rembrandt's paint witnesses to a reverence for life itself.

One work was remarked more than any other – 'Family Group' from the Herzog Auta Ulrich Museum at Brunswick. "An incomparable work painted in Rembrandt's last years," wrote Ellis Waterhouse, the Director of the National Galleries of Scotland, in the foreword to the catalogue, while R.H. Westwater commented: " 'Family Group' sums up on one glorious canvas the whole amazing fund of knowledge of emotion, power and epic simplicity, which the world's greatest painter had amassed." The exhibition was a tremendous beginning.

It should be noted that two years previous to the Rembrandt exhibition the Royal Scottish Academy, whose annual exhibition is current with the Festival, had mounted within the framework of their exhibition one on the French artists Bonnard and Vuillard. This fine exhibition was a true prelude to the sequence of exhibitions of French art that began in 1952. In 1951 there was

an interesting exhibition of Spanish paintings from Morales to Goya drawn largely from Scottish collections, but in a sense that year was a breathing space after Rembrandt and before a succession of exhibitions of the highest standards, which complemented and added lustre to one another.

Neville Wallis in the *Observer* referred to the Degas exhibition of 1952 as a "thrilling Degas collection ... forty paintings and large pastels with the pick of his statuettes." He continued, referring particularly to the pastels,

Here his grasp of form and orchestration of colour transfigured by light might be accounted miraculous, were not every effect foreseen to a hairsbreadth. The unexpected angle of vision, the brilliant cross-hatched strokes, all the devices he brings to his ballerinas, flooding the stage or disillusioning us behind it, might seem at first a dazzling display of virtuosity. The fact is, of course, they result from ceaseless study in which he learned to give monumental expression to seemingly fugitive poses, adjusted to suit his preconceived designs.

"Fugitive poses" described the nature of ballet itself. A movement is stopped momentarily until another grows out of it. Degas comes upon a poise the result of an action and through this moment registers an enactment which shows the whole human being. In the exhibition as one looked at the same themes set down variously but never for the sake of variety, the beauty of the artist's truth to his subjects caused one to return to ask why this angle told so much so well.

The Renoir exhibition of 1953 consisted of forty-six paintings and four sculptures. They covered the artist's work from 1862 to 1918, the year previous to his death. Sir John Rothenstein summed up the appeal of Renoir in his introduction to the catalogue to the exhibition, in these words:

With fluency and skill Renoir has set down for us his sheer delight in the sensuous beauty of the world. Spring, summer and autumn: spring of the quickening of plants and the round cheeks of children and the movement of gay and charming girls across the crowded dance floor of the Moulin de la Galette; summer of the French landscape under sun and the lazy afternoon on the river; autumn of fruits and rich maturity. It is an instinctive art, appealing to the common experience of us all, demanding no intellectual efforts for its comprehension.

To enjoy Renoir is one thing; to experience Cézanne another.

For exhibitions there never was a year like 1954. In addition to Cézanne in the Royal Scottish Academy there was Richard Buckle's exhibition extraordinary – 'Homage to Diaghilev' at Edinburgh College of Art. The Festival Society took due note of these contrasting exhibitions. In the Souvenir Programme, Sir William Hutchison, President of the Royal Scottish Academy, commented on the series of French painters, housed in the Academy – which had paid tribute to Degas in 1911 by making him an Honorary Member – culminating in Cézanne, "possibly the most profound," he wrote, "certainly the most revolutionary, with an influence on modern painting beyond that of the other two." The selection of the paintings was made by Professor Lawrence Gowing, whose introductory article to the catalogue remains a reminder of the honour that was done to Edinburgh by the presence of this exhibition. In his article Professor Gowing made articulate what may have been dimly felt by the lay viewer. We may have apprehended the reality on the canvas but he comprehended it and related the forms and colours on the canvas to the created world which Cézanne observed. Of him Professor Gowing wrote:

The virtue of the living world before his eyes was that it remained real and alive. He assured himself of its continued existence at each look; each touch, owing nothing to the last, could record that its virtue was undiminished. Art was discovered to be a harmony parallel with the harmony of nature, nourished from it, built of it, yet leaving its separate virtue untouched; it was a discovery that the deepest loss might in this abstracted metaphor be made good. The discovery in its humility, brought a tremendous exultation, until the pictures shone with a radiant physical splendour.

This then was the kind of effect which the "finest and most complete showing of Cézanne ever to be seen in Britain", as *The Scotsman* Art Critic put it, could have on those who were prepared to give the necessary quality of attention to the paintings. "It is", the article went on, "one of the Festival's greatest triumphs to have succeeded in assembling it." The assembly came from, amongst other places, museums and art galleries in Boston, Chicago, Los Angeles, New York, Ohio, Amsterdam, Berne and Helsinki and from galleries in Britain. That so many treasures should have been loaned indicates the prestige of the Edinburgh Festival abroad. Behind the exhibitions was a small committee whose work made it possible. Its members

were David Baxandall, Director of the National Galleries of Scotland, Philip James from the Arts Council, and Sir William MacTaggart from the Royal Scottish Academy. The final preparations were carried out by Professor Gowing and Gabriel White.

Meanwhile at the Edinburgh College of Art was the more astonishing exhibition in memory of Diaghilev. There were 1,000 exhibits and from the moment of entry the balletic imagination of that creator of ballet, much fortified by the works of notable artists and the sound of music for ballet by notable composers, took over. It was as if the student's annual revel was in full swing but with a theatrical experience that was more heightened and consistent. At the head of the stairs was the tower from Utrillo's original backdrop from *Barabau*. In a darkened room upstairs were eight model theatres set up for scenes from ballets. There were decors by Picasso, posters by Cocteau for *Le Spectre de la Rose*, and a drawing by him of Diaghilev specially done for the catalogue, settings by Benois, costumes and settings by Bakst, decor and costumes by Derain, Matisse and Braque. The whole place blazed with life, or enveloped the visitor in the atmosphere of the ballet projected from the walls and about him. A screen from the *Coq d'or* shouted its red and golds. The sleeping princess had a room to herself with a blue ceiling, white muslin draperies and the tableau of the beauty not yet awake. The walls were hung with paintings by Bakst. There were original costumes worn by Nijinsky, Karsavan and Fokine, and one can only say – and so on and on.

Inevitably, one was tempted to reflect that 1955 could not possibly produce anything to surprise. It did – Gauguin. David Baxandall considered this exhibition "the greatest Festival Exhibition of the series." "A full-scale exhibition," he continued, "showing the full range of Gauguin's work has never before been held in Great Britain. There had been big exhibitions in Paris and Basel, but these did not show the gradual development, the long struggle to learn, how to say what he felt he had to say, nearly so well as it could be seen in Edinburgh."

Once again the painting experience of a great artist had been made available in Scotland, and one where the witness of the artist to the demands of his art at the cost of radically altering his mode of life was evident. One observed what Gauguin saw being put to his visionary use, and that it was a vision which he lived. Douglas Cooper in his introduction to the catalogue does not

rate Gauguin as highly as Cézanne or Degas. He commented, however:

> But we cannot have too much respect for his immense artistic understanding, for his perserverance in pursuing his original creative aims, and for his courage in daring everything. Unaided Gauguin did more than anyone to change the course of art by the example of his own work: by the time he died the worn out Renaissance tradition had been finally swept away.

Again the galleries of the world were ransacked for the exhibition – there were twenty works from the United States and sixteen from France, seven from Denmark, as well as works from Brussels, Oslo and Prague. If the exhibition was great, then so was the enterprise and effort of the organizers.

As the years passed the exhibitions became bigger. There were seventy-eight Gauguins in 1955, eighty-six Braques in 1956. For the tenth anniversary of the Festival the works of a living artist, Georges Braque, were on show for the first time.

In his introduction to the catalogue, Douglas Cooper, who selected the paintings, wrote:

> . . . as we survey his life's work today, there is no mistaking that we are in the presence of a great master certainly no less significant than Matisse and no less essentially French. Not only is Braque a supreme craftsman who has produced some of the most sublime and beautiful painting of this century, his is also an artist with a fundamentally new and personal vision of the world and of how it should be represented in terms of paint . . . The present exhibition – the first major collection of paintings by Braque to be seen in Britain – is intended to reveal as much of his achievement as is possible within the limitations of space imposed. It is certainly representative and, thanks to the exceptional generosity of museums and private collectors in different parts of the world, contains an unexpectedly large number of his most significant pictures as well as a galaxy of his masterpieces.

The critics agreed with Douglas Cooper's assessment of Braque and of the exhibition and went on to praise the catalogue. This was also the first test of public reaction to what the public called 'modern art'. There were no strong reactions recorded apart from the derisory joke of a councillor who said in the presence of the President of the Royal Scottish Academy, apparently expecting him to agree, "It braques my heart."

The great exhibition the following year – there is no avoiding the adjective – could cause no difficulties to anyone. One

hundred and ten paintings by Monet were exhibited. In size and
splendour there had been no other exhibition of paintings to
equal it. Of all the artists so far exhibited, Monet, the originator
of Impressionism, was most readily acceptable – so much so that
the first effect of being in the exhibition was of being transported
into the Monet sunshine and shimmer. The immediacy that the
artist appeared to catch so easily spread a summer of happiness
about the Royal Scottish Academy galleries. It was a first
impression. The final experience provided a deeper reading of
nature, particularly as one looked at the large canvases of those
late works 'Irises in the Water-Garden' and 'Water-Lilies'.
Whereas before, a moment flickered in sunshine and shadow,
time had entered the canvases and growth was presented. The
stillness contained those significant observations and registrations
from nature that related those beautiful paintings to the subtle,
inevitable changes of existence.

After the concentration on single artists the Festival showed the
Moltzau Collection at the Royal Scottish Academy. This
collection with its wide range of paintings ranging from the
period of Cézanne to 1958, was acquired from the Norwegian
owner through the good offices of Lady MacTaggart, herself a
native of Norway. It was an exhibition of great riches. Some of
the paintings were reminders of past exhibitions, such as the
exquisite painting of Madame Choquet, others such as paintings
by Soutine and Modigliani, forerunners of exhibitions that were
to come. Other works by contemporary artists had not been
shown before in Edinburgh, such as Manessier and Le Moal, and
they demanded that readjustment and exploration characteristic
of new original work. In 1958 the Festival also widened its range
with an exhibition of Byzantine art in the Royal Scottish
Museum. This assemblage of religious art objects from many
countries dating between the fourth and fifteenth centuries was
achieved by the knowledge and labour of Professor and Mrs
David Talbot Rice. Without their authority and the prestige of
the Edinburgh Festival it is doubtful if the museums of Europe,
especially in Russia, Turkey and Italy, would have released their
treasures.

The exhibition of Czech masterpieces in 1959 was not of the
highest standard throughout, although the section showing altar-
pieces from the fifteenth century had a richness and refinement
that implied the existence of a civilization early in the history of
that much tormented area. The official exhibition of 1960 was on

A scene from *Orlando Furioso*, Luca Ronconi's production of
Ariosto's play which set the Festival alight in 1970

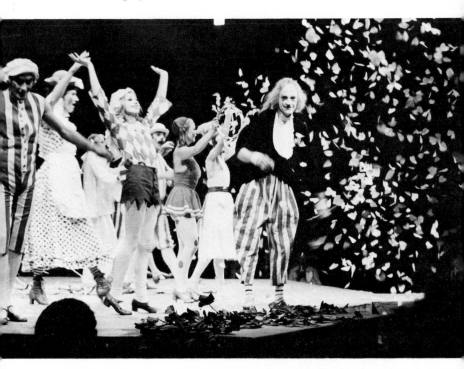

The Actors Company in the pantomime with which they followed
The Bacchae in the Assembly Hall in 1974

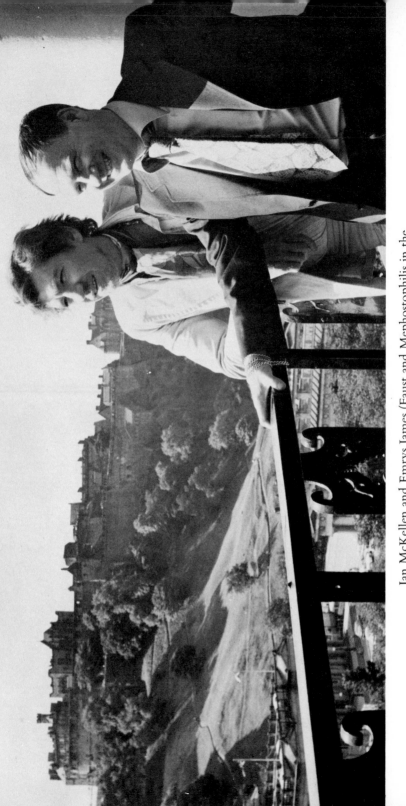

Ian McKellen and Emrys James (Faust and Mephostophilis in the Royal Shakespeare Company's production of Marlowe's *Faust*) on the balcony of the Festival Press Bureau in 1974

The first Festival Executive Committee, 1947:
(*left to right*) Councillor W. P. Earsman, John D. Imrie (the City Chamberlain), Councillor Andrew Murray, H. Harvey Wood, John Storrar (Town Clerk), Councillor I. A. Johnson-Gilbert, Sir John Falconer (the Lord Provost), John Reid, Lady Rosebery and William Grahame

Lord Lyon, H.R.H. Prince Philip and Lord Provost Sir James Miller
at the opening of the 1952 Festival

Gunther Rennert, Intendant of the Hamburg Opera, and Festival
Director Ian Hunter at the 1951 Festival

Festival Director Robert Ponsonby greets members of the company
of La Piccola Scala, including Graziella Sciutti and Maria Callas,
in 1957

A group of the Festival Voluntary Guides with the Lord Provost
Sir James Mackay in 1971

Lord Harewood, the Festival Director, meeting Marlene Dietrich
on her arrival in Edinburgh in 1965

Peter Diamand, Festival Director, welcoming Teresa Berganza
who sang *La Cenerentola* in 1971

Leonard Bernstein being greeted by the Festival Director
Peter Diamand and a piper on his arrival in Edinburgh in 1973

the other hand above expectation for many, at least for those who had seen only individual paintings of the German expressionists. The exhibition was limited to the group of painters that grew round Kandinsky and Marc in the early years of this century, and which came to be called the Blue Rider Group. Dr Rothel of the Munich City Art Gallery arranged, catalogued and hung the exhibition. In the foreword to the catalogue, Robert Ponsonby, then in his last year as Director of the Festival, wrote:

> The series of exhibitions so far presented at the Edinburgh Festival has given ample recognition to the masters of the French school, and since recent criticism and recent developments in painting have clearly shown that the creative impulses of the present generation derive as much from Munich as from Paris, it is hoped that this exhibition – the first of its kind to be held in this country – will help to redress a long standing debt to a group of artists who, apart from being the prime movers of the now world-wide abstract movement, looked with a fresh eye on the possibilities of realism.

Thanks to this exhibition the freshness, vigour, and even daring of the Blue Rider group was experienced nearly half a century after its formation. Der Blaue Reiter took its name from an art almanac edited by Kandinsky and Franz Marc, "a name which still appears to be full of yearning and stormy courage," as Dr Rothel so aptly commented in his introduction to the catalogue. He selected the paintings by the fourteen artists represented, amongst whom were Klee, Jawlensky, Kandinsky, Macke, Franz Marc, Gabriele Munter and the composer Arnold Schoenberg. While at the front in the 1914-18 war, Franz Marc wrote a series of aphorisms. Number 25 began: "In the twentieth century we shall live amongst strange faces, new pictures and unheard-of sounds." In 1960 the visual references in the statement still applied to the experience of the exhibition, while the reference to sound draws attention to Schoenberg, who exemplified the bringing together of music and art.

If 1960 was a good year, 1961 was a great one. Lord Harewood, the new Director of the Festival, presented a fine exhibition of masterpieces of French Painting from the Bührle Collection. Douglas Cooper chose the paintings from this very great collection; "seventy-six of the very best," commented David Baxandall, "and the level of the quality is quite astounding." This exhibition of paintings by the Impressionists

and the Post-Impressionists gave a context to work of individual
painters previously seen at the Festival, but above all it was
simply, enormously enjoyable. And yet for impact and
imagination it could not compare with Richard Buckle's second
exhibition – his 'Epstein' at the Waverley Market. "This, I
believe to be the most astonishing and deeply moving of all
Festival art exhibitions hitherto," said James Cumming in a
broadcast in 'Arts Review', and continued,

> Splendidly isolated in Waverley Market, signally commanded by
> the heroic St. Michael and the Devil – high above the entrance, the
> life's work of Epstein has been assembled vividly, judiciously and
> most beautifully. Above all it is the first and probably the last truly
> great manifestation of his entire sculptures to be reviewed under one
> roof. Twenty-four spacious rooms subtly lit and draped in cool
> reticent colours, display over 200 masterly exhibits in chronological
> groups.

This was the Memorial Exhibition which the Festival Society
declared itself proud to present with Lady Epstein's help.

"Epstein spoke to and for the entire race of persecuted, yet
aspiring humanity", wrote Sydney Goodsir Smith in *The
Scotsman*. He continued, "The persecution is there in every figure
of Christ, the aspiration in such works as Adam and once, in
what I think is his masterpiece, the 'Jacob and the Angel' of
1940–41, he achieved a fusion of the two." But the aspiration in
Adam is matched by a pull of earth and an animal bulk in the
person so as to suggest that groaning creation that emerges with
hazard and difficulty in birth. One's mind goes to Epstein's
'Genesis' and one recollects how he was hated by petty minds for
the expression in stone of truth. One might begin at another
point in the exhibition and find oneself caught up in the
happiness of child-life, in the bursting careless life of babies, or,
looking at the fragile, transparent beauty of the 'Girl with
Gardenias', sense the transience of life. Or one might go over the
long list of portrait heads, and find each one alive according to
his kind from the imperious, romantic 'Cunninghame Graham'
to the compassionate portrayal of 'abject patience' in 'Old
Pinager'. And not only were all these to be seen in the Waverley
Market but seen wonderfully, in the right space in the right light.
It was a triumph for Richard Buckle and in the opposite terms of
his Diaghilev success.

There were two contrasting exhibitions in 1962, the refreshing
Yugoslav Modern Primitive Exhibition in the National Gallery

of Scotland and the wide-ranging, discriminating exhibition of the Sonja Henie–Niels Onstad Collection. In the latter, while there were fine examples of the work of Matisse and Bonnard, the emphasis was on the constructive expressionists.

In 1963 there were two exhibitions of real moment in the Royal Scottish Academy allowing the great majority of visitors to the gallery to experience for the first time in depth the work of Modigliani and Soutine. I had experienced before the strong attraction, and sometimes repulsion, of single works of Soutine but the power that the show as a whole exerted was almost physical. Soutine brought one too close to his painting of the carcase of the ox for comfort, as distinct from the quality of admiration which one paid to its Rembrandt original. Objects and persons spoke out of themselves of the energies that made them what they were. However frenzied (and this was the effect of some of the distortions), there was always a living being at the centre with its – or his or her – own individuality. The reality of the existence of the thing seen and felt seemed to be at the heart of the painting, but it existed by its exertion of its animation on the spectator. How different was the painting of Soutine's friend Modigliani. Straight away the eye went to the firm, elegant, containing line that detached the subject from its background and from the spectator so that it could be observed with a calm mind. Initially also there was the effect of being surrounded by figures depicted in a personal ikonography which inhibited recognition of the subjects as persons. Once a closer inspection was made one knew that the classic formality of line, beautiful in itself, was a means for Modigliani of solving the absence of an agreed idiom for painting portraits, within which exact and delicate observations of personality were made, and made as much by tone and colour as by line. All accidents seemed to have been eliminated until his final statement would admit of no further reduction or addition.

John Russell, in his introduction to the catalogue, refers to his "breakthrough to a complete simplicity which occurred, most notably, in the 'Man with a Pipe'. This was the quality of those late drawings of Modigliani's which, in the words of Miss Mongan of the Fogg Art Museum, 'descend so directly from the greatest master of line, Leonardo da Vinci.' " In the forewords to the two catalogues Lord Harewood pays tribute to the assiduity and ability of John Russell and David Sylvester in mounting the exhibitions, and gives thanks to the lenders of the works. The difficulties were many and great.

In 1964 there were two large exhibitions – 201 works by Delacroix in the Royal Scottish Academy and the quatercentenary commemorative exhibition of Shakespeare's birth at the Waverley Market. The Delacroix exhibition was important because it was the first large exhibition of a painter's work in this country which had greatly influenced the innovating painters who followed him, and who thereafter was for some years unfashionable. Was he, as some felt, the painter of the large romantic gesture, the heroic scene from which the life of men escapes? At the end of a broadcast, David Baxandall had this to say: "To me the final effect of this exhibition is of the variety and universality of Delacroix's genius. It seems to me to proclaim his greatness quite unmistakably."

The Shakespeare exhibition was another piece of imagination by Richard Buckle, emanating, as on previous occasions, from the character of the subject. This time however, fascinating and inspiring as the exhibition was, its true climax could be realized only on the boards of the theatre. Even so, in the Long Room, we looked through the eyes of an Elizabethan from a gallery of the period out to the Thames, while above the richly encrusted ceiling and on the walls the portraits of Elizabeth and of her courtiers reinforced the sensation of being in that other place and time where the wonders of Shakespeare were presented for the first time. In the Gold Room were treasures in small cases, paintings and drawings of scenes from the plays and variants on Shakespearean themes by Kokoschka, Sidney Nolan, Ghika, Keith Vaughan, and others. At the end of the tour was a large model of The Globe Theatre wherein music by Byrd, Dowland and others, and speeches from the unseen lips of Gielgud, Olivier and Dame Edith Evans, were discoursed.

In 1965 the 'classicist' Corot took the place of the romantic Delacroix in the Royal Scottish Academy, whose paintings were exhibited the previous year. There could hardly have been a greater contrast of styles from the same period, for Corot, born in 1796, was two years older than Delacroix, outliving him by twelve years – he died in 1875 – as befitted a painter of serenity. The exhibition was the first truly representative exhibition of Corot in Britain. Some of the works were examined for the first time in this century.

Whereas the Delacroix paintings welcomed the spaciousness of the Royal Scottish Academy galleries, one soon felt the Corots lost something of their presence. Great care and much research

had gone into achieving the exhibition, for which Cecil Gould of the National Gallery had been responsible. His introduction to the catalogue concluded with these words:

> When, indeed, we think back to Corot after contemplating the massed ranks of giants who were his juniors – Courbet, Manet, Degas, Monet, Renoir, Pissarro, Cézanne, Seurat, Gauguin and Van Gogh – we may be tempted to regard him primarily as a forerunner and his glory as something reflected back in time from theirs. Though such a view would not be entirely devoid of foundation it is perhaps more logical, and in the present context more satisfactory, to think first of Corot as a great artist in his own right.

A great artist? Certainly one who gives immediate pleasure, whose work is immediately recognizable as belonging to an individual sensibility of great delicacy, but, I must confess, there was not the excitement of discovery as one went from painting to painting, nor did he grow in stature. Perhaps 'great' is an unhappy word to describe the pleasures of Corot.

There were pleasures of a different kind to be found at the Royal Scottish Museum as one studied the 'Historic Treasures of Rumanian Art'. Bejewelled objects, carvings in wood and metal, exquisite embroidery, stylized paintings on wood, beguiled the spectator to withdraw from the world outside.

Sooner or later one hoped Rouault would make his appearance at the Festival. He did in 1966. Since his death in 1958 there had been many exhibitions of Rouault in other countries, but this was the first in Britain. Because a few canvases and the repetition of a limited number of reproductions had created a specific Rouault, the variety and intensity of his expression in many subjects came as a surprise. In the Festival Souvenir Programme John Russell, who selected the paintings in consultation with the painter's daughter, Mlle Isavelle Rouault, wrote:

> ... the exhibition is designed to show Rouault in the round ... There are paintings that are pure untroubled eye-music and there are paintings in which Rouault explores the darkest places which society and the individual have to offer (or to hide). There is something of everything and something for everyone: and there is above all the figure of Rouault himself – a man who was, but would never have claimed to be, one of the greatest European originals.

So at one moment one might look at 'Night Landscape' – a great sky with light breaking through threatening cloud dominates the figures of workmen on their way to the labour

that industry demands of them, a grave and beautiful painting with social indictment implied; at another at the superb depiction of a dancer – all concentrated energy in the thrust upwards of the leg; at another at the degradation of a 'Drunken Woman'; at another at the melancholy tenderness of 'The Old Clown', given a monumental treatment; at yet another at the gravity and tragedy of 'Christ Mocked' – the list may be extended for pages. This was Rouault.

There followed in 1967 the first large retrospective exhibition in Britain of Derain. Peter Diamand acknowledged the debt to Jean Leymaire for creating the exhibition and to Madame Alice Derain, the artist's widow, "without whose help the exhibition could not have been realised", and then went on in the catalogue to state it would "help reassess an artist's work which has suffered from many years of neglect and lack of imagination." What Derain could, and did, give to the great majority of Festival visitors was the enjoyment of pictures which were themselves a studied enjoyment of the visible world. They did not call for those readjustments to the style of the painter which are a stumbling block to the uninstructed. On the other hand Derain may have been undervalued by critics because he shows no marked departure from accepted styles. Even so that very individual stylist, the sculptor Giacometti, wrote of him: "Derain excites me more, has given me more and taught me more than any painter since Cézanne; to me he is the most audacious of them all."

There were three other exhibitions in the twenty-first Festival – 'Treasures from Scottish Houses', a fine collection of decorative objects in the Royal Scottish Museum, and 'Two Hundred Summers in a City' in the Waverley Market to mark the bicentenary of the New Town of Edinburgh. The greater part of this inventive exhibition allowed the visitor to walk through parts of the New Town in miniature and to meet, by means of models and set scenes, the people who inhabited Edinburgh at the time of the building of the New Town.

The third of these three exhibitions marked a departure from previous practice. One of the reasons for the continuing liveliness of the Edinburgh Festival has been its ability to respond to developments in art that have taken place outside the official Festival. In 1966 the Demarco Gallery opened. Its 'fringe' Festival exhibition showed the work of fifty-six contemporary artists drawn from many countries. In 1967 came what is referred to in *International Art Exhibitions*, arts magazine yearbook 10, as "the

famous Edinburgh 100". 'The Edinburgh Open 100' exhibited 100 works chosen by a jury consisting of David Baxandall, then Director of the National Galleries of Scotland, Sir Ronald Penrose, Director of the Institute of Contemporary Art, and Norman Reid, Director of the Tate Gallery. There were 1,500 entries. Prize money of £4,150 was awarded to nine artists. The first three, who received awards of £1,000 each, were Robyn Denny, John Hoyland and Victor Newsome. The exhibition was sponsored by the Richard Demarco Gallery in association with the University of Edinburgh and with the support of the Scottish Arts Council. The skills of the final hundred were undoubted, but to many of the spectators the predominating effect was an anonymous cosmopolitanism. More important, it brought the visual arts of the Festival firmly and sharply into the domain of new work in the 'sixties.

The following year the Festival gave a new view of the modern art of the 'nineties in its celebration of the centenary of the birth of the Scottish architect Charles Rennie Mackintosh, one of the founders of modern architecture. His masterpiece is the Glasgow School of Art. Short of holding the exhibition there, the designing of rooms in the Mackintosh style in the Royal Scottish Museum, in which were displayed Mackintosh furnishings, designs, silver and paintings, was the best possible solution. The designer was Henry Hellier, Head of Design in Glasgow School of Art. The compiler of the exhibition was Andrew McLaren Young, Professor of Fine Art at the University of Glasgow. Three hundred and fifty Mackintosh items would in any case have shown the original, inventive mind of this artist, but brought together as they were in the context of Mackintosh's room and architectural designs, the *fin-de-siècle* decorative element was placed with the Scottish vernacular, in which Mackintosh's creative imagination was rooted.

Edinburgh was due another debt to Glasgow in the exhibition in the Royal Scottish Academy where paintings from Boudin to Picasso lent by Glasgow's Municipal Art Galleries revealed the strength of Glasgow's permanent collection, particularly in the Impressionist and Post-Impressionist period.

There was a third Festival exhibition – the strong, earth-bound sculptures of Wotruba. These were, unusually for Festival shows, not shown to their advantage but displayed in a self-conscious decorative design which looked like a hangover from the Mackintosh exhibition.

A fourth official exhibition reflected the increasing, stimulating

part that the Demarco Gallery was playing in the art life of Edinburgh. This was the exhibition 'Canada 101', described in the Souvenir Programme as the successor to the previous year's 'Edinburgh 100', also conceived by Richard Demarco and even more productive of bewilderment and dissent. That the Festival should show works which call into question the nature of art, that should put to the test the assumptions of the spectator, is surely very desirable. This was the character of 'Canada 101'. Some thought it a case of the Emperor's clothes all over again, some that the objectives were merely sensational. Certainly some of the social comment in a few paintings told the brutal truth brutally, but others revealed fine craftsmanship and delicacy of feeling. In any case the Festival had ventured in 1967 and again in 1968. It was to go even further in 1970.

After the disturbance of the two previous years 1969 was comparatively quiet. There was an exquisite exhibition of 'Sixteenth-Century Italian Drawings' in the Merchants Hall, an architectural exhibition in tribute to the gold medalist from Glasgow, Jack Coia, a lavish exhibition called 'Pomp' at the Royal Scottish Museum – a grand display of precious metal work, organized by the Worshipful Company of Goldsmiths and lent by the City of London – and 'Contemporary Polish Art' at the Scottish National Gallery of Modern Art. Interesting as these were, they could not compete with the great exhibitions of previous years.

1970 produced two contrasting exhibitions, the traditional 'Early Celtic Art' at the Royal Scottish Museum and the explosive 'Contemporary German Art' from Dusseldorf. The former, with its craft and art objects from a remote past and drawn from many countries, required that reading of the situation which demands attention to detail. It might not have been popular, yet Professor Piggott's imaginative presentation persuaded the numbers to come and many to return to explore again. The stylized decoration of the objects pointed to a style of life.

Against this the Dusseldorf exhibition presented a series of experiences made out of the amorphous chaos in which man lives today. As against Art being conceived as a made object, this exhibition contrived situations and events which changed the spectator to a participant. One room with furred objects that moved, in plates served for eating, implicated the visitor in a blood-guilt situation. Naturally there was hostility, but there was

also the compulsion to look again at the ordinary objects that come our way, so that we might see them for what they are, in truth extraordinary – as extraordinary as any common act is in this life.

When in the 1950s the Festival began to mount its incomparable series of exhibitions of the *œuvres* of acknowledged masters, the unique position of the Edinburgh Festival and the consequent desire of entrepreneurs and respresentatives of other countries to display there the finest art possessions of their countries, allied to the standing of those responsible for mounting the exhibitions, made possible these great exhibitions. By the twenty-fifth Festival all these favourable conditions had long since ceased to obtain. Costs had risen inordinately and requests for the loan of great paintings had made owners chary of parting with them.

The exhibition of 'The Belgian Contribution to Surrealism' in the Royal Scottish Academy galleries in 1971 was therefore a triumph for the Director of the Festival and the organizers. Peter Diamand wrote in the catalogue: "There has been no large exhibition of surrealism in Britain since the war and never a large exhibition, such as this one, dealing with the important contribution which the country of Belgium has made to that fascinating movement in the visual arts." In her survey of the surrealist movement in the catalogue, Madame Gisele Ollinger-Zinque wrote: "Let us first lay down the guiding principle: the artist reveals in broad daylight what he has seen in the 'night' of his mind. Let us recall that he does so quite freely, without any hindrances or taboos, trusting the unbridled imagination of the surrealist credo: 'L'esprit contre la raison' (R. Crevel)."

In the exhibition one walked into a dream, in which the mystery was the greater for the clarity with which objects and persons presented themselves, just as the disturbance was the stronger on account of the preoccupied calm of the figures. Magritte and Paul Delvaux were well represented. The exhibition also included paintings by Pierre Alechinsky, Poly Bury, Jacques Cheamy, Octave Landuyt, Marcel G. Lefrancq, Marcel Marien, Maurice Roquet, Armand Simon, Raoul Abac, Serge Vanderoam and E.L.T. Mesens – artist, poet and champion of the surrealist movement, who died in May 1971, and to whose memory the exhibition was dedicated. Peter Diamand made an interesting point in his acknowledgements in the catalogue, when he wrote: "As this exhibition demonstrates, the surrealist

movement continues in the work of younger Belgian painters and indeed at this very moment there is a small group of Scottish painters in Edinburgh working the same vein."

Some exhibitions are of interest because they draw attention to the continuing vitality of their subject, others because they remind us of our changing history. It may be that the two exhibitions to commemorate the bicentenary of the birth of Sir Walter Scott belong to the latter category. The exhibition in Parliament House demonstrated Scott's prodigious output, and mounting it in Parliament House gave the exhibition Scott's own environment. The other exhibition, 'Writer to the Nation', attempted, as John L. Paterson, its devisor and designer, wrote, "to create in visual and aural terms something of the quality of the writer and his work; to breathe life into what is only a name to a wider public." Of the celebration of literary men by visual means one can only hope that the spectators are sent away with a renewed curiosity in the writer's books.

The exhibition of 'Contemporary Romanian Art' at the Demarco Gallery was a very different kettle of fish. "These eleven artists and the constructivist Group Stigma from Timisoaro", wrote Richard Demarco in the Souvenir Programme, "should prove that twentieth-century artistic expression can still derive strength from long established traditions embedded in an agrarian society." The exhibits witnessed, I consider, much more to the contemporaneity of the artist than to any society, though the carved wooden angels of Ovidiu Maitec had their beginnings in a simpler country world, not that they looked back. They belonged with the curious interpretations of the figures of man constructed by Paul Neagu, whose work has been seen in Edinburgh on several occasions since 1971.

There was one other very approachable exhibition in the official Festival, 'Coia Caricatures'. For seventeen years previous to 1971 Emilio Coia had enlived *The Scotsman* with portrait-caricatures of celebrated artists at the Festival. A selection of these shrewdly observed, but always kindly noted, pastels and drawings was a welcome addition to the exhibitions.

The 1972 Festival did not provide a major representative show, but the paintings at the Royal Scottish Academy of Alan Davie made a considerable impact. "Visitors to the Festival Exhibition", wrote James Cumming in the Souvenir Programme, "will readily become familiar with certain characteristics in the

work of Alan Davie: an innate love of colour, a joyous spontaneity of handling paint, a sustained vitality and intensity of concentration and a long experienced love of lyrical images, moods and symbols, which lend themselves naturally to strangely poetic and fantastic titles." The titles, one must admit, seemed to be an afterthought, even red herrings which might get in the way of a response to the enormous exuberance of Davie's imagination. The exhibition was mounted by the Academy, to honour this Scottish painter of international repute.

The Demarco Gallery continued to show its aliveness to the contemporary European scene by presenting a second 'Exhibition of Contemporary Polish Art'. In this exhibition there was no reliance on past traditions. All was concept and conception, new forms and novelty – an exhibition not to be readily assessed, nor did Richard Demarco ask for this. The exhibition, he said, ". . . should not . . . attempt to answer questions, rather it should pose them." It did.

No questions were posed by the exhibition of 'Italian Seventeenth-Century Drawings from British Private Collections'. This was a rare exhibition after the manner of the exhibition of Italian sixteenth-century drawings in 1969, and suitably housed, as was that exhibition, in the Merchants' Hall in Hanover Street.

If an Arts institution is to retain the breath of life after it has settled into an agreeable and agreed pattern, it will do so only if it is prepared to change the pattern in response to the developing interests of new generations of artists. Reluctant as I am to say it but needs must, the impossibility of presenting an endless series of great one-man shows of acknowledged masters may have done a service to the Festival. The outcome of the difficulty has been a shift of emphasis in the Festival to exhibitions of new or experimental art. "We, today," Paul Nash wrote, "must find new symbols to express our relation to our environment. In some cases this will take the form of an abstract art, in others we may look for some different nature of imaginative research. But in whatever form, it will be subjective art."

These words were written more than forty years ago as a contribution to the manifesto of Unit One, a group of English artists, including architects, who found it necessary to band together to defend their art against those interests determined to preserve the *status quo*. They apply to the conditions of today. The response to the changing condition was seen in the official

Festival in its sponsoring 'Edinburgh 100', in 1967, in its acceptance of the 'Contemporary German Art Exhibition' from Dusseldorf in 1970 – with its implication of spectator participation – the exhibition 'Contemporary Romanian Art' in 1971, in which Paul Neagu and other artists continued to work on their exhibits as if there could be no finality, and again in 1973 in the 'Permanences de l'art Francais' at the Royal Scottish Academy, which was intended to demonstrate, in George Boudaille's words: "the bold innovatory character of contemporary art."

One could set over and against this exhibition in 1973 'Objects U.S.A.', which was on view at the City of Edinburgh Art Gallery, a new locus, administered by George Wright Hall whose death in the autumn of 1974 was a serious loss to that gallery. 'Objects U.S.A.' was apparently a crafts exhibition. In so far as the term 'craft' consigned the objects to a lower category that 'art' objects, then the term was inadequate to the intention and realization of the exhibition. Its director, Lee Nordness, made the appropriate point with clarity. He wrote:

> During the past twenty years the interaction between the once separate worlds of painting–sculpture and crafts has become so intimate that separating the expressions into 'major' or 'fine' or 'minor' or 'decorative' can now only be done on a quality level, not on a media one. That is, when one puts a contemporary painting beside a contemporary object in glass, the painting may well be deemed the 'decorative' object and the work in glass the 'fine' one.

There was also in 1973 an exhibition of photographs and theatrical effects to the memory of Sir Tyrone Guthrie. This was appropriately associated with the new production of *The Thrie Estaites*.

The quotation in this chapter from Paul Nash may well have found its way on to the page, not because it was appropriate to the matter under consideration, but because it was associated with the exhibition in the 1974 Festival, which gave me much pleasure, 'Art Then: Eight English Artists 1924–1940'. It was organized by David Baxandall. The works exhibited in the Scottish Arts Council gallery under the auspices of that body, were by Barbara Hepworth, Henry Moore, Paul Nash, Ben Nicholson, John Piper, Ceri Richards, Alfred Walls and Christopher Wood. Admirably arranged, it gave one the sensation of being at the beginning, and fulfilment of a time where each of these artists had come to know what they had to

say in their media. To a greater degree, invention, freshness and genius spoke out from the walls of the Scottish Gallery of Modern Art, in 'Paul Klee: The Last Years'.

It was as if one had been returned to the pristine years of the great one-man shows of the Festival. The more one returned to those small, humorous, sad paintings, with their exquisite mingling of innocence and sophistication, the more one felt in the prescence of a man of rare spiritual quality. Yet neither of these exhibitions was under the auspices of the Festival. The word 'fringe' does not, of course, apply. In any case the Festival Society acknowledged them in their Souvenir Programme. If the Scottish Arts Council, the Scottish National Gallery of Modern Art, the Scottish National Portrait Gallery (which presented a collection of portraits, entitled 'A Face for Any Occasion'), and other institutions undertake the responsibility of presenting a wide range of exhibitions, then the Festival Society may be encouraged to continue its increasingly adventurous policy in the visual arts, without, of course, losing touch with the historic and broader interest to which it is committed by policy and success.

Inevitably in putting on new work risks are taken and many who go to the new exhibitions come away baffled. Whatever could be said against 'Aachen International 70/74', its New and Super-Realism made its presence felt to such effect that one found difficulty in adjusting to the more usual proportions and perspectives of the other exhibits in the Royal Scottish Academy gallery. The remark does not take account of the Conceptual Art from Dr Peter Ludwig's collection, who was responsible for the selection for the exhibition. The Festival Society presented a second exhibition of modern art, 'Eleven Dutch Artists', in association with the Scottish Arts Council. This exhibition revealed the desire of several of these artists to use the documentation of everyday life as a means of expression. It seemed to pose the question, at what point, if any, do these given objects, generate an interest and control of the sensibility, by which they have become different from what they seemed to be when in their use and wont situation?

It is tempting to end the chapter with a question, but then the exhibition of 'Eighteenth-Century Musical Instruments: France and Britain' must be remarked, at the City of Edinburgh Art Centre. The instruments were beautiful in themselves, beautiful for their purpose and beautiful to the ear.

11

The Film Festival

That art which is of this century as none other, has had its Festival as a separate but integral part of the Edinburgh Festival from 1947. Closer to the day-to-day interests and dreams of populations, the cinema has exhibited the flawed features of twentieth-century humanity – its banalities, its self-indulgence, its crude escapism, but also the vitality, courage and quality of imagination that men have made out of the given situation. The Edinburgh Film Guild, which took the initiative in establishing the Film Festival, was founded in 1930 with a view to presenting "unusual films not normally seen in the ordinary cimena". The first Chairman was J.H. Whyte, the Editor of *The Modern Scot*, a literary quarterly which published new Scottish poetry and prose alongside comment and writings from other countries. The context is significant, for when, seventeen years later, the Film Guild mounted its first Festival its concern was to show the best documentary films available, an area of film-making unlikely to attract the stars to Edinburgh.

This was the point of beginning and the first statement about films in the Festival was made appropriately by John Grierson, founder of the idea of documentary, who referred to this art as "the creative treatment of actuality". He also found it appropriate and natural that the interest in social realism on the screen should develop from the land that produced Robert Burns.

Eight years later, in 1955, in his reply to the welcome extended to visitors to the Film Festival by the Lord Provost of Edinburgh, Dr Carl Dymling, then the leading film producer in Sweden, said,

> The Edinburgh Film Festival has come to mean a great deal to us all. Every film-maker, to whom the artistic value of a film means more than, or just as much as, its entertainment value, has learned to appreciate that in Edinburgh he will find a sincere interest, a fair

chance, a sound judgment, regardless of any tourist interests or commercial considerations. This is an achievement.

Dr Dymling's last sentence indicates the peculiar difficulty of maintaining standards in an art where commercial success was essential to its continuing existence. The conditions, however, within the field of documentary were more favourable than in features. The quality of the first year's films was indisputable.

In 1947 the Film Festival presented Rossellini's *Paisa*, Rouquier's *Farrebique* and Paul Rotha's *The World is Rich*. From Sweden there was work by Arne Sucksdorff, from Canada experimental films by the Scot Norman McLaren, as well as short films from Denmark. Compared to the greatly expanded Festival of recent years, the one week of films looks insignificant. Nevertheless it created an immediate prestige.

1948 was more ambitious. Over a hundred films from twenty-five countries were shown in three weeks. Flaherty's *Louisiana Story* was given its première. Already the Festival was going beyond documentary. Rossellini again contributed a film – *Germany, Year Zero*, while from France came Nicole Védrès' *Paris 1900*. Yugoslavia sent one of its first features, *Slavitza*. Whereas every experiment in the Arts other than cinema was set against the background of accepted masterpieces, practically every film exhibited was experimental in the sense that it was new. Many, perhaps the majority, of those shown which had an immediacy of effect at the time – I think of *Louisiana Story* – have since become dated. A few remain testimonials to those men of genius who adapted life to the form of the medium. Films of this calibre still work.

One of these, *Jour de Fête* with Jacques Tati, was given its première in the 1949 Festival. The Edinburgh Film Festival testified to the character of its purpose in films which were serious at the moment of their production – from Russia, Hungary and Poland that year came films made out of their societies. *The Last Stage* from Poland was a frightening indictment of Nazi brutality.

In 1950 the scope and number of films in the Festival again increased. One hundred and seventy films from twenty-four countries were presented. Of these, fourteen were feature films, five of which were premières. As it got older, the confidence of film-makers in many countries increased in the Edinburgh Festival. By 1949 it was already a meeting place for directors and

producers. In that year Robert Flaherty, John Grierson and Sir Stephen Tallents met and talked at the Festival, which early instituted discussion sessions with directors, so that their views in film-making might be better understood. This approach did not make Press headlines. It was in line with the aims of the Film Guild, that amateur body – one acknowledges the dignity of the word in this context – to promote an intelligent interest in cinema.

The numbers of films shown, the numbers of the audience, the range of interests, increased, but the realist tradition – based on documentary but not necessarily in that category – remained central. In 1955 the film *Oro di Napoli* was attended by its director Vittorio de Sica. In a speech he prophesied a revival of what he called neo-realism, remarking as example his own *Umberto D.* The mention of the film brought applause, approbation that confirmed the existence of a growing film *cognoscenti* in Edinburgh. That Festival opened with Pabst's *The Last Act*. The emphasis on the problems of men in society was continued in *The Blackboard Jungle*. Russia, Czechoslovakia, Poland, Yugoslavia, China, Japan and India were among the countries that sent films in 1955. During the Festival the Japanese entry *Ugetsu Monogatari* received the Selznick Golden Laurel Award for its contribution to international understanding. The Japanese also presented *Children of Hiroshima*, an account of the consequences of the atomic bomb dropped on that city.

Education films and films specially made for children were also increasingly getting attention. Seven films for children were shown in 1955 and a public conference was held on the subject 'Making Films for Children'. This, along with a private meeting of members of U.N.E.S.C.O., led to the setting up of an international centre concerned with the making of children's films.

At the tenth anniversary of the Film Festival Her Majesty the Queen, the Duke of Edinburgh and Princess Margaret attended a special performance of Gene Kelly's *Invitation to the Dance*. The seal of royal approval was paralleled by that of distinguished film-makers. Sir Michael Balcon stated: "Edinburgh is rapidly becoming the most important centre in the world for film festivals and I do so hope that it will not be debased as some other festivals have." The Report on the Tenth Festival took stock. It noted that, as in previous years, programmes of international films for children were shown, that the Educational Film Conference which had become established had as its theme that

year 'Youth and Film', that the British Film Academy's third annual celebrity lecture was given by Mr Charles Frend, that once again the Selznick Golden Laurel Awards organization had honoured the Festival by making known there the award which went to Sir Michel Balcon for *The Divided Heart*, and that the first International Art Film Competition had been organized within the framework of the Film Festival.

Government representatives attended the Festival from twenty countries including Australia, Bulgaria, Canada, Ceylon, China, Czechoslovakia, Denmark, France, Germany, Hungary and India. These eleven indicate the worldwide respect for the Festival. Three hundred and sixty films were submitted to the Festival. Out of these two hundred from thirty-one countries were selected for screening. Of these, forty-four were feature films.

The above summary and list does not exhaust the events of the Festival. The Festival had been brought into existence by the enthusiastic endeavour of the Film Guild. Ten festivals later the same honorary officials, and especially the Honorary Chairman, Norman Wilson, and Forsyth Hardy, Honorary Secretary, assisted by an advisory body, some part-time workers and one permanent salaried official, kept it going. There was no Director.

"It is safe to say that no other international Festival on the scale of Edinburgh is run on so little cost", ran the 1956 Report. It continued, "It must be recognised, however, that this is no longer a virtue but a serious disadvantage."

As if the undertaking was not already in danger of crushing the enthusiastic Festival workers, they seemed to make sure of their disintegration under the burden by publishing a finely produced film magazine in the winter of 1956 entitled *The Living Cinema*. This was the preface to the first number.

For ten years the Edinburgh Film Festival has been presenting from all over the world examples of what it terms 'the living cinema' – that is films which by their originality and imagination, by their quality of truth and their sense of revelation, reach out towards a new cinema that is fresh and natural, that is close to the people and the drama of our times and that uses to the full the unique creative powers of the film.

The Living Cinema is intended to be an extension of the Festival in print. Its aims will be the same – to recognise and encourage all new ideas and developments which contribute to a vital and vigorous cinema.

The Living Cinema offers a forum for the discussion and analysis of

all aspects of creative film-making. It is hoped that writers and film-makers of all countries will use its pages to express themselves with freedom and frankness.

The preface summed up what the Festival had done and was doing, and daringly provided a measure against which future Festivals might be put. The magazine was published from Film House, 6-8 Hill Street, offices now much too small for the projection of the Festival.

In 1957 Calum Mill was appointed as the first Director. The post was not regarded as a full-time one, though the hours worked in the summer must have made up in overtime any shorter days of winter. In 1958 the Film Guild and therefore Film Festival moved into their present premises – Film House, 3 Randolph Crescent, a fine, commodious Georgian building, into which was built a film theatre. There was room for a restaurant, receptions, which became a feature of the Festival, and for discussions. Three years later *Films of Scotland*, the major film-producing body, took up residence there.

The question which the Festival of Music and Drama had asked for itself in 1947 – can one have a true festival without showing the native product in the company of that of other nations? – was posed for film in the presence of the office of the Films of Scotland Committee. In any case the Director, Forsyth Hardy, was also by this date Vice-Chairman of the Film Guild, and therefore of the Film Festival. He is presently the only remaining link with the founding committee of the Guild and Festival.

Whatsoever the strains on the organization, the only material question is the character and quality of the product. In 1957 Dilys Powell, film critic of *The Sunday Times*, remarked that the first thing that struck her that year was that the Festival laid more stress than it used to on the feature film. She remarked on the variety. One must also comment on the variety of standard. The films ran from a British farce, *Lucky Jim*, which made one wonder what justification there was for this other than box office, to the rare quality of Bergman's *The Seventh Seal*. In 1958 another Swedish film, *Wild Strawberries*, again directed by Bergman, had the quality which made it a festival event. John Grierson had reservations about it, but he concluded his talk in 'Arts Review' with these words: "Please call it, none the less, an important picture – because it is intense, because it is beautifully

made and because Bergman feels everything he does."

It is significant that Grierson draws the attention away from
the expertise of Bergman, and even from his individual style, to
the sensitiveness of his response. Unlike the characteristic traits of
the cinema, which seem to emanate from the large screen,
nothing is forced on the attention. The events seem simply to
happen, but, of course, they are the outcome of the most careful
consideration and planning.

In the same talk John Grierson discussed the film of
Hemingway's novel *The Old Man and the Sea*. He was not very
satisfied with the result and ended with these words:

> This picture was made at great cost – I think foolish cost – with the
> thought that it was a big box office proposition. It ought to have
> been made by a poet who didn't give a damn about the box office
> and who believed that the sun and the wind and the sky and the old
> man and the sea were everything. It wasn't. The ironic thing is it
> isn't going to make much money after all.

The comment points to the ambiguous relation which the Film
Festival must have with the rest of the Edinburgh Festival if it
succumbs to the attraction of putting on probable commercial
successes for the publicity which they may give the Festival or for
the money. In any case such films contradict the original aims as
stated in the first number of *The Living Cinema*. Not that *The Old
Man and the Sea* was a case in point. It had more unrealized
potential than the boring play *The Hidden King*. On the other
hand the crass, insensitive badness of *Song Without End* was fairly
characteristic of the romanticizing of the life of a great artist,
examples of which have emanated from Hollywood over the
'Golden Years'. Sir Compton Mackenzie referred to it as "the
sumptuous parody of the life of Franz Liszt . . . a great artist who
wore himself out by his generosity to other artists, old and
young." At best this film should have been declared a fringe
event. Properly, it should not have been exhibited at the Festival
at all.

It may be that, since the advent of the mass-provider,
television, those bad old days are past. More important in the
very year of *Song Without End*, the festival showed a great film
"This film, *The Virgin Spring*," wrote Alan Dent, "created by
Ingmar Bergman, is quite simply, a superlative work of art – a
masterpiece." *Song Without End* is forgotten; *The Virgin Spring*
remains and others, if not of the greatest art, of such fine quality

as to refresh simply by recollecting them. Amongst them was Haanstra's first feature film, *Fanfare*. Edinburgh had already rejoiced in his documentaries, *The Rival World, Rembrandt*, and the exquisite study of a craft, *Glass*. *The Human Dutch* was still to come. What begins to emerge as one resorts to the memory of the years of the second decade of the Festival is the predominance of quality in conditions where this is much more difficult to achieve than in the traditional arts. There is another significance.

Because film art is especially collaborative in the making, it tends to reflect the character of the nation as well as that of the film-maker. There was, therefore, a real justification for giving a special showing of French films, Dutch and Polish. No one was more aware of this potential than John Grierson when in 1947 he advocated giving a hearing to one another's cultures. The tone of the culture is less likely to get through when the eye of the producer is on a world market or where the finance is from a sponsor whose special interest must be plugged. The sense of freedom to record the living scene and to let comment arise out of it, to be financed to do this, was the impression made by the Dutch documentaries, just as the quality of the Bergman films seemed to be equally unimpeded by other considerations.

Year after year the Festival demonstrated, in a few films, inevitably this liberty and honesty of expression, which lead to diversity. Bergman's *The Face*, Strick's *The Savage Eye* and *The Running, Jumping and Standing Still Film*, produced by Peter Sellers and directed by Richard Lester in the 1959 Festival brought together quirky English fantasy, the direct concern with social irresponsibility of an American film-maker, and the insight of the Swedish director who always looked beneath the appearance.

In 1960 Polish films held the screen but there were two fine films from Holland, *The Knife* and *The House, The Virgin Spring* from Sweden, a film about Victor Pasmore, and an exceptional Norman McLaren from Canada.

In 1962 the Festival took as its main theme 'The Film and Literature'. It was a rich Festival, though *The Playboy of the Western World* remained too much the play itself. There was a charming short film about Dylan Thomas's poetry and an outstanding film made out of Euripides' *Electra*. This was one of the great moments of Festival to be treasured in the memory as Giulini's conducting of Verdi's *Mass* is treasured. Nothing on the modern stage, it seemed to me, could convey the grandeur and terror of the tragedy as did this cinema version which placed it

on the barren hillsides of Greece and under massive Mycenaean ramparts. I was proved wrong by the visit of the Piraikon Theatre from Greece, which astonished and overwhelmed audiences in their production of Sophocles' *Electra*. No matter, the achievements of the stage production underlined the worthiness of the film to be put alongside the great original dramas. There were fine films too outside the main theme such as the two nature films *Boy and Waves* from Poland directed by Selsicki and *Pan* from Holland, directed and photographed by Hermann van der Horst. One might name ten or eleven more and still not exhaust the quality.

If 1963 produced nothing of the stature of *Electra* it commanded respect for its display of intelligence. Its main interest was 'the Film and Drama'. It showed the British première of Genet's *The Balcony*, the British première of Pinter's *The Caretaker*, and Ionesco's *The New Tenant*. This last film was made by the drama department of Bristol University. It anticipated in its origin the many independent films shown in 1969. There was also a film about the Australian artist Sidney Nolan. None of these could exert the broad interest that had been expected of films. Others of quality in that year did, such as *The Given Word* from Brazil, which had won the Golden Palm at the Cannes Film Festival the previous year.

On account of the publicity that attends the names of stars and more recently of certain directors, there is always a danger in the film world that new work which relies on its innate virtues is missed. In 1964 a season of Bergman films properly claimed attention, as did with equal cause Haanstra's *The Human Dutch*. The film, however, that was perhaps most to be admired was the first feature film directed by a 31-year-old Hungarian, Sandor Sara. This film, *Current*, explores with sensitiveness the developments of the lives of six young people after a seventh friend has been drowned. There is a quiet maturity about it. Another rare film goes with it in my mind, *The Memory of a Rose*, from Russia, a ballet of growth and decay.

Policy, it seems to me, mattered much less than the state of the market. Between 1960 and 1967 a continuity of quality was maintained, though bolstered occasionally by repeating films previously seen in earlier Festivals. Now and again one had the feeling that other film festivals better financed had become more attractive to new films. Or there may have been a shift of interest in the direction of the cinema.

The hand-held improvisory effects of the television film, *Culloden*, related a twentieth-century documentary approach to the much glamourized battle of 1746, hinted at the move from accepted techniques and attitudes, but the same central interests prevailed. A film version of Wagner's *Flying Dutchman*, *The Knack* and *High Noon* (part of a Zinneman retrospective) were shown in 1965; in 1966 the charming Russian comedy *Beware Automobile* was presented, *Dr Zhivago*, and also a German retrospective season. 1967 continued the operatic interest with *Lady Macbeth of Mitsensk*; there was yet another fine Bergman film in *The Silence*, a good Dutch entry in *The Voice of the Water* directed by Bert Haanstra, *To Each his Due*, a fascinating Italian film about the Mafia, and there were Bulgarian films and good Polish films. The Festival was very much as it had been, busy in seeking out the readily acknowledged best and finding it as it was available.

The new Director Murray Grigor was apparently carrying on the policy of his predecessors, Calum Mill, Theo Lang, D.M. Elliot, Michael Elder, Ronnie Macluskie and David Bruce. In the following year, 1968, the shift in emphasis was such as to make all concerned take a new look at the Film Festival. It had changed.

Just how it had changed tended to be obscured by the ballyhoo got up over Roger Corman's *The Trip*. More regrettably the same loud noises were continued the following year, largely associated with the season of Samuel Fuller films. My view is that the special interest in the 1968 Festival was in its reassertion of the value of the documentary. Documentary has never lost its major place in the Festival, though the high quality of the fictional films gained for them deserved prominence. The reassertion was made by John Grierson in his celebrity lecture, and again when he was honoured by the Golden Thistle Award made by films of Scotland for distinguished service to the cinema.

The retrospective exhibition of his films from *Drifters* (1928) to *Seawards the Great Ships* (1960), for which he wrote the treatment, gave a secure traditional base to a Festival which got attention from the Press because it was more experimental than those preceding it. Again it should be stressed that the Festival had always been prepared to screen new and 'uncomfortable' works if they were thought worthy of selection, but Murray Grigor found a new resource in the productions of the University of Southern California. At a stroke, it put the Festival on the side of the new, young makers of film, for whom until

recently there had been limited opportunities to make films and to show them. If the best of these are placed in the context of more considered productions, then the interest of the Festival has widened without losing sight of its central concern. I do not think it is the headline-catching *The Trip*, brilliant as was its technique, that is now remembered. More memorable and more valuable was the first film of the Swedish director Jan Troel, *Here is Your Life*. "The sensitive expression of 'the heartbreak of things' " – I quote from Alexander Scott's criticism – in this autobiographical film showed the maturity regrettably lacking in the Samuel Fuller shows in 1969.

"When the Edinburgh Festival ends on Sunday," wrote Molly Plowright in the *Glasgow Herald* in 1969,

> a brave experiment will have been accomplished, which is exactly as it should be . . . Where the new Edinburgh image differs from way out Festivals such as Oberhausen is that while they are anarchistic, Edinburgh is not. It is dedicated and this has been reflected in the major films. Peter Fonda's *Easy Rider* comes to mind at once and Peter Whitehead's *The Fall*. Both are deeply serious in their striving to express a current theme.

"The feeling for current trends in the cinema" which the critic of *The Sunday Telegraph* had remarked of the 1968 Festival was successfully realized in 1969. Of this year the same critic wrote, "Its scale is impressively wide ranging; its theme radical though some have been shown at other Festivals, the new films are generally committed and contemporary." The view was corroborated by a week of new Swedish films. This was enough to justify the Festival and to absorb the silliness of the idolising of the Fuller films.

"The special merit of the twenty-fourth Edinburgh Festival proved to be its diversity." Work by that whole range of contemporary film-makers, from Godard to Corman, was on view. Liveliness and technical quality were assured. And yet it is doubtful if 1970 will be remembered as a vintage year. A good year all the same – it included retrospective showings of Chabrol films. But there was nothing of the superb quality of *Electra* (1962), not even of *The Knife* (1961), nor of the Hungarian film *Current* (1964).

The twenty-fifth Film Festival, like the Edinburgh Festival with which it had been associated from both their beginnings in 1947, was an occasion for celebration and recollection. In a comment in the Festival's Programme, Forsyth Hardy, then

Director of Films of Scotland, Vice-Chairman of the Festival, and a founder member of the Edinburgh Film Guild, wrote:

> The Edinburgh Film Festival was an act of faith: an act of faith in the cinema. The men who founded it believed it was worthwhile giving of their energy to bring to the attention of the world, through the festival, the finest examples of film-making they could find. After twenty-five years it is still an act of faith. But now behind the festival is a volume of achievement in which it is possible to take a modest pride.

The emphasis which Forsyth Hardy put on "an act of faith" was due especially to his knowledge that the Festival had survived and grown despite very inadequate resources. It had won prestige in the face of competition with other film festivals, which had been well funded by government or by their municipality. It had survived in the first instance by the great efforts of Forsyth Hardy, Norman Wilson, and others, and it had made its mark by the good judgement of the original committee and by their ability to create, not a monetary fund, but a fund of goodwill and trust. The problem for future Festivals was to maintain the acceptability of the Festival over a wide area and to achieve significant financial support, now more necessary than ever before. The quality of the films in the twenty-fifth Festival and the development of the policy of showing retrospective programmes of the work of distinguished film-makers certainly warranted support.

It is at this point that the present writer must admit his inability to give an in any way adequate account of the Film Festival in the first four years of the 'seventies. Within two to three weeks – the Film Festival tended to spill over from its usual fortnight – up to 120 full-length feature films might be shown, not to mention large numbers of documentaries and cartoons. Also, one's way through this jungle was not helped by an increasing use of superlatives to describe the films on view. The words 'great', 'masterpiece' and 'spectacular' were much in evidence. "This year's Edinburgh Film Festival", the comment in the Festival Souvenir Programme of 1973 ran, "has set itself the difficult task of surpassing last year's spectacular event." The devaluation of language allied to the inflation of reputations is not favourable to what is presumably the desired objective, of maintaining the status the Film Festival had achieved; nor, for me at least, did the description of one aspect of the development of

the Film Festival in the Festival Souvenir Programme of 1974. The writer was referring to one of the four main sections of the Film Festival. The statement goes: "The first consists of a retrospective devoted to a major Hollywood director, who has not received the critical appreciation he merits – such as Samuel Fuller, Douglas Sirk and Frank Tashlin."

There is a presumption in the use of the word 'major' which the retrospective of the first-named suggests was wholly unwarrantable. To name the other directors in the same context put them under suspicion. Offputting as was the tone of the article – though it was in line with writers of other fans of the Film Festival – it did give an outline of the content and direction of the Festival's programme. The article began: "In recent years, the aim of the Film Festival has been to develop a more coherent and integrated programme, directed at changing prevailing attitudes towards film."

One notes the hieratic stance – someone knows what the audience ought to think. Having described the first section of the Film Festival, the article describes the others:

> The second section focuses on the cinema of ideas, Third World and political cinema. The socially committed cinema of Jean-Luc Goddard and Glauber Roca have been featured strongly in recent years. Another clearly defined category is the independent American cinema, an area which no other film festival celebrates. This section has encompassed the diverse talents of directors like Andy Warhol and Jodorowsky, in addition to the more commercial work of directors like Roger Corman and Robert Altman. The final section concentrates on new directors whose work redefines the language of film. The personal vision of directors like Stephen Dwoskin and Werner Herzog have made a powerful impact on the international audience.

Despite my strictures on the character of the publicity, the summary does take account of the developments that began to occur after Murray Grigor became Director of the Film Festival in 1967. From then on there was a resurgence of confidence, an explosion of new life, marred admittedly, in my view, by a lack of judgement and partisanship. But the positives matter. Lynda Myles, Director since 1974, continues the policy.

In 1971 there were retrospective projections of the work of three directors – Bernardo Bertolucci, Norman McLaren and Peter Watkins. The undoubted distinction and commitment to individual aims of these directors made them a commendable

choice for the twenty-fifth Festival. So rich in numbers and variety of films was this Festival that one might have pursued a special interest throughout the fortnight, beginning say from the work of Bertolucci, whose films are the outcome of a mingling of literary and film cultures, or from the neo-realism of Watkins, or from the technical experiments of Norman McLaren. In one field one would have studied the adaptation to film of Kafka's *Metamorphosis* and in another the experimental films of the Edinburgh-born artist Eduardo Paolozzi, whose sculpture constructions could be seen in the Scottish National Galley of Modern Art in the Royal Botanic Gardens. Links with the other Festival were particularly effective in the 1971 Film Festival. Amongst them was the showing of Belgian surrealist films. These added to the information and understanding of the Belgian surrealist exhibition in the Royal Scottish Academy.

In different vein from such interests was Milos Forman's first American film, *Taking Off*. Its reputation had arrived before it, but there were other films about which little was known previous to their showing. Some of these left the Festival recognized for their merit. Amongst them was Ruy Guerra's *Gods and the Dead* and Nelson Pereira dos Dantos's *Lust for Love*. These were films from Brazil, a country which had previously sent to the Edinburgh Festival tragic, memorable, heroic films that were marked with the authority of truth. There was a film from France, *Heureux Qui Comme Ulysse*, the last film in which that great comic actor Fernandel appeared. There were Czech films and Russian films and Chuck Jones's *Road Runner* cartoons from the United States – many films, of course, from the U.S.A., Italian films, West German films and *One Day in the Life of Ivan Denisovich*. This film, from the book by Solzhenitsyn, was made by a combination of American, British and Norwegian companies. The cast was made up of British and Norwegian actors and was shot mainly on location in Norway near the Artic Circle. Ivan Denisovich was played by Tom Courtenay. The authenticity in the style of the film, in its slow development, in its close observation of small movements, as if the mere making of a movement in the terrible cold was of consequence, returned one to the documentary tradition on which the Edinburgh Film Festival was founded.

None of these films might have been seen at the Edinburgh Film Festival, for the Festival that year was in the grip of its most serious financial crisis. Edinburgh Corporation and the Scottish Film Council rescued the Festival, and the enormous efforts

made, for the greater part by devoted young people, resulted in a Festival which was admired in Britain and abroad.

In 1972 the Festival opened with John Huston's new film *Fat City*. He was there to hansel this clear-eyed film about the world of professional boxing. There was nothing experimental about this film, but there was nothing romantic in the look of the scene which the director presented. This year the Film Festival paid tribute to women directors of film. There were films by Germaine Dulac, Dorothy Arzner, and Ida Lupino (*Three Lives*), and a film made by Kate Millet (the author of *Sexual Politics*). There was also a frightening film, *The Other Side of the Underneath*, directed by Jane Arden.

At this time, during the early 'seventies, the idea was discussed, by those responsible for the organizing of the Film Festival, of moving its dates so as not to coincide with the Edinburgh Festival of Music and the Arts. There were many points for and against the proposal, but I am glad it has not been moved, for the single reason that it allows for comparisons between the treatment of a subject in the art of film with its treatment in drama or opera. Further, the other arts increasingly benefit from contact with film. Jane Arden's *The Other Side of Underneath* originated in *Holocaust*, a piece of theatre by Jane Arden about a girl becoming insane. It was first produced for the Traverse Theatre. The ideas in the theatre presentation and in the film came from the psychologist R.D. Laing. They reflect his interpretation of the nature of schizophrenia. In 1973, (*see* page 164), the Actors' Company put on at the Lyceum a lunchtime double bill, one of the items being *Knots* from the book by R.D. Laing. At a time when specialisations divorce the Arts (and sciences), the "circulation of ideas", to quote Matthew Arnold, throughout the whole body of experience which the Arts make available is of consequence.

In 1972 there was again a great variety of film. Joseph's Losey's *Assassination of Trotsky*, Charbrol's *Ten Days' Wonder*, Jan Troell's *The Emigrants*, Robert Altman's *Images*, and Roy Hill's *Slaughterhouse 5* were shown. The retrospective of films by Douglas Sirk seemed to be another attempt to justify a Hollywood reputation, achieved for the greater part in the 'fifties by such films as *Tarnished Angels, Magnificent Obsession*, and *Has Anyone Seen My Gal?* and with the help of Lana Turner, Jeff Chandler and others of that ilk.

The same director, who came from Germany – his name there being Dietlef Sierk – began his film career as director with a

German version of Ibsen's *Pillars of Society*. In fact almost the entire *œuvre* of Sirk could be seen at the Film Festival. Halla Beloff approached the Sirk retrospective with considerable suspicion. This is how she concluded her review of Sirk in the radio programme 'Festival Orbit '72'.

> ... the Sirk retrospective is a revelation ... The vision is marvellously fluid, and the much vaunted lightening is really there. And there is a subtle civilised presence even in the most unlikely contexts ... It's an amazing refreshing experience to decide to look at these films with an open eye, to be enamoured of the image and absolutely held by Hollywood, a modern folk art, rising to the heights.

Halla Beloff made another point which may be more germane to the success of Sirk's films than any ethos dreamed up in Hollywood. ". . . in each he was also making his own picture", she said. He was, she said, "a highly cultured theatre man from the Weimar Republic, with Brecht associations; that he made many original films in Germany in the thirties." I suspect his success was despite Hollywood, and despite the box office. So far, in my view, a Hollywood director born and bred in that ethos had not turned in a film which stood up to appropriate critical scrutiny.

Curtis Harrington, of whose work there was also a retrospective showing, began, outwith the commercial studio, by making 'underground' films. His thrillers *What's the Matter with Helen* and *Who Slew Auntie Roo?* suggest in their genuinely strange atmosphere that he has managed to bring to them the resources of his earlier work. For the record, I remark that Samuel Fuller returned with a new film, *Dead Pigeon on Beethoven Street*. One of the features of the Edinburgh Film Festival has been the attendance of the film-makers. In 1972, in addition to Samuel Fuller, it was visited by John Huston, Douglas Sirk Joseph Losey and Peter Ustinov.

Of this Festival David Robinson wrote in *The Financial Times*:

> We don't appreciate the Edinburgh Film Festival nearly enough. It has the misfortune to coincide exactly with Venice, which can upstage it in glamour and seniority; while the National Film Theatre's programmes and the imminent London Film Festival tend to steal some of its thunder as far as this country is concerned. Which doesn't alter the fact that Edinburgh manages to show upwards of 100 films in the course of three weeks, packaging them

into as imaginative and enterprising a programme as you can find at any international event.

Once again the Film Festival was attracting a wide critical interest which for some years had flagged, and nearly petered out. In 1973 Derek Malcolm wrote in the *Guardian*:

> Not for the first time the Edinburgh Film Festival has comfortably exceeded expectations. It is now, in its twenty-seventh year, one of the most coherently planned and best run of Europe's annual cinematic beanfeasts. The fact that it is put together by a group of young enthusiasts, led this year by Lynda Myles on an absurd shoestring of a budget, makes this all the more remarkable.
>
> One is now inclined to believe that if it spent half the money of most of its competitors it would be twice as good as them. It is already ahead of some on a mere £5,500, of which the Corporation contributes £2,000. If the Edinburgh Festival may, in general, be accused of middle-aged spread, there could be no better way of dispelling that image than backing its film wing better. There are no hardening arteries at Film House.

It is necessary to emphasise, on account of Derek Malcolm's statement, that the Film Festival is not under the jurisdiction of the Edinburgh Festival Society. Like the Tattoo, it appears in the Souvenir Programme under 'Other Events'. Consequently the Festival Society cannot either affect the policy or programme content or give the Film Festival financial backing. That comment on the Film Festival appears in this book indicates approval and a desire to encourage it.

There was in the early 'seventies a growing volume of praise for the Film Festival. Significantly several reviewers compare the Edinburgh Festival with European film festivals. Nigel Andrews wrote of the 1973 Festival in *The Financial Times*:

> This year's Edinburgh programme, for example, easily holds its own with both Cannes and the Berlin selections. Not only has it cornered some of the best products of the earlier events but it has embellished its programmes with a number of new films (Zanussi's *Illumination*, Melville's *Un Flic*), two or three remarkable 'rediscovered' classics (Medvedkin's *Happiness*, Murnau's *Tartuff*, Tarkovsky's *Andrei Rublev*) and no less than seven retrospective programmes.
>
> The chief retrospective honours this year have gone to the American comedy director, Frank Tashlin, represented by some thirteen films, and by an excellent new book of critical essays which follows the festival's earlier monographs on Corman and Sirk.

The other directors given retrospective treatment were Ivan Kershner, Werner Herzog and Ousmane Sembene. There was also a season of Japanese films. There was the French quasi-documentary, political *Coup pour Coup*, which caused managers and owners without seeing it to agitate against its showing, and there was Jean-Luc Godard's *Tout Va Bien* which, according to Godard, asked the question "What role should intellectuals play in revolutions?" It did not answer the question and it raised many more questions. There was scarcely a film-making country that was not represented. To limit the list as I have done is to omit many films of particular interest, amongst them the two-hour surrealist 'epic', Alexandro Jodorowsky's *The Holy Mountain*.

Such prodigality allowed for diversity of opinion. Thus some critics felt that by setting up a retrospective for Tashlin, as if his work had particular significance, was getting his contribution to cinema out of proportion. George Melly, in an article in *The Observer* which was favourable to the Festival elsewhere, commented on the introduction in the Festival programme to Tashlin, that it was, "an almost ludicrous example of solemn hagiography."

The article continues, however, ". . . it would be ungrateful not to salute Miss Myles and her collaborators for having conducted us on a remarkable survey of the less well-charted shores of today's cinema, and in particular there was an impressive number of documentaries largely on the theme of alienation, perhaps the principal obsession of our times."

The Festival, then, by 1973 had established itself as of consequence to the critics, film-makers and the interested public for the quality and character of many of its films, for its range, for its policies and for the relevance of its selection of films to the social and psychological interests of the day. This success was increasingly noticed in other countries. As the *Gottinger Tageblatt* put it at the end of the 1974 Film Festival: "The best of English cinema, as it is called in the Scottish capital, is the Edinburgh Film Festival." It was a nice note to strike before the article continued to acknowledge that the Edinburgh Film Festival's interests extended far beyond English-speaking films.

Yet such were the financial straits of the Film Festival immediately before its opening in 1974 that there was once again doubt about its survival. Interest in the German press in the 1974 Festival might have been expected, since ten new German films were included in the programme. This was the main centre of

interest though the sixty films by Raoul Walsh, the maker of popular American films, were inescapable. The worthiness of a Festival retrospective of this director was questioned. The debate continued. In any case the 1974 Festival explored very different territory in the films of the Dutch director Franz Zwartjes, debatable in quite another way on account of his studious approach to sex. It may be that the overall quality of film shown in 1974 was not up to 1973, but this is the nature of the case.

After the first Edinburgh International Festival of Music and Drama in 1947 the question of that Festival's survival could be put aside. Not so the Film Festival. There have been years of comparative assurance of continuity, but even that assurance was achieved at the cost of excessive effort and devotion as to a cause. If one considered the scale of the Film Festival it is difficult to believe that Lynda Myles is its first full-time Director, an appointment made possible by the financial support of the Scottish Film Council. Voluntary and part-time labour has helped to hold the Festival together, though the gap between one Festival and another was bridged by a single assistant, Joyce Marr, whose secretarial abilities were used to advantage. She died in the autumn of 1974.

With the recognition at home and abroad of the quality and character of the Festival, such shifts and other ingenious recourses, necessitated by frequent crises, should no longer be acceptable.

12

The Tattoo

More than five million people have witnessed the spectacle of the Edinburgh Military Tattoo, which runs current with the Festival but is not under its management. The setting itself, on the esplanade before the ancient castle, the late performances in a dark lit by shafts of light as troops march and countermarch in and out of history, is enough to stir loyalties deeply. The past is suddenly and dramatically present as the massed pipes and drums of the several Scottish regiments that are the heart of the matter cross the moat and fill the arena with colour and sound. The appeal is worldwide – one elderly lady has made the pilgrimage annually from Pennsylvania for many years – and the devotion from many south of the Border, especially from the north of England, is such that they make the journey to Edinburgh for the Tattoo alone but, all in all, it touches most deeply the Scots. The beat of the drum and the sound of the pipes is a command to identify with the courage of soldiers who have borne the brunt of battles in defence of their native land through the often tragic history of Scotland. The pipes and drums provide the most inspiriting music of all and the one piper who ends the tattoo on the battlements brings a melancholy beauty that removes each Scot at least, and many others, to those places of the heart where listening is everything and speech nothing.

Brigadier Alasdair Maclean, C.B.E., late of the Queen's Own Cameron Highlanders, created the Tattoo in its present form in 1950. Previous to that, in 1948 and 1949, there had been military displays including piping and dancing directed by Colonel George Malcolm of Poltalloch. Brigadier Maclean directed the Tattoo until 1966. Over that period he ranged the world in search of new contributors. He considered 1957 as his most successful year, for then while the Scottish contribution remained central, from overseas came the Danish Life Guards, men of the Turkish Army with the band of the Corps of Janissaries

accompanied by Standard Bearers and cavalry in formations dating back to the thirteenth century, and the Royal Canadian Mounted Police. Delightful and fascinating as were the annual spectacles, they were always more than that. The styles of dress, marching and riding, and music told also of the purposes and cultures of the representatives of the various countries. The clean-cut jib of the Mounties, allied to the red of their tunics, suggested a built-for-service rig which contrasted with the ceremonial panoply of the Turks. Behind them lay ancient rites and customs that belonged to a far different culture from that of the West.

Both contrasted with the Royal Danish Life Guards of Foot – the King of Denmark's household troops – whose light-blue, dark-blue and scarlet uniforms, when associated with their automaton-like precision drill, made one feel they had stepped immaculate out of Hans Christian Andersen's box of toy soldiers. Only, remarkably, those soldiers were mainly National Service men with no more than fourteen months' service to their credit. Place such foreign styles with the 'Symbol of Scotland', as the first tattoo billed a Scottish item in 1950, and one begins to glimpse the imaginative range of Brigadier Maclean's pageant. In the first year also one item was headed 'With Measured Tread'. The words expressed the gravity and poise of the slow march which is equalled in the character of the music of the pipes for this ceremony.

As time passed, competitive elements were introduced and short dramatic features. In 1971 the raising of the Gordon Highlanders showed the famous kisses of the Duchess of Gordon which apparently helped with the recruitment of men – and here the needs of drama are apt to confuse truth, even though it be stated that the first battalion of the Gordon Highlanders was raised far south of the Duchess's county, Aberdeenshire. This sentimental contribution has its strong attraction, as has the participation of spectators. On one occasion when, with characteristic invention and daring, Brigadier Maclean had introduced the 'Twist', he found himself confronted by a mêlée of spectators who joined in. He remarked that while all was for the best in this encouragement of camaraderie between the Services and the citizens, the dignity of the Tattoo had to be preserved. Dignity with humour, within the organization – often of a great variety of elements, and with spontaneity – this was one of the achievements of the Tattoo under Brigadier Maclean. He remarked with pleasure on the warmth of the Friday and

Saturday night Tattoos, the days when Glasgow floods Edinburgh with its citizens who are always ready to demonstrate their communal enjoyments. There is always applause at the Tattoo, but not the welcoming roar of the weekends.

In 1967 Brigadier J.S. Sanderson, D.S.O., O.B.E., took over as producer and commentator. The interest and variety continued. In his first year the contributors included the Bersaglieri Corps, famous marksmen from the Italian Army, who gave an outstanding gymnastic display, and there were folk dancers and singers of the Band of the First Battalion of the Jamaica Regiment. That year there was also a historical representation of the military use of the horse from early times to the present.

Since then the Tattoo has extended its range of interests. Scottish dancers have made their appearance over a number of years, but in 1972 the Golden Lion Dance performed by members of the Singapore Armed Forces and in 1974 the Sri Lanka Dancers, with elephant, demonstrated in the northern light of Scotland the sinuous, intricate movements of dancers of a different culture. At the heart of the Tattoo remains the Scottish soldier. However strange and attractive the lone piper may be to the many visitors from many lands, his appearance to Scots carries a deeper implication. He is the symbol of courage and determination that kept Scotland a nation.

A chance of geography threw up a precipice about which is now the city of Edinburgh. Few cities have a precipice at their centre. On this dramatic height is the castle that so often repelled its invaders, but sometimes was conquered. No other city can show its military splendour from so advantageous a place. It is a thrill for the crowds to surge up the breadth of the Lawnmarket into the narrow entrance of the esplanade and then look at the gateway into the castle in expectation. It is an expectation that is always satisfied. And after the human spectacle is done, "the huge castle rears its state" as Scott put it, but it is seen as Sir Walter could not see it, bathed in a white light that sets it apart in the night sky.

13

Directors and Direction

The question 'Whither?' might hardly seem worthwhile asking of the Festival, since its objectives were stated at the outset, and have evidently been heeded. Yet within the concepts of "the highest standards of performance and the best in the arts" a variety of interpretations is possible, and a greater variety now than in 1947. Further, the longer the Festival has continued, the more frequent has been the performance of new works and exhibitions of new work. In 1947 the overwhelming desire of audiences was to have the opportunity of hearing acknowledged masterpieces of music and drama. They symbolized the renewal of a civilization that had nearly been destroyed by war. Yet one of the greater virtues of the Festival has been the recognition that unless new works, or works of this century, were given a place, the drive and imagination of that first Festival would die. The credit for this response, for it amounts to a response, to the changing climate of opinion, belongs primarily to the Directors, then to the programme committees which have supported their decisions, and to the Council of the Festival Society of which the Lord Provost is Chairman.

For the Souvenir Programme of each Festival the Lord Provost writes a foreword, a formality; it might be thought, which does no more than witness to the Town Council's acceptance of responsibility for the Festival, and offers a cordial welcome to visitors. Frequently the foreword has gone beyond this. Sometimes the statements have revealed a personal commitment, because the Lord Provost has seen the Festival as belonging to Edinburgh's way of life. Appropriately on the occasion of the twenty-fifth Festival, the Lord Provost, Sir James W. Mackay, conveyed the idea in his foreword that he felt himself to be the heir of an inheritance which it was his duty to transmit to those who followed. That inheritance he considered was based on spiritual values. He saw this idea as the prime motivation of the

Festival, and in his article quoted the following passage from a statement made in 1947 by Lord Provost Sir John Falconer, First Chairman of the Edinburgh Festival Society: "The human mind needs an occasional stretch into an overflowing fountain of grace and beneficence to confirm its weak faith and to anchor it to something higher than itself." Sir James then commented:

> It was on this charter of idealism that the Festival was launched. Over a period of twenty-five years detail changes have been inevitable. Successive Lord Provosts, as Chairman of the Festival Society, have been inspired by Sir John Falconer's concept of the grand design and have striven to maintain the standards that have been the touchstone of success. And now looking forward twenty-five years – we shall have new members of the Festival Society, new audiences and new directors. In the midst of such a natural course of events the Festival must remain true to the idealism of its founders. It must not be the instrument of ribald or derisive jests nor the vehicle of extreme experimental phenomena. Rather it should be permitted to acquire the patina of tradition and reflect some of Edinburgh's golden age of Arts and Letters.

Bearing in mind Sir James's last statement, and also his warning that the Festival should not be "the vehicle of extreme experimental phenomena", it is interesting to compare comments on the Festival in the foreword of his successor, Lord Provost Jake Kane. In the 1972 Souvenir Programme he wrote:

> Many elements have contributed to its success – principally perhaps an undimmed idealism of purpose, a catholicity of taste combined with high artistic integrity and of course a perfect physical setting.
>
> With Festivals as with people, success and advancing age bring their own problems. There is the tendency to become 'instituionalised' and to lean more heavily on tradition; there is the temptation to play to the *cognoscenti* and to eschew the experimental or controversial.
>
> But if the Festival is anything it is an adventure. It must continue to seek out the best in music, drama and art wherever it is to be found. It must never be afraid of the new or the unfamiliar.
>
> Nor can it afford to become the preserve of an elite. Rather it has now attained the point where it is ready to reach out, not only to wider circles abroad, but to many in our own city and country who have so far remained aloof, and who do not yet appreciate how much the Festival has to offer them.

The difference of emphasis does not necessarily imply contradictory views, though the more venturesome attitude may

be crucial to a Festival where there is no danger of the classics in the Arts losing their place. It may be that in extreme forms of experimental art the classics of tomorrow will be discovered. One of the rare things about the Festival is the discovery of a new enjoyment. Once discovered, the Festival's bush telegraph is astonishingly effective. The discovery may be that there is happiness for all to be found in something very old, such as *The Thrie Estaites* in 1948, or it may be something outrageously experimental, such as the Mummenschanz Company in 1974, who provided an art that was equally suitable for children and intellectuals. It did not matter whether you thought you understood it, which I thought I did, or whether you had not the faintest idea what it was about, because it was impossible not to laugh and feel sad at what was happening on the stage of the Church Hill Theatre. I am confident that both Lord Provosts would have approved and enjoyed the show. What both have is confidence in the idea of the Edinburgh Festival to the extent of implementing their confidence with money.

The success of the Edinburgh Festival has caused other cities to send representatives to Edinburgh in order to discover the recipe for success. The most recent came from Philadelphia, U.S.A., in 1974 with a view to producing a master plan for a new festival there. The document, entitled 'The Philadelphia Festival Master Plan', came to the conclusion that "... the total economic impact of the Edinburgh Festival on the region is $38,452,125," that is to say about £17,500,000 annually. The document gives another figure. It states of the Festival, "It achieves up to $5,000,000 annually in the value of world-wide press coverage for the City."

The question that would seem to be before us is not whether Edinburgh can afford the Festival, but whether it could afford to do without it. More significantly, the question of 'affording' has never been pushed. This is not to suggest that the Festival has not worked to a budget, assessed its resources all along the line, and allocated resources as those responsible deemed most fit, but to note that the determinants of the existence and continuity of the Festival began in another area. That the Festival should turn out to be a money-maker was not the intention of its original sponsors. It would be very dangerous, I am sure, to think of it in these terms. The right terms of reference were those used by the Lord Provosts in their forewords. The true determinants were the will, the knowledge, and lastly the money. The structure of the

Festival allows for the proper functioning of these. The generous tradition of Edinburgh Corporation in financial support has now been taken over jointly by the new local authorities, the City of Edinburgh District Council and the Lothian Regional Council.

Without the will which must originate in the community and find expression through the Local Authorities and their appointments to the Festival Council, the Festival would have ceased to exist after the initial euphoria of success. The money is to a large extent dependent on the will to allocate adequate resources to the enterprise. In so far as there is official recognition of the cultural value of the Festival to Edinburgh, to Scotland and to civilization, the money will tend to be found. It is true the Festival begins as 'pleasure for a minority', but its impact is like the widening circles of the stone dropped from a height into water. One cannot estimate the spread of happiness and the penetration of insight for which the Edinburgh Festival has been responsible. But neither the will nor the money could realize the Festival without knowledge, the source of which is the Director.

The quality and character of the Festival rests ultimately with the Director. The brief – high standards, with interests at the centre to attract the amateur in the arts – is so wide that the character of the Festival might vary considerably within it. Further, the audiences of 1974 are different from those of 1947. What might have appeared in the late 'forties or early 'fifties as "extreme experimental phenomena" today might be categorized simply as "lively and imaginative enterprises", particularly as the terms are related to the visual Arts. One is aware there are different kinds of experiment. There are those whose sole virtue is that no one thought of doing them before, like the first man to attempt to push a pea up a mountain with his nose, or there are those equally vapid, whose success is assessed by their ability to shock. Presumably Sir James McKay had this kind of trifling in mind in his reference to "experimental phenomena", for the most serious danger to all institutionalized art events is in their failure to reflect the livelier imaginations of the day in their programmes. The Edinburgh Festival has been peculiarly successful in conjoining the best from the past with the finest that can be obtained from the present. The Directors have not only been knowledgeable of the Arts, past and present, but sensitive to responses in the developing tastes and changing interests of the audiences. And yet at the heart of the Festival there still stand the acknowledged masterpieces of music, drama and the visual Arts.

In 1947 William Shakespeare held the centre of the dramatic stage of the Festival, as he did in 1970 and 1973. Yet the style of presentation of Shakespeare in 1971 could not have been envisaged in 1947. The *Lear* of 1971 on the open stage of the Assembly Hall related to the discovery of the potential of that stage in 1948. The presentation belonged to an Edinburgh Festival drama tradition which began with the experiment of *The Thrie Estaites*.

When one refers to the Directors of the Festival having a special knowledge of the Arts, one may unintentionally bring to mind the image of an aesthete detached from common life. Yet when one looks at the special successes of each of the five Directors, those in a variety of ways embody vivid experiences that have been communicated with great skill and conviction to people from all over the world. The name Epstein carried a very different meaning to many Edinburgh people and others after the Epstein exhibition in the Waverley Market. It may be that Lord Harewood's allowing us to see the largeness of Epstein's human concern and the generosity of Epstein's creation of human character in the portrait bronzes that range from infancy to old age will rank as his most outstanding contribution to the Festival to most people. It may be that Peter Diamand will be remembered especially by the majority of people for the "dazzling and imaginative theatrical event" – as he called it – of *Orlando Furioso* which was presented at the Haymarket Ice Rink in 1970. Increasingly the Director is less concerned with sustaining a community of interest and more with extending community through the enlarging spectrum of the arts. With these considerations in mind we look briefly at the five Directors.

For Sir Rudolf Bing, the first Director, the extent and limitation of his objectives were clear. "England had been starved", he wrote in the 1971 Souvenir Programme,

> of international art and artists for five years; thus I thought of an international festival of orchestral music, great soloists, drama, ballet – and opera – Glyndebourne Opera! Where could such a festival be held? Near London, I thought, it would have to be: Cambridge or Oxford with their architectural beauty ... but I could not get anybody interested. Then Edinburgh came to mind.

The account of how Edinburgh came to have its Festival differs a little from that given by Harvey Wood, but the significant point is that Edinburgh stepped in where others feared to tread

and then went on to give the Director the help which made possible the realisation of an enormous enterprise. From the beginning the Director had the devoted and efficient service of a company whose combined knowledge covered the total requirement. John Reid, the City Social Services Officer, was the first Honorary Secretary and Administrative Director. He was assisted by William Grahame who became Secretary and Administration Manager. Directors and Lord Provosts came and went, but it seemed the patient, resolute Willie Grahame, whose sense of comedy took him through many near disasters, would go on for ever. He retired at the end of the twenty-fifth festival. His successor, George Bain, well-versed in the tradition of Festival administration, took over in 1971.

As the Festival grew in size and complexity so the team of patient enthusiasts increased, some taken on for the duration of each Festival, such as Dick Telfer at the Assembly Hall, and Graham Melville Mason at the Freemasons' Hall, others on the strength of the permanent administration. Without these professional administrators chaos would ensue, but equally without the voluntary help of professionals in other capacities the Festival could not continue. The efforts of Sir Andrew Murray, first as the first Chairman of the Finance and General Purposes Committee and then as the Lord Provost, who succeeded Sir John Falconer in 1948, were considerable and essential to the success of the first four years. Sir Andrew has continued his close association with the Festival as Chairman of The Festival Guild. A feature of the administration of the Festival has been the long service of many of its members. Just how wise were the judgements on who should be members of the Festival Council and advisory bodies from the beginning is evident from the number who have continued to give assistance from that date to the present.

The fact was that persons with a wide and detailed knowledge of the Arts were available in Edinburgh and in nearby Glasgow. If one lists the professions of those of the first Council, one recognizes in them the heirs of the Enlightenment; if it was possible to reflect in the twentieth century Edinburgh's golden age, then it would shine out from the representatives of the Law, music, painting, drama, architecture, literature, the University who allied themselves with members of the Town Council to form the Council of the Edinburgh Festival Society.

Amongst them still active in Festival matters are Lord

Cameron, David Baxandall, Dr Hans Gal, the Countess of Rosebery, Sir William Mactaggart. One notes that Edinburgh's Lord Provost Jack Kane was on the Festival Council twenty-nine years ago.

This meant that the Director had knowledgeable support and that there would not be any difficulties in communication. In one way the early Festivals were easier to conceive, if not to execute, than recent ones. There was then no doubt as to where the Arts began and ended. There was no doubt that if the numbers attended the great display of music and drama, then this was success. And this as we know was completely achieved. Equally there was complete agreement between the first Director, Sir Rudolf Bing and public as to the most treasured success of the first Festival – the reunion of Bruno Walter with the Vienna Philharmonic Orchestra. He reiterated this view in the Souvenir Programme of 1971 and then continued: "I was lucky enough to persuade Artur Schnabel, Joseph Szigeti, William Primrose and Pierre Fournier to form a piano quartet." Luck no doubt was on Sir Rudolf's side, but the formation of the quartet was the kind of venture which was to be made, and on a grander scale as Festival succeeded Festival.

The lines laid down by the first Director were continued by the second, Ian Hunter, who had been Rudolf Bing's Assistant Director until 1950. He was Director for six years, and was responsible for a major development during the period. "At the time I took over in 1949, planning the 1950 programme, the pattern of the Festival was largely set and my first year differed from its predecessors in that I was anxious to give the visual arts an importance comparable to that of the other arts." The Rembrandt exhibition was the first result of Ian Hunter's enterprise. There followed the exhibitions of Degas, Renoir, Cézanne and Gauguin. In 1951 was the year of the Festival of Britain. A special subsidy was given to the Festival to allow the visit of the New York Philharmonic Orchestra. The Orchestra gave fourteen concerts exclusively for Edinburgh audiences. So the geographical range of the Festival was extended westwards. Four years later, still under the Hunter régime, the Kabuki dancers from Tokyo presented their ritual dances at the Empire Theatre. It seemed that within the then agreed terms of reference of the idea of Festival, the riches were endless. And yet the climate of feeling was moving towards informality and spontaneity.

A Director, as well as being knowledgeable about the Arts, a first-class administrator and a persuader, must also be a kind of barometer. Robert Ponsonby, who had been Ian Hunter's deputy and who succeeded him as Director, had this additional quality. It was he who engaged Anna Russell in 1959 to make fun of the Festival, and then in 1960 the *Beyond the Fringe* team. He was aware that the Festival was so firmly established that it required for its health some good-humoured self-mockery. But the spirit of an impish Puck must have been inside himself, for on being requested, as were the other Directors, to write an article called 'Looking Back' for the Souvenir Programme of the twenty-fifth Festival, he dwelt with special pleasure on exhilarating, light-hearted moments. The best of these to which he referred was the dazzling performance of *Arlecchino* by the Piccolo Teatro of Milan, for which he was responsible for bringing to Edinburgh. Of this he wrote: "Marcello Moretti in the title role was unforgettable. At one point after a scene of quicksilver chaos and dialogue *fugato con fuoco*, total silence descended and the stage was discovered to be occupied only by a small blanc-mange quivering gently by the footlights."

He began this article by telling two tales of Beecham – one to do with his failure to coax Sir Thomas to the rostrum in the Usher Hall in readiness for the appearance of royalty in the Grand Tier. At the time Robert Ponsonby was deputy to Ian Hunter. He reported Sir Thomas as saying: "I don't want to be kept waiting about on that rostrum. I was once kept waiting twenty minutes by the Princess Royal. Stuck in the lift, she was. Having a baby at the time, I remember." With that he sailed on sedately. (History does not relate whether the infant referred to was his successor, Lord Harwood.)

Catholicity of taste – to which Lord Provost Kane referred – is an essential prerequisite in the Director. In a single paragraph Robert Ponsonby set out the programmes he valued especially during his régime. "I am still asked", he wrote,

> which events I am proudest to have been responsible for presenting at the Festival. I would say La Scala, with Callas and the Renaud-Barrault Company in 1957; Ballet Premières and Ansermet's Stravinsky and Britten concerts in 1958; the Stockholm *Walküre* (with Svanholm, Nilsson, Meyer and Söderström among others), Babilée and Fournier-Kempff Beethoven Sonatas in 1959; the Leningrad Philharmonic and Roger Planchon's company in 1960.

To have brought this list alone to the Edinburgh stage is a formidable achievement.

Not only is the number of distinguished names impressive but also the spread. There was something of the highest quality for the most eclectic taste. The range remained under Lord Harewood, but by his grouping of events, his featuring of selected composers, and his sense of what might be especially 'charged with meaning' for his day and the more adventurous spirits, he added a new intensity to the Festival. If one selects a few of the names of the composers featured during Lord Harewood's régime, such as Schoenberg, Boulez, Tippett, Shostakovich, and Janácek, one might conclude that the emphasis had moved from the accepted and more acceptable repertoire from past composers to the moderns and to some, Boulez in particular, whose demands were cerebral. And yet this would be a wrong conclusion. The heart was still as much in the Festival as the head. Indeed, between 1961 and 1965 there was a stirring of passions and of questioning along with great enthusiasm.

Lord Harewood's comments on his preferences, as they are stated in his article in the 1971 Souvenir Programme, show the strength of his feelings about the Festival and about Edinburgh. The point at which his article begins is significant. "Anyone connected with the artistic side of a festival", he wrote,

> would prefer visitors to remember what is home grown, in the sense that it is inspired and rehearsed and cooked up especially for a particular festival, rather than the imported package, however good the latter may be. The home grown performance, if ambitious enough, may easily be more expensive, but it will avoid the facelessness of some imports and it will not have been seen and heard at other festivals. While I worked in Edinburgh, I was proud of a performance of *Gurrelieder* in 1961 under Stokowski, which was I think genuinely representative of the work. *Gurrelieder* opened the first Festival for which I was responsible, and a work of equal scale, Mahler's Eighth Symphony in 1965 opened the last I ran; it too was home grown, with the S.N.O. and the newly formed Festival Chorus under Alexander Gibson, and I think it was no less representative.

Lord Harewood was "equally but differently proud of a season by the Prague Opera in 1964" when the Czechs presented a repertory of British premières – Smetana's *Dalibor*, Janácek's *The House of the Dead*, Cikker's *Resurrection* and the first Czech-language performance in Britain of *Katya Kabanova*, on which he

commented: "I doubt if any operatic performance for which I was technically responsible in Edinburgh gave me more pleasure than theirs of *Katya*; it seemed to me as near a complete realisation of a composer's aim as one is likely to get in an imperfect world."

How utterly wrong Lord Harewood's words prove the idea of a Director of a festival of the Arts, as a man detached from human concerns, for the realisation of a great composer's work meant the making available of memorable experience, of involving people in moments of purer intensity than what their lives normally can give.

When, therefore, people write silly letters in the Press or give expression to superficial half-truths about the Festival being a pandering to minority interests, all who desire to incorporate as many as possible in the generous spirit of the Arts naturally feel indignant. There is an interfering spirit, which may be more evident in Scotland than elsewhere, which is dangerous to the quality of life with which Arts festivals are concerned. One understands why Lord Harewood elected to end his short article on the Festival with these words:

Edinburgh is the perfect city in which to hold a festival, partly because it is of exactly the right size to provide an impressive frame and yet not to swamp a programme with its everyday activities, partly because it is a marvellous place in its own right. Scotsmen are used to making up their minds and disinclined to accept other people's valuation, and this independence applied to their festival as to anything else. While I respect the independent spirit I used sometimes to wish that people quoted in the press, would sometimes say they liked the festival they found in their midst rather than dilating on the inconveniences it caused them. Nonetheless it would be inappropriate to omit to say how that every time I drove from the airport to start one of the dozens of visits I made to the city for meetings, my first glimpse of the Castle, whatever the weather, whatever my mood, never failed to produce that lifting of the spirit which is commonly associated with love.

No words could be more appropriate to end the account of Lord Harewood's unreserved commitment to the Edinburgh Festival, and beyond it to the spirit of truth as it is expressed through the Arts, than the last sentence in his article. It points to Lord Harewood's awareness that the Arts are not sufficient in themselves. Unless they connect with, indeed draw strength from, the community which they serve, the virtue of honesty and

naturalness will cease to be present in them. The special use of many of the Scottish contributions was in the immediacy of their relation to the people of Scotland. There was another strength which came to the Festival unasked – the Fringe.

Comment has already been made on the Fringe in the chapter on drama, on which art the Fringe stands or falls, but I return to it as a preliminary to remarking on the direction of the Festival during the present Director's reign. During the early 'seventies the drama on the Fringe has had almost as much attention by drama critics as has the drama in the official Festival, and sometimes it was given more favourable attention. When one considered the immense range of companies which now perform on the Fringe, one should not be surprised that the Fringe has some outstanding successes, as well as many failures that go unnoticed. These successes are not always sporadic. They tend to be associated with groups who have produced plays on the Fringe over many years – such as the School of Performing Arts of the University of Southern California, Cambridge University Theatre, the Oxford Theatre Group, and the Edinburgh Dramatic Society, who claim to be the founders of the Fringe. I have deliberately selected amateur groups, any one of which is capable of giving performances of professional standard. One must then add the professional companies, outstanding amongst them The Traverse, and the solo performances of such as Calum Mill, Russell Hunter and Tom Fleming.

It would be surprising with the presence of such forces if the distinction between the drama in the official Festival and the Fringe did not become blurred. The solo performers have performed with acclaim in the official Festival on several occasions. There may be a question as to how best to use the continuing dramatic achievements on the Fringe, and especially those achievements which reflect in drama 'the pressures of the age'. This is the field of the Traverse. Throughout the year in Edinburgh the Traverse Theatre presents new theatre in new styles of production, which allows for the absorption of contemporary events and opinions into drama – just as the Demarco Gallery has shown new experimental work, and more recently put on shows which brought together art and drama. The Demarco Gallery has provided events which sometimes were on the Fringe and sometimes in the official Festival. But since in the field of the visual Arts official bodies other than the Festival Society have mounted exhibitions in Edinburgh during

the Festival, which flag they fly is no great matter.

There has been no doubt about the attitudes of Directors to the growing strength of the Fringe. Lord Harewood expressed his approval of it in a broadcast, remarking as well that it must remain free to go its own way. Mr Diamand has also expressed his admiration of the Fringe. He recognizes it not as a rival, but as an additional enrichment and as a possible resource. The question of how best to use it is simply a practical one, raised admittedly with the recollection of the pleas of Michael Billington in the *Guardian* in 1973 and Harold Hobson in *The Sunday Times*.

There is a natural tendency to evaluate Festival drama on the experience of the year on which one is making comment. Observing the vitality of Fringe drama, and sometimes its professionalism, one may feel at a loss to understand why the Festival with its great resources does not do better. It may be that the perspective on which some adverse critical comment is made is not wide enough. It may be that Mr Diamand and his assistant in drama, Bill Thomley, have made a more subtle response to the needs of the situation than has been credited to them. It may be that one's perceptions are clouded on account of certain preconceptions.

For instance, the Fringe, by its nature, is presumed to be full of the joy of life, spontaneous, refreshing and daring, whereas the official Festival, by its nature, is presumed to be the choice of the Establishment, all dressed up and going nowhere. But turn back the pages of this book and one discovers, I believe, the latter proposition will be found to be untrue. What the Festival has done in providing new or rare drama – for instance the Noh plays – is far beyond the abilities of the Fringe. The question at issue, however, is about vitality. It may be that the idea of promoting companies from the Fringe on occasion whose work has been seen to be of striking merit over some years should be given consideration. Even so, there are facts to be acknowledged which suggest Mr Diamand is very much alive to the whole situation.

As the Festival has aged there is evidence to suggest that the audiences have become younger – and in one year at least, under Mr Diamand, the performers younger as well. It seems to me that no one has been more alive to the risk of sterility in the Festival, resulting from promoting accepted attitudes to the Arts, than Mr Diamand – attitudes, not works or programmes. As far as I am

concerned the newest experience I have had in the Festival was in the playing of the later quarters of Beethoven by the Amadeus String Quartet. One wonders if it would have had quite the effect it had without the unspoken, but implied, invitation of the Festival as a whole to enjoy its variety with a free mind and response.

The situation which Mr Diamand inherited when he became Director in 1966 was a more complicated one than any of his predecessors. In certain respects he had greater difficulties. There was greater competition for the best artists by other festivals in other countries. Other countries were no longer so ready to subsidize their companies for visits to Britain and the opportunity of mounting exhibitions on the scale of the Monet or Rembrandt no longer existed. Further, questions about the purpose and nature of art were insistent – they were implied in some of the new shows at the Traverse and in the exhibitions at the Demarco Gallery. The more fluid climate of opinion as to the function of art demanded recognition and yet there remained the main body of the Festival audience which included an increasing number of young people avid to witness the great masterpieces of the past. In other words the central purpose of the Festival remained unchanged.

Peter Diamand had in his first year another conditioning factor – the programme of Lord Harewood. He made his statement about his attitude to this inheritance in his article in the 1971 Souvenir Programme. It begins:

When I started, comparatively late, to prepare 'my' first – the twentieth – Festival for 1966 I was apprehensive that a taste of déjà vu or entendu might be felt. My predecessor, Lord Harewood, had introduced an artistic policy which gave special emphasis each year to two or three different composers. I saw no reason to change it. Robert Schumann and Alban Berg were the central figures for 1966, Berg being represented by nearly all his works, including his two operas which were most impressively performed by the opera from Stuttgart.

In 1967 the Edinburgh Festival 'came of age'. This, we felt, had not only to be celebrated, but it also had to mark the beginning of a new phase.

One way in which this was reflected was the first appearance of Scottish Opera at the Festival. It proved there now existed a home grown company fully qualified to compete with all other groups, foreign and British, which during the first twenty years had contributed to the reputation of the Festival. In a year in which

works by Bach and Stravinsky were prominently featured, Scottish Opera's performance of *The Rake's Progress* and *The Soldier's Tale*, well cast, thoroughly prepared and imaginatively staged, formed a brilliant introduction of a hitherto only nationally acknowledged company to the international scene.

In the same year another Scottish group, the Edinburgh (then still 'Scottish') Festival Chorus, launched by Lord Harewood and trained by the shrewd, enthusiastic and gifted Arthur Oldham, received the highest praise from its conductors Karajan, Abbado and Kertesz.

Those passages from Peter Diamand's article reveal how much the life of the Festival depends on the Director's insight into where the source of that life is to be found. Had the interest and the ideas of the first Festival been slavishly pursued, then the witless remark that the Festival is an imposition might have some truth in it. But the Festival draws its strength increasingly from the native contribution, a direction planned and welcomed by the present Director and his predecessor, Lord Harewood.

The Festival becomes most truly international at the point when the home country's contribution is central. Until recently Scotland has not had the forces in music and drama adequate for the task. The adequacy and availability of the musicians has been achieved, and though unrelated to this development, new music of acknowledged quality has been composed by Scottish composers. Their increased representation in the 1974 Festival was evidence of this. In contrast the last new Scottish play presented in an evening — there was the short play *The Knife* by Ian Brown at lunch time in 1973 — was *Confessions of a Justified Sinner*, an adaptation of James Hogg's novel by Jack Ronder, in 1971.

It should have been, one felt, a success, for the novel had that dark disturbed spirit and horrible intensity which has been too much a part of the Scottish religious psyche. Even if it did not come off entirely, it was surely a right idea for the dramatic opening to the twenty-fifth Festival, as was the new work commissioned by the Edinburgh Festival Society, *Te Deum for Orchestra and Chorus*, by Thomas Wilson, for the opening concert of that year. The work did not receive great acclaim by the critics, though Conrad Wilson in *The Scotsman* drew attention to its character. He remarked of the composer:

. . . he has treated one of the traditional forms in a way that reflects the unease of the world today . . . it could almost be an Anti Deum

[but] what he has done is to set them [the words] in a way which seems to question not God but the future of mankind . . . At the end the singers sustain their last note with what seems to be intended as a ray of hope, while the orchestra adds softly sinister comments. It is a strongly wrought score, a fine vehicle for the chorus.

The word 'sinister' was also applicable to *The Confessions of a Justified Sinner*. The play did not find a form adequate to revealing the character of the novel, but it demanded serious attention. Certain kinds of failure – and at the most this was a failure in realizing the stature of the original – are far better than many easy successes. The significance of Wilson's composition and Ronder's adaptation, for the Festival and for Scotland, is in an awareness of techniques and ideation that put these creators close to imaginative centres of concern today. Whereas however attractive was that Scotch farce *The Comedy of Errors* by William Shakespeare at the Haymarket Ice Rink also that year, rapturously received by mainly Scottish audiences, it could have made visitors believe that kilts and Scotch comics are still the staple of Scottish entertainment.

As may be seen from comment in the chapter on drama, exception is not being taken to the diverting adaptation of Shakespeare. The principal reason for referring to the production again is to draw attention to the stretch of interest in drama achieved by Peter Diamand and Bill Thomley in 1971, and also to draw attention to the desirability of keeping the Scotch high jinks in balance, if it is possible. It may be possible, for C.P. Taylor, Hector Macmillan, Stanley Eveling and on occasion Stewart Conn have all shown their dramatic writing talent on the Fringe or elsewhere. The problem remains – with new plays there is no guarantee of success and somehow the failures in this art appear more nakedly than in music. It may be presumptuous to suggest names. The particular relevance in producing these evidences is on account of their drawing attention in two areas on which Mr Diamand made comment. The first is related to youth. Mr Diamand deliberately set out to interest young people and to give the most talented opportunities to perform in the Festival. He considered that an appropriate way to celebrate the twenty-first birthday of the Festival was to introduce younger artists. He refers to this in his modest way in his article for the 1971 Souvenir Programme where he wrote:

Another aspect of the Festival entering into a new phase was the

growing share which younger artists – some of them, at that time, little known – had in the Festival programme. Among them: pianists Martha Agerich, Stephen Bishop, Rafael Orozoco and singers Helen Donath, Edda Moser, Shirley Verrett, Giacomo Aragall and Luciani Pavarotti. (Barenboim had conquered Edinburgh audiences already in 1965 when he virtually at a few hours' notice replaced Claudio Arrau.)

He regarded the twenty-fifth Festival as the appropriate occasion for the appearance of the National Youth Orchestra of Great Britain and for the introduction of a number of young soloists, among them Margaret Price, the Welsh soprano, Pinchas Zukerman, the Israeli violinist, the Russian pianist Vladimir Ashkenazy and André Previn, the young conductor from the United States. Here was the official Festival with a youth policy far beyond the Fringe, but another aspect of Mr Diamand's policy, related more closely to it. In 1970 in the Haymarket Ice Rink he put on the uninhibited, noisy, colourful, spectacular *Combine Stomp*. In the same place he put on – though one should mention Bill Thomley's name in both connections – the adaptation of Ariosto's *Orlando Furioso* which carried everything before it. Those items, though on a scale beyond the capacity of the Fringe, had the unqualified exhilaration which one might expect of the Fringe.

The second area for which Mr Diamand has special regard, to which the last two paragraphs of his article in the 1971 Souvenir Programme testify, is the necessity for the Festival being 'rooted' in Scotland. Of course had the Festival not had the support of many people in Edinburgh from its beginning in 1947 the Festival would not have continued. Some of the many may never have attended the Festival but the welcome of the people was noticed by Kathleeen Ferrier in 1947; it rose to a crescendo when Menuhin, Cassado and Kentner went to Pilton, and it surprised T.S. Eliot after his arrival in Edinburgh to attend the première of his play *The Cocktail Party*. He had enquired of his taxi driver the fare from the Waverley Station to his hotel, at which the taxi driver indicated he would accept none, not from "Mr. Eliot, the poet."

Such episodes are indices of attitudes, but more deliberate, and with undeviating persistence, has been the service of the Festival Guides to visitors. They have given meaning to the *mise-en-scène* of the Festival, historic Edinburgh. Voluntary guides have made 'Special Tours' – as the 1947 Souvenir Programme put it – from

that date to the present down the Royal Mile. In 1961 the Festival Guild was formed to support the Festival by the enthusiastic interest of its members and by making donations to the Festival from time to time. The Festival Club in the Assembly Rooms and Music Hall in George Street is another facility which has been in existence from the first Festival. Even so, all these items together do not take account of Peter Diamand's conception of the present status of the Festival as far as he is concerned. He ended his comment in the 1971 Festival souvenir Programme with true Scottish understatement. The statement holds good now as it did then. It is proper that the last word on the Festival in this book should be from the Director. He ended his article thus:

After twenty-five years I believe that the Festival, while having sustained and perhaps enhanced its international reputation, is now even more deeply rooted in Edinburgh and Scotland that it was – also perhaps because more Scottish artists than ever are involved in it. I believe too that younger audiences take a more active interest in the Festival than they used to do. To keep their interest alive will be an important task, a great challenge for the coming years.

The city and citizens of Edinburgh will continue to be splendid hosts to the artists and to the visitors – not the boastful, flashy, sometimes oppressive kind – more in that cautious yet reliable spirit in which one Edinburgh citizen summed up his feelings last year: "I quite liked the Festival, I even enjoyed it. All in all we are none the worse for it."

Index

Index